UNLOCKING THE PROS' HOTTEST POST-PROCESSING TECHNIQUES

THE HDR BOOK

Rafael "RC" Concepcion

The HDR Book, **2nd Edition Team**

CREATIVE DIRECTOR
Felix Nelson

ART DIRECTOR
Jessica Maldonado

TECHNICAL EDITORS
Kim Doty
Cindy Snyder

PHOTOGRAPHY
Rafael "RC" Concepcion

PUBLISHED BY
Peachpit Press

Composed in Hypatia Sans and Rockwell by KelbyOne.

Trademarks
All terms mentioned in this book that are known to be trademarks or service marks have been appropriately capitalized. Peachpit Press cannot attest to the accuracy of this information. Use of a term in the book should not be regarded as affecting the validity of any trademark or service mark.

Photoshop is a registered trademark of Adobe Systems Incorporated.
Photoshop Lightroom is a registered trademark of Adobe Systems Incorporated.
Windows is a registered trademark of Microsoft Corporation.

Warning and Disclaimer
This book is designed to provide information about high dynamic range photography and photo-processing techniques. Every effort has been made to make this book as complete and as accurate as possible, but no warranty of fitness is implied.

The information is provided on an as-is basis. The author and Peachpit Press shall have neither the liability nor responsibility to any person or entity with respect to any loss or damages arising from the information contained in this book or from the use of the discs, electronic files, or programs that may accompany it.

ISBN 10: 0-321-96694-5

ISBN 13: 978-0-321-96694-0

9 8 7 6 5 4 3 2 1

Printed and bound in the United States of America

www.peachpit.com
www.kelbyone.com

To Albert J. Fudger:

*You have been with me through thick
and thin. You have served as a sounding board,
cheerleader, jester, motivator, critic, and as
a person that teaches me humility and the gift
of hard work in everything you do.*

It is an honor to call you my best friend.

I appreciate that above all.

ACKNOWLEDGMENTS

This book was written on the shoulders of so many incredible people. While the list of people that I'd want to thank specifically would be a book in and of itself, I'm going to try to do the best that I can to keep it as short as possible.

To my father, Rafael Concepcion, who has since passed on. I'm sure he's looking down, smiling at what he was able to create, and I'm grateful to him for raising me with a sense of right and wrong, and giving me the intelligence to choose.

To my brothers, Victor, Everardo, Jesus, and "baby bro" Tito, for being there when I've needed them. A special thanks goes out to my brother Carlos and his wife Vicky. One conversation with Carlos changed the course of what I've done, and I'm grateful for that. Last, but not least, to my brother Dave: you've been a sounding board and confidant for so long, it is hard to imagine a time when I wasn't with you.

To my uncle Rene, who is always a trusted advisor in my life. To my sister Daisy Concepcion and Norman Wechsler, who always believed I would be able to achieve great things. To Jim and Danielle Bontempi, the best in-laws one could ever ask for. To Merredith and Tim Ruymen for being a lifeline to our world in New York. Erin and Bill Irvine round out a great family that I'm thankful for.

I've been blessed with great friends. Jennifer Vacca and Lucy Cascio at Zoot Shoot Photographers gave me my start in a studio. Charlie Enxuto and Steve Zimic taught me so much at Split Image Photo. Annie Gambina of New Horizons let me wreak havoc in her classrooms. Matt Davis has always been a great cheerleader and sounding board. I've received inspiration and sage advice from Brigitte and Debbie Calisti. I've spent days on end laughing with Kyle Robinson and his wife Teresa. Bruce "Disco" McQuiston and I shared many a tender moment listening to Enigma. Mike McCarthy will forever be one of the funniest guys I know. Jane Caracciolo has been the person whom I'd call in the middle of the night to answer the most complex of problems. Her mother Jane Caracciolo, Sr., will forever be known as my second mother—one whom I love immensely. To Andrea Barrett: I miss you! Matt Wanner's a heck of a firefighter, and an even better writer and friend. Then there's Jeremy Sulzmann and Mohammed al Mossawi, two of my mates while living in Germany. Here are two friends I can call on to fly around the world (or share a tube ride) to meet me in London for just one night.

To my Tampa crew: Kathy and Rich Porupski: you're an extended family for me now and have been so gracious to my family. I truly appreciate that. Jim Sykes: thank you for being so willing to help me in my times of need. Erik Valind: I so miss you here in Tampa. Big up to Ryan Gautier! Donna Green: thanks for the sounding board and laughs during my frustrating moments! Rob Herrera: you are always up for an adventure. It has been great to call you a friend. Wendy Weiss, who gets to pull double duty as my photography buddy and doctor. You couldn't imagine what an office visit is like now! A special thanks goes out to my friends Jay and Susan. Sabine calls you more her friend, and that warms my heart every time you guys come out and visit. Sean Neumier: I *will* beat you at *Street Fighter*. Count on it. :)

To Ken and Elise Falk: thank you for sharing in my adventures and being such great friends to Jenn, Sabine, and I. It's good to be able to get into a four-way with you guys (on the phone) and just laugh through the night.

A special thanks goes out to Yolanda, Neil, and the Corteo family for being such great friends to us here in Tampa (and for having the best pizza around).

To Bonnie Scharf: I've known you for over 21 years, and you're like a sister to me. Fortunately for me, you've been there through thick and thin. Unfortunately for you, you've had to put up with me for that long!

To Mike Wiacek, my favorite Google Guy: thanks for being such a supporter—and an even greater friend!

This book would not have been possible without the guidance and tutelage of Scott Kelby. I met Scott several years ago, and still keep a picture of that meeting to this day. While I'm grateful for his experience and skill at being the best in the business, I'm an even bigger admirer of his grace, candor, goodwill, trust, and unbending dedication to his friends and his family. He's an awesome mentor, and he and his wife Kalebra are models for what true friends and dedicated Christians should be. For that, I am forever grateful.

I've been inspired by Joe McNally's work for longer than I've been using Photoshop. To be able to count him and his wife, Annie, as trusted friends and mentors has been one of the best gifts a person could ask for.

To Bert Monroy: you embody what it means to be brilliant at Photoshop. Thank you for being a great friend and inspiration to me.

Then there's my family at KelbyOne. To my editors, Cindy Snyder and Kim Doty: thank you for chiseling and polishing this book to perfection. To Jessica Maldonado: you're the best book designer in the business! To Kathy Siler, for always making me smile! To Felix Nelson, our Creative Director: thank you for steering this ship on top of the five thousand other things you're busy amazing people with. To Brad Moore: thanks for being such a great sounding board and lunch partner. To our IT director, Paul Wilder: thanks for keeping me up and running, and letting me run my experiments on the computer. To Dave Moser: thank you for being our fearless leader, and such a wonderful friend. To Mia McCormick: I am ever grateful to you for being a mentor to me in front of the camera. To have someone as good as you are looking after that makes me grateful to have a friend in you. Ron: man, the office just wouldn't be the same without you. You've become my beacon, and a great friend. To Meredith: thank you for being at the helm of my podcast. I've appreciated your control more than I'll ever say. To Charlotte Langley: as much as I will miss you here at work, I am so happy you are leaving for L.A. Just remember us when you become super-famous!

A special shout out to my fellow Photoshop Guys: Matt Kloskowski, Pete Collins, and Corey Barker. Pete, you are sage-like with your philosophy and wisdom. I can't tell you how much I count on that. Corey, one of the biggest joys I've had these last couple of years has come from just driving around for lunch. Thanks for that!

My sincere appreciation goes out to all of my friends at Peachpit Press: Scott Cowlin, Sara Jane Todd, Gary-Paul Prince, Nikki McDonald, Barbara Gavin, Jennifer Bortel, Laura Pexton Ross, Lisa Brazieal, Nancy Davis, and Nancy Aldrich-Ruenzel. A special thanks goes out to my editor, Ted Waitt, for all of his help on the book!

The work of the following people never ceases to inspire me: Moose Peterson, Jay Maisel, Katrin Eismann, Deke McClelland, Terry White, Rich Harrington, David Ziser, Brooke Shaden, Joey Lawrence, John Paul Caponigro, Lois Greenfield, David Lynch, Andrzej Dragan, David Hobby, Steve McCurry, Jeremy Cowart, Susan Meiselas, Vincent Versace, Jeff Revell, Bill Fortney, Stephen Hart, Michael Frye, and John Loengard. To Gregory Heisler: you have been a hero to me photographically for a long time now. Can't tell you how happy I am to now call you a friend.

Many thanks go out to some people who I find amazing in the world of HDR: Michael Steighner, Rick Sammon, Brian Matiash, and David Nightingale. A special thank you goes out to Trey Ratcliff. Trey, you're a wonderful trailblazer for this technique, and your passion truly shows. I am honored to call you my friend.

A special thanks to Klaus Herrmann, Jacques Gudé, and Tracy Lee for agreeing to be profiled in the book. You should each stand and be proud for producing amazing work. Such an inspiration.

To the team at Jade Mountain: Karen and Michael Allard, Edmund Modeste, and last, but certainly not least, Karolin, Nick, and Yasha Troubetzkoy. My time at Jade Mountain has served as a welcome retreat and an incredible fountain of inspiration. It's an honor to be able to share your vision of paradise in this book. I will forever be an evangelist for this little slice of heaven.

To my wife, Jennifer Concepcion: Aside from being my loving wife, you are such an integral part of my success. You are my editor, my proofreader, my assistant, my confidant, my advisor, and the shoulder that I rest on when I can't go any longer. You're the inner eye no one sees, and the reason I get to do any of this. I love you more than I could ever say.

To my little girl, Sabine Annabel: I tear at the mere thought of coming home and hearing "Whatcha doing Daddy?" for it takes every single boo-boo away. You're the apple of my eye, and your smile brings me the greatest peace. Daddy loves you through and through. Yesterday, today, and tomorrow, too.

Last, but certainly not least, thank you, my dear reader. By the sheer grace and goodwill from the Almighty, He has blessed me with a life where I get to share the things that I truly love with each and every one of you. It's a gift I accept with great humility, and enormous pride, and I am very grateful.

ABOUT THE AUTHOR

RC is an award-winning photographer and author of the best-selling books *Get Your Photography On the Web* and *The HDR Book* by Peachpit Press. He is an education and curriculum developer for KelbyOne, and co-hosts the popular podcasts *Photoshop User TV* and *Photography Tips and Tricks*.

An Adobe Certified Instructor in Photoshop, Illustrator, and Lightroom, RC has more than 14 years in the IT and e-commerce industries, and spends his days developing content for all applications in the Adobe Creative Suite. As an Adobe Certified Expert, RC worked with Adobe in writing the Adobe Certified Expert exam for Photoshop CS6, Lightroom 4, and Lightroom 5.

He has held training seminars in the U.S., Europe, and Latin America, and is a highly sought guest instructor. Recently, he has worked with the Digital Landscape Workshop Series with Moose Peterson, Joe McNally Photo Workshops at Jade Mountain, His Light Workshops with famed landscape photographer Bill Fortney, and the Voices That Matter: Web Design Conference in San Francisco. He is presently on tour with the Adobe Photoshop for Photographers seminar tour in the United States for KelbyOne.

RC lives in Tampa, Florida, with his wife Jennifer and daughter Sabine.

CONTENTS

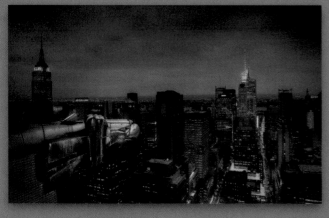

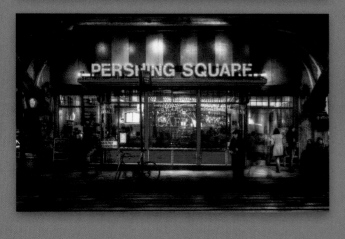

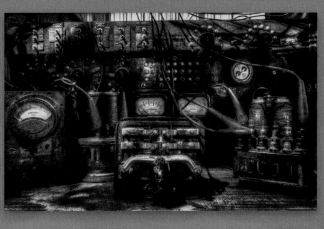

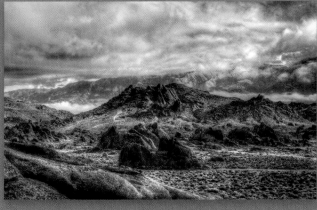

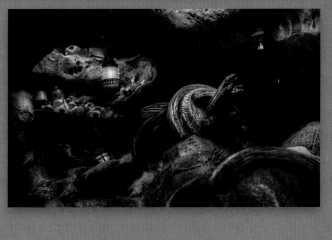

CONTENTS

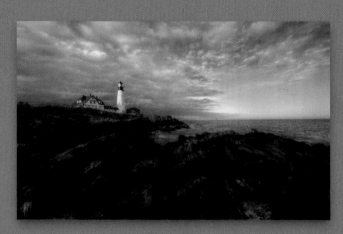

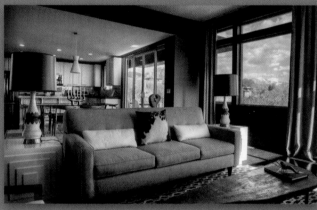

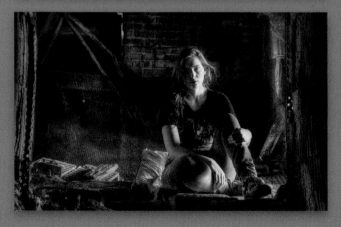

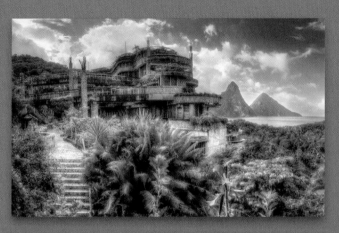

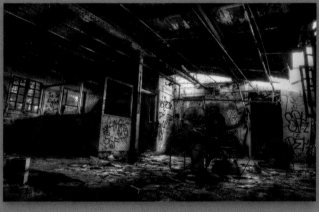

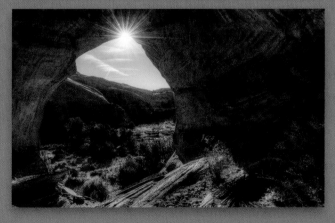

INTRODUCTION

It's pretty safe to say that HDR photography is in full bloom. Your iPhone has an HDR picture mode. Google offers HDR filters to pictures uploaded to Google+. There are filters from various companies emulating HDR effects, offering to give you "that HDR look" that you are looking for. With so much HDR imagery available, I feel like the number of people who are interested in the technique has increased since we last spoke. It made me want to go back and think about the relevance of what I had written previously.

When I wrote the first version of this book, I really set out to debunk the entire idea that HDR was this overly complex dark art that few could really master. The fact of the matter is that making an HDR file is actually pretty easy: capture a set of images, jiggle a couple of sliders, and export. You're done. I felt like some of the stuff that was out there actually made the process harder than it really needed to be. I wanted to write a book that taught you *how* I came to the results of some of my images.

By sharing with you why I moved a slider (instead of giving you a recipe or a preset), it would help you think about what to move in your next image. I also wanted to cover a dirty little secret about processing HDR shots: you're not really done with the file after tone mapping the image. Much like every other genre of photography, the post-processing of the image is an important component of taking a good image and making it a great one. Many people used Photoshop or software from onOne Software, Nik Software (now the Google Nik Collection), Topaz Labs, and others to finish a file, but that step was usually relegated to the "Oh, I tone mapped the file and I did *some post* to it" part of the conversation. In fact, that *some post* part is the most important part of the conversation when making an image.

So, in the interest of full disclosure, I will tell you this: I am not going to talk about how reading the histogram during your capture session can benefit you when making HDR images. It doesn't. I'm not going to

tell you that the best way to shoot an HDR shot is to start in manual mode. It isn't. We have cameras that can capture a series of images of a scene with incredible accuracy and great range. Let's let the technology capture as much as it can, and let's focus on playing with the results the best way we know how. Let's also do this in as straightforward a manner as possible.

In thinking about this second book with this mentality, it made me go back and look at a lot of the techniques in the first book and made me want to go back and pare down a lot of it. Are there dozens of different programs that you could use to make an HDR file? Yes, but many of the people in this space use one: Photomatix. Is there a way that you can do post-processing tricks in a handful of different programs? Sure, but the best program to start all of this in is Photoshop. Are there different ways to emulate a bunch of post-processing techniques that we could explore? Yes, but a large number of users out there use plug-ins to do this heavy lifting. Instead of taking a "Well, one *could* use this software" approach to tell you how to do something, I focused on a "This is what *I* would do in this scenario" approach, which lets you explore the workflow for making an image and see the tools that are best used to make them. Most of them can be downloaded as trial versions. At the end of the exploration and learning process, you can then decide which ones of these are essential to the kind of work *you* do. You can then keep or jettison tools as they fit what you are shooting.

So, we will cover what kinds of things I would recommend to you in terms of gear and technique to capture a series of images. Once we've covered that, I'll spend some time talking about the kinds of things I look for in a scene to make an HDR. This will get you best prepared to get out there, look for the shot, and get the source files you need.

We'll then spend some time looking at Photomatix and how we can use it to create a tone-mapped file (the merger of a series of exposures). There's really not that much to Photomatix, and I feel like going through the

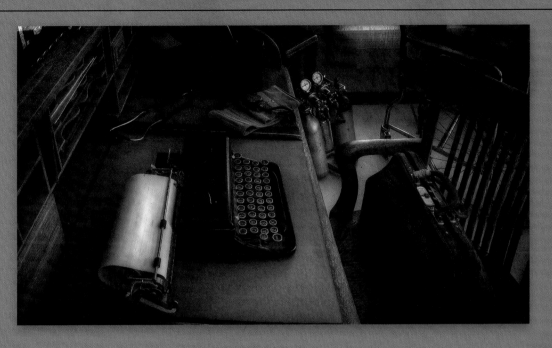

process in my specific order will get you making good tone-mapped files out of the gate. (I'll cover how to use Photoshop and HDR Efex Pro for tone mapping HDR in videos on the book's companion website at **http://kelbyone.com/books/hdr2** in the event that you want to see other options.) Now you're ready for the post-processing part.

The rest of the book takes you through 10 projects from start to finish. I'll talk about how I got to the tone-mapped version of the file, and what kinds of things I wanted to focus on in Photoshop to take that image to the next level. The images for each of these projects will be available to you on the book's companion web-site (**http://kelbyone.com/books/hdr2**), so you can follow along. You are free to use those images for whatever you'd like. If you post them socially, I only ask that you let people know that you're experimenting with images from this book. In a couple chapters, you'll see a section called "It's Your Turn." Here, I'll show you my finished file and give you the source files for the project to see what you can come up with.

I also wanted to introduce you to a few HDR photographers out there who are making great work. These photographers can offer great insights and help inspire you along the way.

For those of you who purchased the first edition of this book, I give you my thanks and present to you a book that further focuses my HDR technique to just what you need, and shares new techniques. I'm giving you 10 new projects that you can play with and share, and introducing you to new photographers for additional inspiration.

For those of you picking this book up for the first time, I promise you a straightforward, no-nonsense approach to teach you the tools you need to express yourself in this HDR world. I'm thrilled that you've considered this, and can't wait to share with you what I've learned.

Let's get to it!

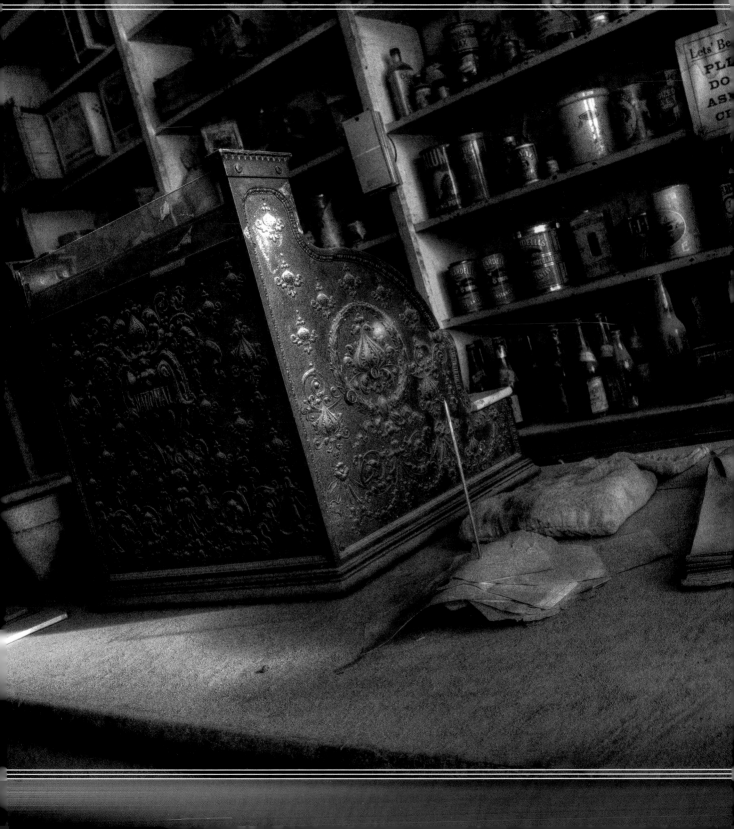

ONE

Tools & Techniques

Like with anything in photography, working with HDR images will require three distinct things: hardware, software, and technique. On the hardware front, you don't require that many things to set up an HDR series. Camera aside, the hardware listed in this chapter can even be seen as recommended, rather than required—you can make HDR images without it. What you'll find, however, is that while the images will certainly be good, it's the extra investment in the hardware that can take them to the next level. Steadying your camera is paramount in HDR, so anything you can do to make that happen is key.

On the software side, there are a multitude of options for you. In this book, I make certain recommendations (one of the biggest changes for me has been moving back to tone mapping using Photomatix over HDR Efex Pro, which we'll talk about later), but you can obviously substitute with your own choice. That said, I will point out that when you take a look at the HDR images out there, you'll see common pieces of software that are used. Many times, that look that you think is really cool is all based on a specific piece of software. Is that a bad thing? Not at all. Look at it this way: if you were off to build the frame of a house, you wouldn't try to use plumbing tools. There are specific things to be used for specific reasons, and HDR does have a specific list. Do you need all of them? It's up to you. Thankfully, you can work with all of the software in a trial version to see which one fits.

Finally, there's technique. Whether it's panning with your feet, or why to click a specific button on a screen, there are certain tips and tricks out there that make getting that great shot easier. This chapter is about pointing out those things that will make your life easier (the result of a lot of frustrating moments for me, by the way). Enjoy!

YOU NEED A BRACKETING CAMERA

Back in the film days, photographers had to use their best guess as to the exposure of a scene. They'd look at the scene and say, "I think this scene is 1/60 of a second at f/5.6. Man, I hope I'm right." Not having the luxury of a display on the back of their cameras, they often had to wait a few days to see if their guess was right. Because of this limitation, photographers finally said, "Forget this! I'm going to take an image at the exposure that I think it is, and then I'm going to take the same shot 1-stop underexposed, and then take it again 1-stop overexposed." By taking these three shots of the scene, they'd ensure that at least *one* of these frames would be right. Sure, this meant that they needed to develop three negatives to see which was right, but it sure beat missing a moment or having to travel back to the location and set up the image again.

This process is known as bracketing, and most DSLR cameras can now do it automatically for you. What I think is cool about this is that it's just an extension of the early days of bracketing. Instead of developing those three images to see which one is the best, you can use software to merge all three of them together. The software then lets you control how those files blend with one another!

HOW MANY IMAGES

When working with bracketing, you tell the camera how many frames you want to shoot, and how much of an exposure difference you want in between the images. Let's say that the scene reads 200 seconds at f/8. If I set my camera to capture nine images with a 1-stop difference in between them, the images shown here would be the exposures that would come out.

Now, how many images you need and how much of a range you need between them is the subject of much debate. At a minimum, the images should be about a stop apart from one another, which incidentally happens to be the maximum increment for most Nikon cameras. Canon cameras can shoot brackets with as much as a 2-stop difference between images—something I've always been jealous of, being a Nikon shooter. To make a good

HDR, you should start with three exposures: one is the "normal" metered image, and the second and third are the overexposed and underexposed ones. You can do some cool images with one shot, as you'll see at the end of the book, but get used to getting at least three. There are some scenes where I think having five, seven, or even nine frames will help (shooting in daylight, I almost always use nine frames), but three should be your minimum.

By the way, only the newest Canon cameras will allow you to shoot more than three frames per bracket. This is where my jealousy is tempered. If your camera doesn't shoot more than three, that's fine, just start with that.

SETTING A NIKON FOR BRACKETING

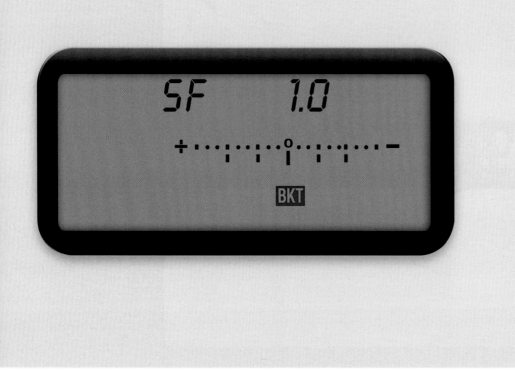

On the back of your camera, press the Menu button, then select Auto Bracketing Set<AE Only. On the top of your camera, press the BKT button, and then use the main command dial to choose how many frames you want to shoot (this will appear in the control panel on the top of the camera). Now, use the sub-command dial in front of the shutter button to adjust how many increments there will be between exposures. The maximum increment of exposure on most Nikons is 1 stop.

SETTING A CANON FOR BRACKETING

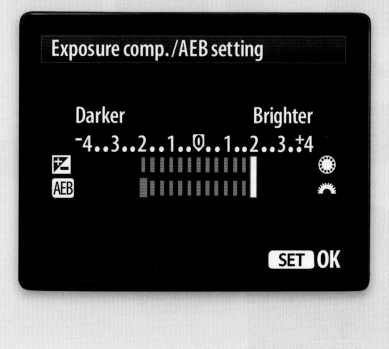

Go to the Camera tab menu in the LCD on the back of the camera, then scroll down to Expo Comp/AEB (Auto Exposure Bracketing), and press the Set button. Now, use the Main Dial on the top of the camera to choose how many frames you'd like to capture, then use the Quick Control Dial on the back of the camera to set the exposure compensation amount. The –1 and –2 settings speak to how many stops difference there will be between the images. I usually set this to –1, but in situations of bright/high contrast, I switch it to –2.

CHANGE YOUR BRACKET ORDER

By default, when you shoot a bracket of images, your camera will shoot the metered image first, then shoot the underexposed image, then shoot the overexposed image. The problem with this is that when you go to look at the images (on your LCD, in Bridge, or even in Lightroom), it's hard to tell which image was the "start" of the series.

To help with this, change your camera's bracketing order. On a Nikon, from the Custom Settings menu, choose Bracketing Order>Under>MTR>Over; on a Canon, from the Camera tab, choose Custom Functions>Exposure>Bracketing Sequence>1. Now, when you look back at your images, you'll always know that the darkest image is the start of the bracket series.

While this sounds like a "why doesn't my camera just come like this by default" kind of moment, there are times when setting it back/leaving it set to the default MTR>Under>Over makes sense. Imagine you're taking a shot of a person smiling for an HDR and you decide to shoot a 9-stop bracket. The person smiles and you press the shutter at the very exact moment you need the image. That first frame is the one that really captures the gesture you are looking for. If you're set to Under>MTR>Over, you've just captured the most important gesture 4-stops underexposed. In those instances, where you have to absolutely guarantee that the first shot is the "money shot," I'd temporarily switch back to the default mode.

KEEP STEADY WITH A TRIPOD

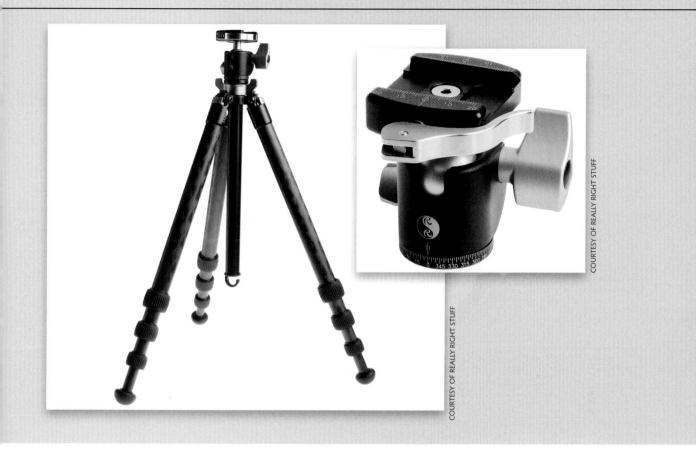

COURTESY OF REALLY RIGHT STUFF

COURTESY OF REALLY RIGHT STUFF

Because you are exposing a series of images that will be merged together, it's extremely important that your camera stay as still as possible. Not only will you reduce blur during those longer exposures (where hand-holding just isn't possible), it will also eliminate any micro movements you make from shot to shot.

I use a Really Right Stuff TQC-14 tripod with a BH-30 ballhead. I made the decision to get this tripod because I wanted one small enough to fit in a carry-on bag, rugged enough to take me through rivers, streams, snowfalls, and rooftops, but light enough to not be a nuisance. The thing is built like a tank and has served me well, but it is definitely a tripod that you need to save up for (for more info, check out: http://kel.by/1l6u9qd).

Other tripods that I've seen a lot of people using recently are the MeFOTO tripods—portable, lightweight, and budget friendly, these could be a good way to start in the world of using a tripod. I always tell my friends that any tripod you use will be better than having no tripod at all. So, whichever tripod you decide to get, make sure that it is one that you will carry with you at all times. If you decide to save a few dollars and get a heavier one, this will guarantee that the tripod will permanently live in your trunk and not on your shoulder. Choose wisely, and carry it everywhere. It's the difference between a good shot and a great shot.

USE A CABLE RELEASE

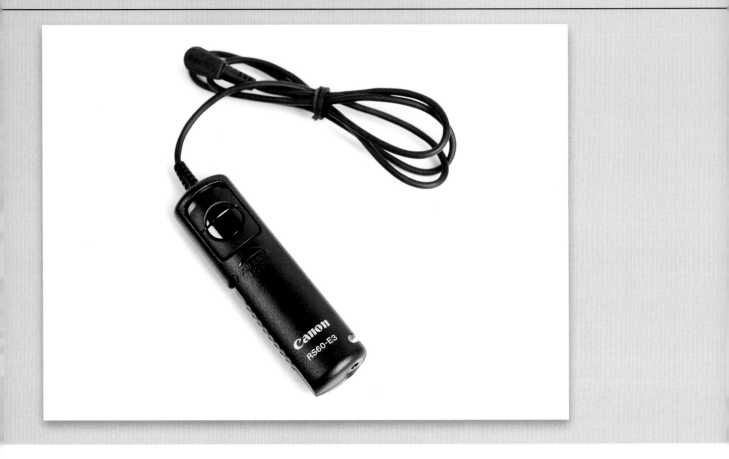

The more you touch your camera, the more you have a chance of introducing camera shake. To combat this, I always recommend using a cable release. This lets you click the shutter button without having to touch the camera. Very, very essential and quite cheap.

One of the other things I like about having a camera release is that most of them have a lock switch, which keeps your shutter button depressed. When I'm working on long-exposure images, I usually press-and-lock the remote release and go do something else while the pictures are being made. You see, I like to shoot UrbEx photography—shooting in places where I really don't want to spend a lot of time hanging around. Scoping the next shot while one is being made cuts down the time that I'm at the location and makes me more efficient. Landscape shots during the golden hour

mean that you're spending a lot of time making more images of a single location. If you spend that time scouting the next shot, you can guarantee a bigger return at a critical time.

I also like to place my tripod in places where someone may say, "Um, excuse me. I don't think that tripod can be there." Locking the remote and walking away from the camera lets me meet an oncoming person away from the camera. Fast talking and a kind smile can give me extra seconds while my camera is making the shots. I'll even lock my remote and pretend to be on the phone. People on the lookout will think that I am not "actively" shooting, when all the while, the camera is doing its business. Sneaky? I know, but I'm trying to make great pictures—by hook or by crook.

EXPOSURE DELAY MODE/MIRROR LOCKUP

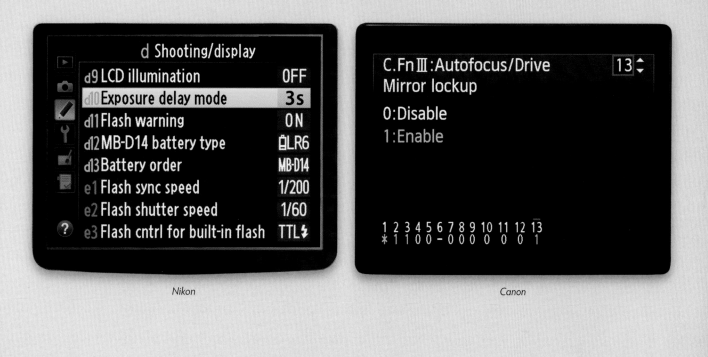

Nikon

Canon

There is a mirror near the sensor in your camera that flips up to expose the image that you are making. When you absolutely need to guarantee a tack sharp image, Exposure Delay Mode (on a Nikon; Mirror Lockup on a Canon) is key. On a Nikon, when it's set to Exposure Delay Mode, after you press the shutter button, the mirror locks up, then the camera waits up to 3 seconds (depending on the delay time you chose) before taking the picture. On a Canon, when you set your camera to Mirror Lockup mode, the press of the shutter button will automatically open the mirror and lock it up in place. A second press will make the exposure. By giving yourself a second between those two clicks, you can minimize the amount of shake that the camera feels when the mirror comes snapping up. On a Nikon, just go to the shooting menu, scroll down to Exposure Delay Mode, and choose your delay interval. On a Canon, go to the Custom Functions menu on the LCD on the back of the camera, then under Mirror Lockup, choose Enable. On both cameras, you'll have to press the shutter button a number of times to get your bracketed shots.

SHOOT IN CONTINUOUS MODE

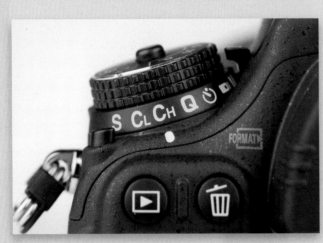

Nikon

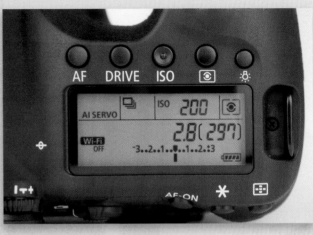

Canon

If you're not as concerned about the images being tack sharp, most DSLR cameras have a continuous shooting mode, allowing you to hold down the shutter button and fire off a series of images. The camera will continue firing off images, so long as its internal buffer does not get full. Now, when you have your camera set to shoot a bracket, you can hold down the shutter button and the camera will only shoot the bracketed series and then stop. This will help you when working with longer exposures, because each time you press-and-release the shutter button, you're introducing the possibility of camera shake. By pressing-and-leaving your finger down, you minimize that shake. On a Nikon, change the Release Mode dial to CH or CL; on a Canon, press the Drive or AF·Drive button on the top of the camera, then rotate the quick control dial until you see the stack of photos icon in the top LCD.

Here's an added benefit of using a cable release: if you press-and-lock a cable release, the camera will shoot the bracketed series and not do anything else until you come back and unlock it. That is a big plus!

Note: Five or nine frames should fill up your camera buffer. So, for me to eliminate that worry, I shoot with the fastest memory cards I can get my hands on. In terms of speed and reliability, I'm a big fan of Lexar cards.

SHOOT IN APERTURE PRIORITY MODE

Nikon

Canon

In order to get great HDR images, you want to collect a series of images that vary based on exposure—from really underexposed to really overexposed. You can achieve that goal in a variety of ways: changing aperture, adjusting the shutter speed, or adjusting your ISO. You want to make sure you shoot these images in aperture priority mode. Aperture priority mode controls how much depth of field you have in an image. A shallow depth of field (f/2.8 for instance) could have an element in focus and the area immediately around it out of focus. An f-stop of f/11 would keep more elements in the area in focus.

When you set your camera to aperture priority mode (the A mode on Nikon cameras, and the Av mode on Canon cameras), you're telling your camera to keep your aperture fixed for the duration. This forces the camera to use shutter speeds to make the exposure changes and prevents any change in the depth of field, which can ruin the image.

TRY SPOT METERING

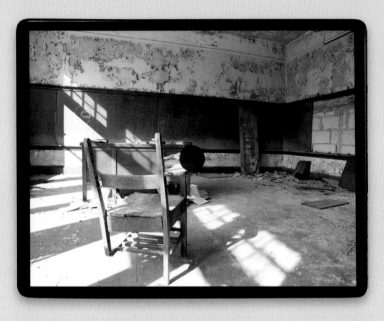

When you look through your camera's viewfinder and focus on something, your camera takes the scene in and processes what it thinks it should be exposed as. Most cameras now use three different settings to do this:

Spot Metering: The camera uses the exact area your "dot" in the viewfinder is on to calculate the exposure.

Center-Weighted Metering: The camera uses the center area of the viewfinder as its start, and takes into account some of the area around the center to calculate the exposure.

Matrix Metering (or Evaluative on a Canon): The camera takes multiple areas of the whole scene into consideration, and calculates an exposure based on all of those factors.

HDR is about getting that one specific thing exposed properly, then adjusting the exposure based on the bracket. By switching to spot metering, it lets you get very specific about the area in question and expose from there. On a Nikon, rotate the Metering button on the top of the camera, then rotate the main command dial until the Spot Metering icon (the single dot with a square) appears in the control panel. On a Canon, press the Metering Mode Selection button on the top of the camera and then, while looking at the LCD panel, use the Main dial to choose Spot Metering (its icon is a single dot within brackets).

SHOOT IN RAW

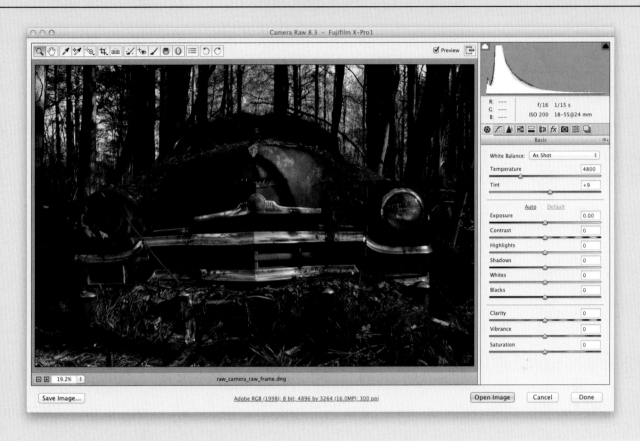

Whether you're making an HDR or shooting any other photographic work, shooting in RAW is one of the best ways for you to be able to have latitude with your images. A RAW file is essentially a negative for an image. The camera captures all of the data of a scene and stores it in this file for you to process later. Once you open up the RAW file in Photoshop, Lightroom, or another program, the file is then converted to its pixel-based counterpart. While they may be bigger than JPGs, they are the original source work for your images. Shoot them, keep them, and treat them well.

EXPERIMENT WITH JPG

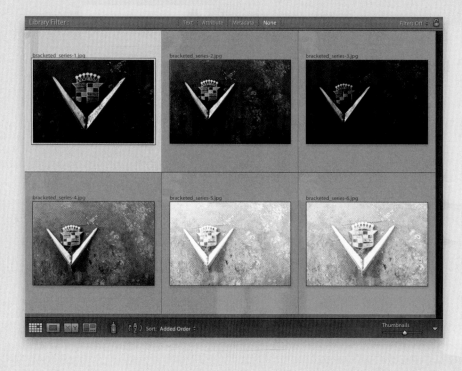

While shooting in RAW is something that I constantly encourage, a conversation with my buddy Matt Kloskowski got me really thinking one day. Matt revealed that he had spoken with someone at one of the more popular HDR software companies, and that person said that an HDR image could actually look "better" from a JPG than a RAW file.

What's the logic behind this? When HDR software attempts to tone map an image, it first converts the file to its pixel-based counterpart. While their JPG conversions may be good, you're not going to be able to beat what your camera, Photoshop, or Lightroom can do.

This is one that I'm really playing with now by either shooting RAW+JPG in my camera, or exporting a series of JPGs before I tone map. You should give it a try, too.

SHOOT MORE THAN YOU NEED

There's a lot of debate going on about just how many images you need when working with an HDR file—three, five, seven, or nine. As a person who writes about technology on a daily basis, I have the most non-technological answer for this: The amount of images that I make for an HDR file is directly proportional to how close I live to the place that I'm shooting.

For example, this picture was taken in Stuttgart, Germany. Generally, I want to start with five images. However, I live across an ocean from there, and the chance that I'll get to go back there again is going to be almost nil. Therefore, I am going to shoot nine frames and shoot the snot out of it. If I live next door to this place? Maybe I'll just try three. If it doesn't work, I'll just come back tomorrow.

I believe that giving the software more stops in the bracketing process really can eliminate problems in the processing of the file because the software has an easier time making the leaps between super-dark images and super-light images. Does this take a little longer? Sure. Can it produce some extra files that I may not need? Maybe.

I'm not trying to Iron Chef a picture here—making it with as little time and resources as possible. I'm trying to make a great picture. If it takes a little longer, and requires a little bit more resources from me as insurance, I'm fine with that.

SHOOT FOR THE BASEMENT

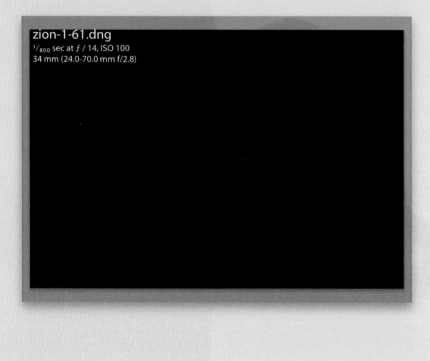

zion-1-61.dng
$1/_{800}$ sec at ƒ / 14, ISO 100
34 mm (24.0-70.0 mm f/2.8)

See the image here? Chances are you can't, but there is an image there. When I shoot in daylight scenarios, more often than not, I tend to shoot so that my lowest exposure has very, very little detail. To do this, I make sure that I shoot between seven and nine frames. If, after shooting the seven (or nine) frames, the lowest of the exposures is too bright, I will adjust the EV spacing to −1 or −2, until I make sure it gets me to the basement. *Note:* For more on this, go to the book's companion website, mentioned in the introduction, where I've provided a video.

SHOOT WITH A LOW ISO

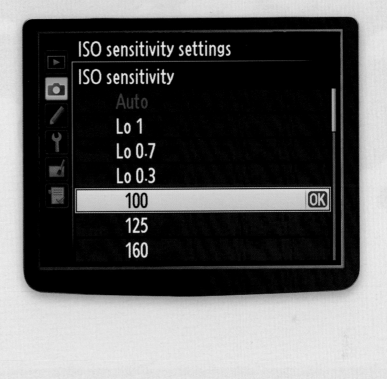

HDR photography produces noise, no doubt about that. Because of this, you want to make sure that you shoot at as low an ISO as possible. For your ISO setting, the lowest number you can get to (100 or 200) is usually the best. This will surely make some of the shots you make in your bracketed series hard to hand-hold, so in this case, you will need to use a tripod.

WAIT

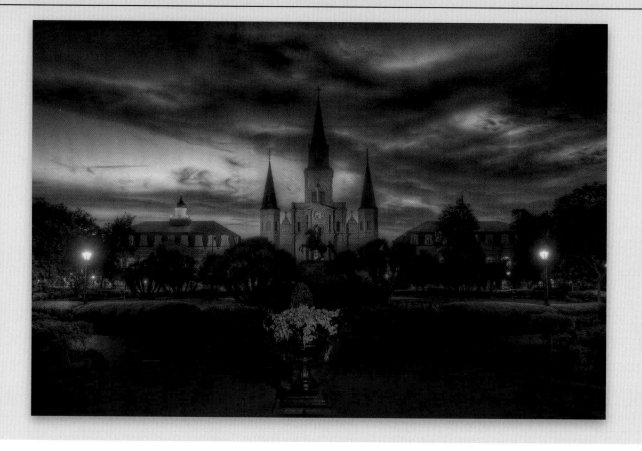

When you're working with HDR images at night, you're going to get really long shutter speeds. This is one of those cases where I think it's always best to wait. If you set up a bracket of five images, and then you shoot image one and two, then you see people coming near the frame, just stop. Let those two exposures finish and let the people/car/cloud/bird, etc., go by.

When the scene is where you need it again, continue. Sure, the ghosts of the people can sometimes be cool, but often they're a little distracting.

WATCH OUT FOR THE 30-SECOND LIMIT

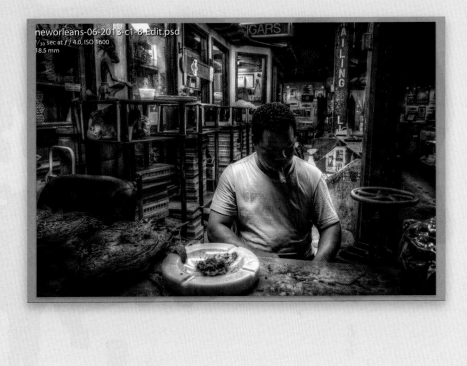

neworleans-06-2013-c1-8-Edit.psd
$1/_{30}$ sec at $f/4.0$, ISO 1600
18.5 mm

This happens to me when I decide to get greedy. I get to an exposure at dusk or at night and I think to myself, "Man, I want to get the best picture that I can with as little noise as possible. I am going to set myself at f/22 and move my ISO down to 100 for super-clear pictures." I look in the viewfinder and notice that my starting exposure is 1/4 of a second.

You see, when your camera starts making longer and longer exposures, it has a limit of what it can expose for—30 seconds. If any of those exposures that are 2- or 3-stops apart need longer than 30 seconds, it will just expose for 30 seconds and stop. Your result? A set of images that, at their higher exposures, look exactly the same because the exposure is the same. 30 seconds.

To combat this, you're going to need to make a couple of changes: you'll either need to increase your ISO so that your exposures are shorter, or reduce your aperture, affecting your depth of field. For me, I tend to choose aperture, as more and more cameras these days are better at handling higher ISO images.

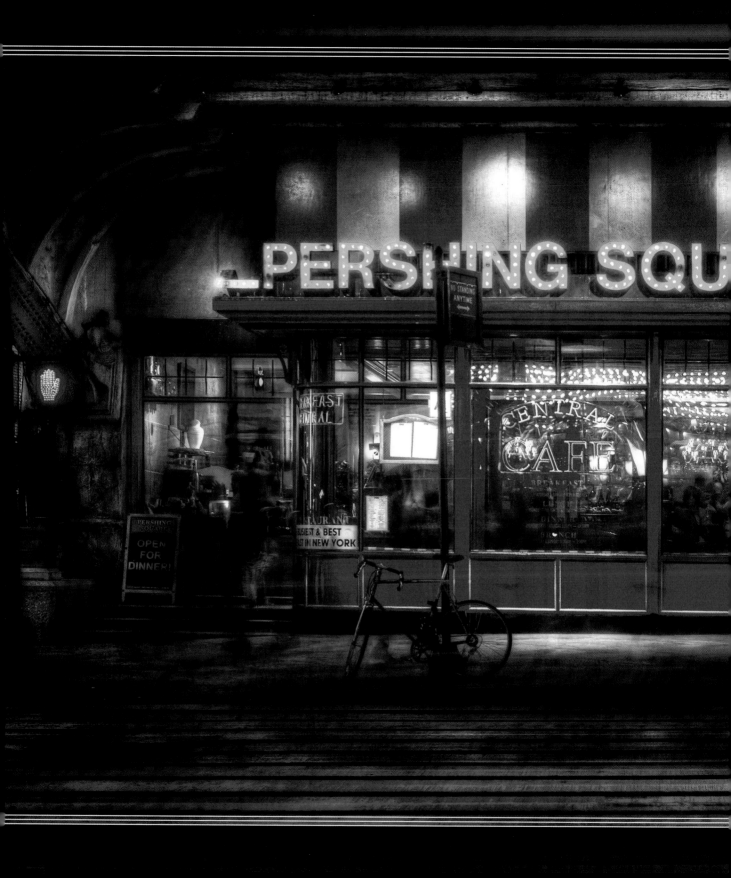

TWO

What to HDR

A couple years ago, I sat with Scott Kelby and Jeff Revell, taping the second episode of the talk show, *The Grid*. One of the topics of conversation that came up was whether HDR, as a technique, was dead. Jeff made a really good analogy for how users think about HDR photography. He called it the "Cinnabon analogy." Basically, when someone first runs into a Cinnabon, they can't get enough of it—the sweet goodness! In no time flat, they're having Cinnabon all the time. Then, all of a sudden, they realize that they're really not into it any more, because they've overdone it.

While I can certainly see where something like that *could* happen, I have my own theory: I think that many people who get into HDR photography tend to go into it guns blazing, shooting everything that sits in their path in a series of bracketed images, hoping that the HDR gods will smile upon them and bestow them a good image. But, there are two problems with this line of thinking: (1) Most of the HDR that you see out there that you really like has been post-processed in Photoshop to some degree (I would argue, to a large degree). (2) There are certain images that just "work" with HDR photography, and others that do not.

If you look at the images out there that have been processed, you'll notice that there is a series of patterns that comes up. Once you know what those patterns are, you can make better choices as to when you think you will go for HDR or not.

While this may not be a complete list of what to HDR, this is certainly a start for you to think about. Combine a couple of these, and you're sure to have an HDR hit.

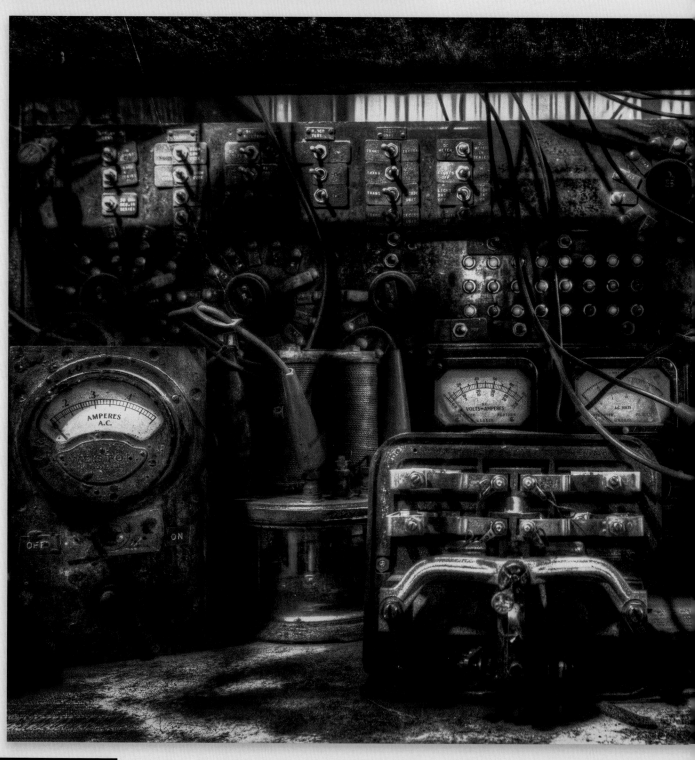

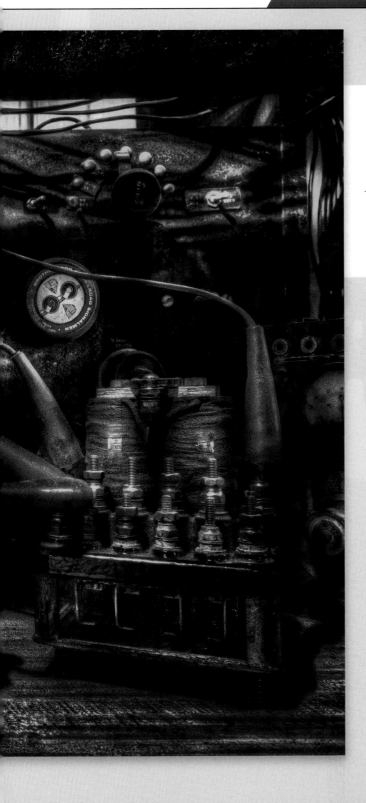

Old Stuff Rocks

Part decay, part nostalgia, it seems like anything from yesteryear is automatically a great candidate for HDR photography. The textures that you can find in older things, combined with their novelty, make it surreal enough to really do well with this treatment.

Overhang? Shoot It!

Whenever I see something near an overhang, I will automatically HDR the shot. More often than not, the exposure that is outside of the overhang is very different from the exposure inside of it. Because of that, we're predisposed to expect one part of the image to be darker.

When HDR is done properly, and we can see both parts, it stands out for us.

It's All About Texture

I've always argued that HDR is more about texture and tone than it is about color. Textures in photography tend to make the image a little more tangible to us. When HDR amplifies these textures, it makes people want to reach out and touch the image. That kind of connection is very important.

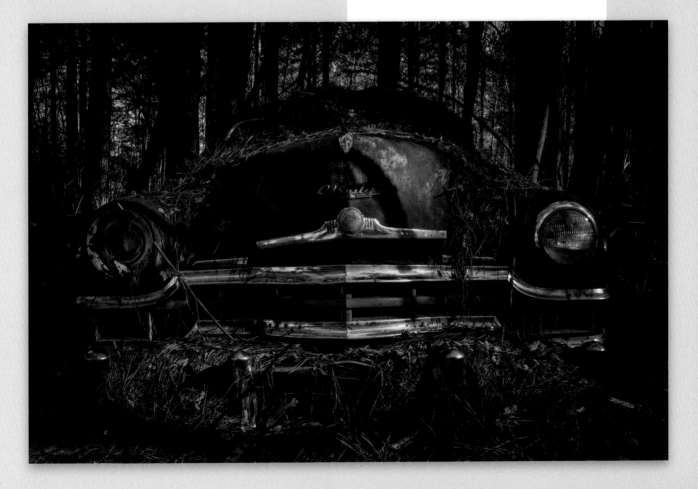

Two Rooms with a View

If you're in a room when you are taking an exposure, and you have the ability to see clear into the next room, there's a good chance that you may want to consider doing HDR. In this example, the room in front of me is at one exposure, but we can easily see that exposing for that one would mean that the room I'm in would be dark. By doing an HDR of this area, the image is closer to what we would normally see.

It's quite interesting. We're pretty in tune with what we expect our photographs to deliver to us. Normally, if we saw this picture without HDR, we wouldn't think twice about it. But, because we can see both areas, our brains say, "Hey, how did he get the other room…?" Blammo. You have people's attention.

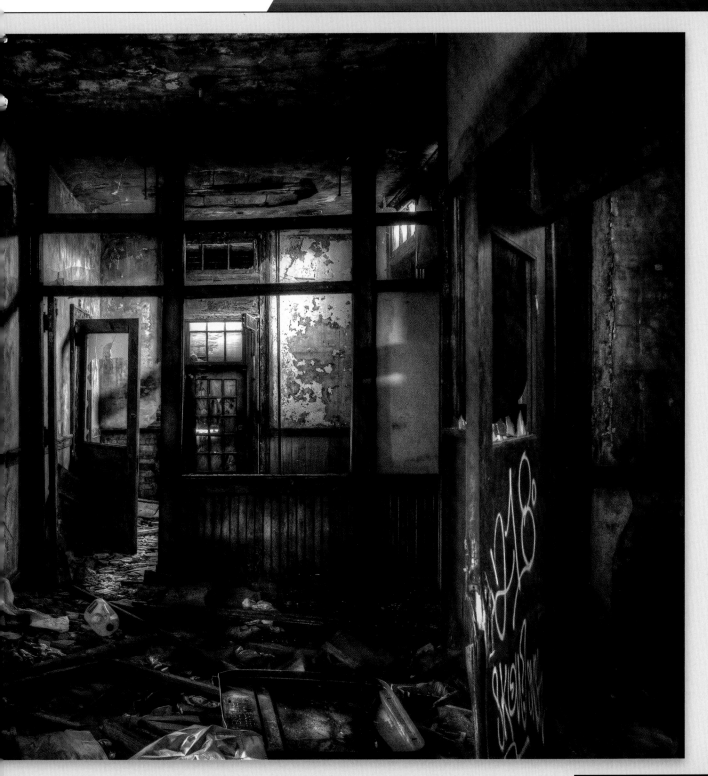

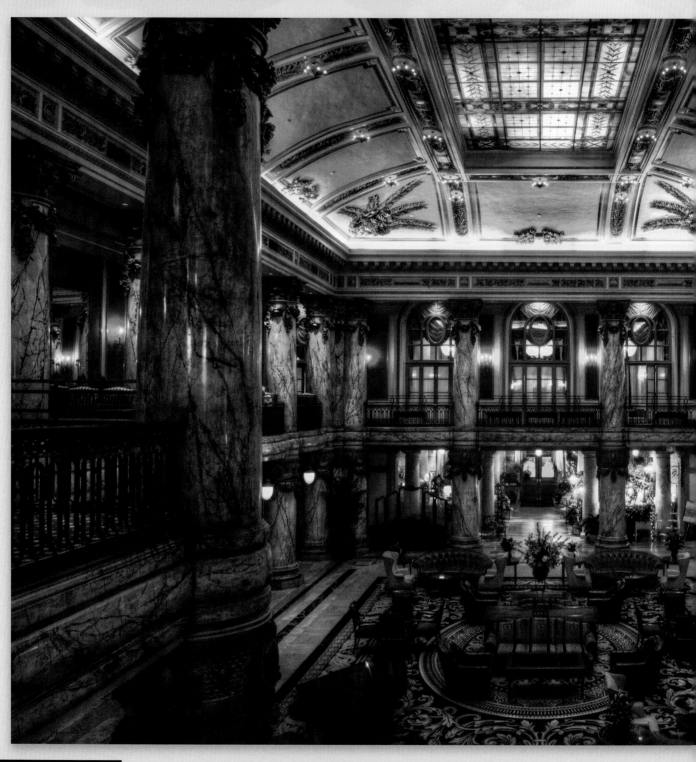

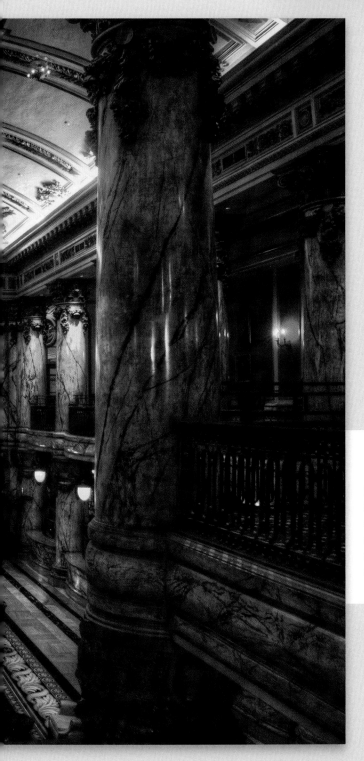

Dimly Lit Interiors

I almost wrote this tip as Church Interiors, but truth be told, anything that is indoors that is dimly lit does very well with HDR. The overexposed areas bring out the details in the room, while the underexposed portions of the image give almost an ethereal nuance to it.

Machinery HDRs Well

Metal is just made for HDR. The more knobs and controls that you are faced with, the easier the choice to make the image into an HDR. The amount of texture you can get with the metal just makes it sing!

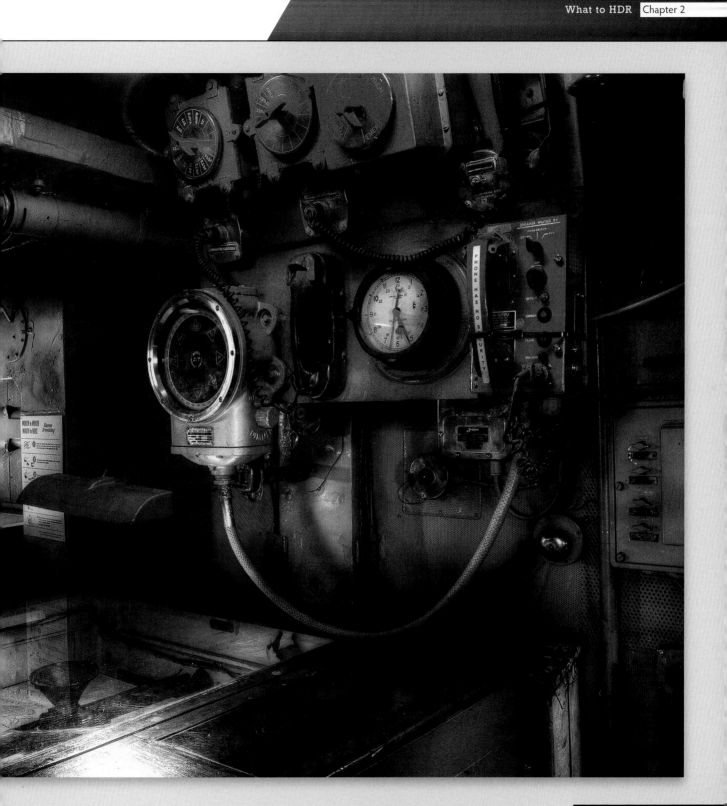

Sci-Fi Was
Meant for HDR

There's not that much to say here. If you're anywhere near a Star Wars, Star Trek, or other type of sci-fi convention, you should be thinking about HDR. The metal and interesting characters will make for a great series.

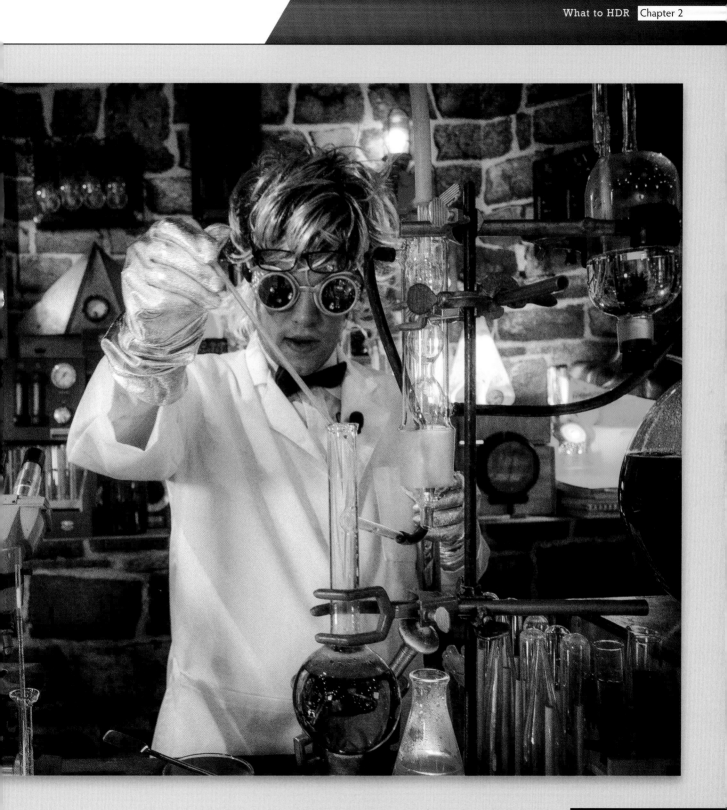

UrbEx HDR Is *du Jour*

Urban Exploration, also known as UrbEx, is a trend that's popping up more and more in HDR photography. People going into abandoned, decrepit buildings to explore what is in them has been happening for several years now. With the advent of HDR, photographers that have been into UrbEx have taken to recording their explorations in HDR. Interesting colors, textures, and abandonment—sounds like great HDR territory.

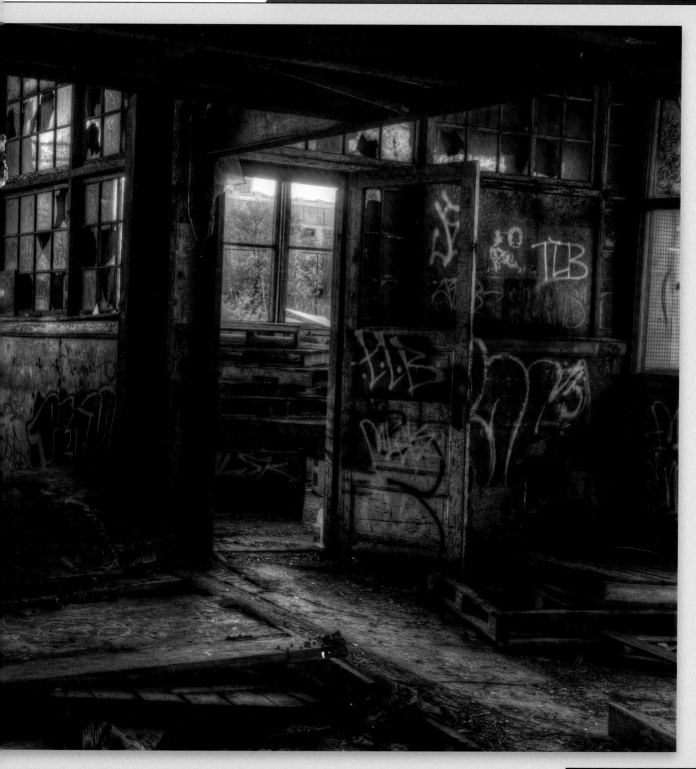

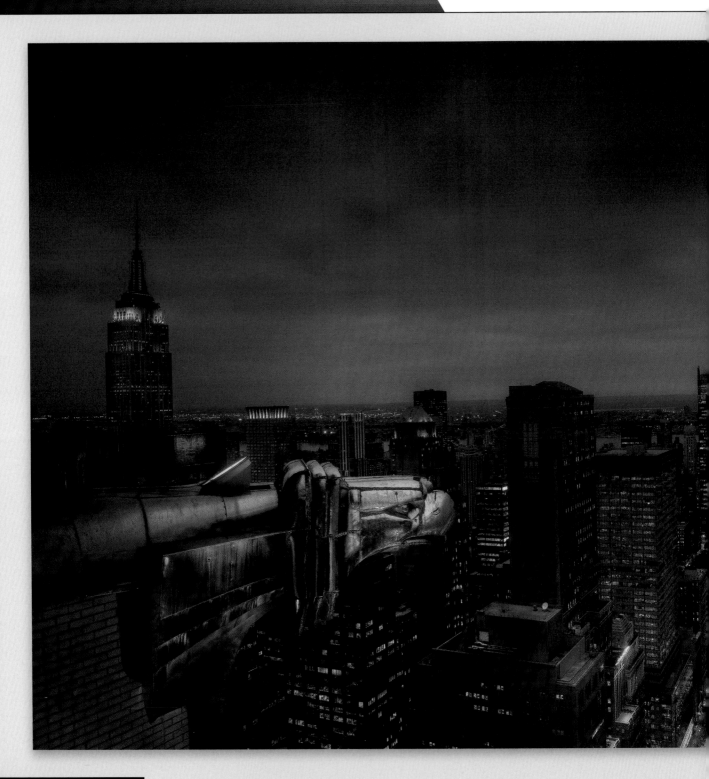

Twilight (Not the Movie)

While this is true in photography in general, it is definitely something to keep in mind when shooting HDR. There's something to be said about the last few minutes of light when you're shooting HDR that really brings out some amazing colors and tones. I think this has to do with how saturated in color these moments are, and how that saturation complements the texture that you see in the image.

HDR Portraits

If you have a gritty scenario, I would suggest that you try to do an HDR portrait. Originally banished to the world of "There's no way you can do that," I believe that a portrait done in HDR can provide a really different look for a subject.

This will require a good bit of Photoshop skill, however. Thankfully, that's what the rest of this book will be about.

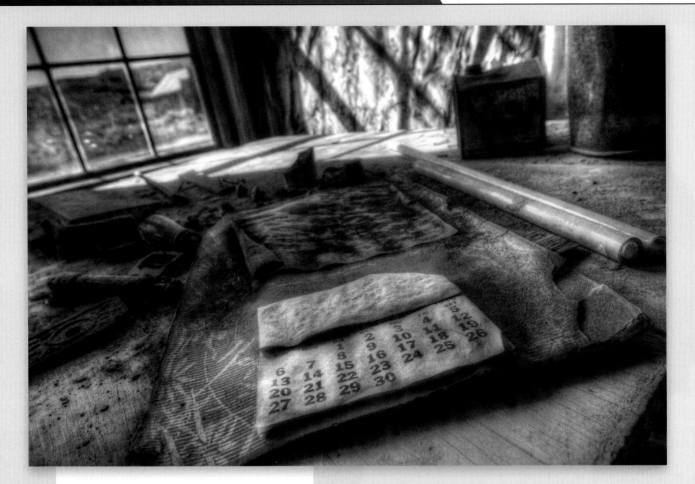

See Outside a Window? HDR It

Whenever I am looking for places to shoot, I'm always particularly interested in windows. If there is a window in a shot, more often than not, people are not prepared to see out of them in daylight shots. The exposure that is indoors is usually different from what you see outdoors. When you process such an image so that both of these areas are properly exposed, the picture looks magical.

Careful with Putting Too Many Together

I'm a big advocate of putting several of these tips together to make an even better picture. Take a look at this picture as an example. There is texture in the walls and water. There are archways and windows with people in them. There's great color. All of these make for a great HDR image, but combining too many of them can be a little overpowering. There is *one* thing that can make this thing better, though...we'll talk about it on the next page.

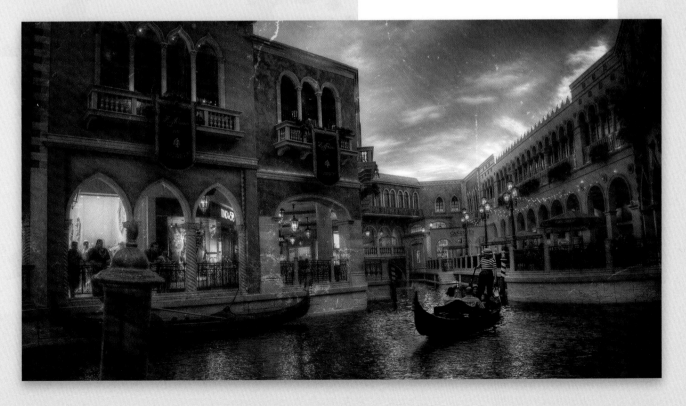

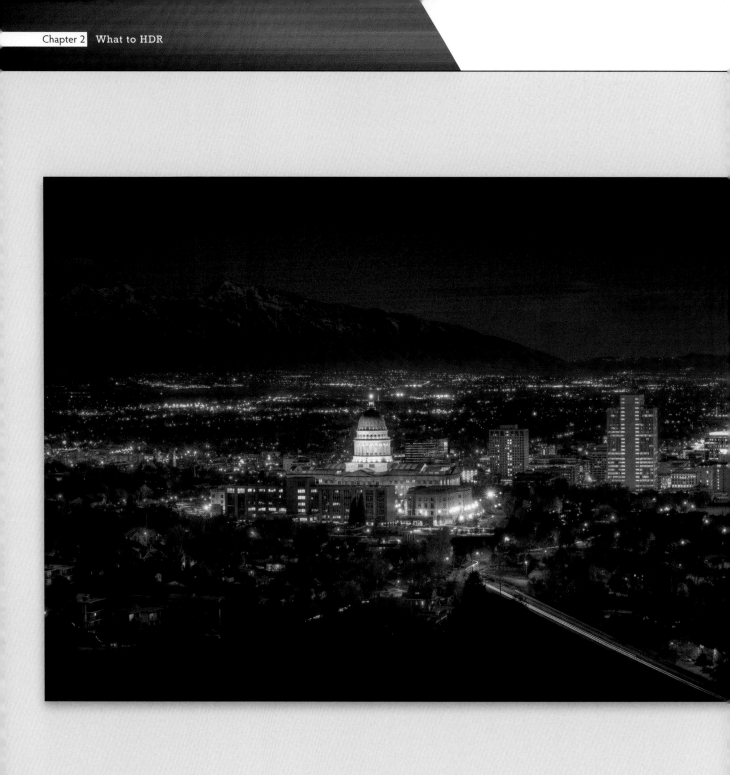

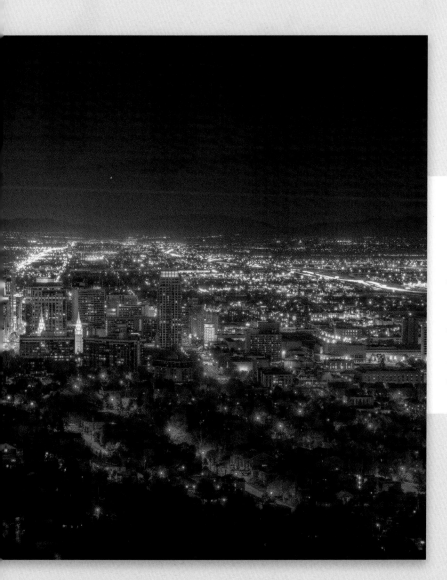

Go Big or Go Home

One thing that I've noticed is that when you combine multiple elements into an HDR image, you don't really get to see the full value of it unless it's printed big. I mean really big. This shot is a 30-image composition of Salt Lake City that can print at around 6' wide. When you have an image this big, you can really stand in front of it and explore regions of it, getting lost in all of the tone and texture.

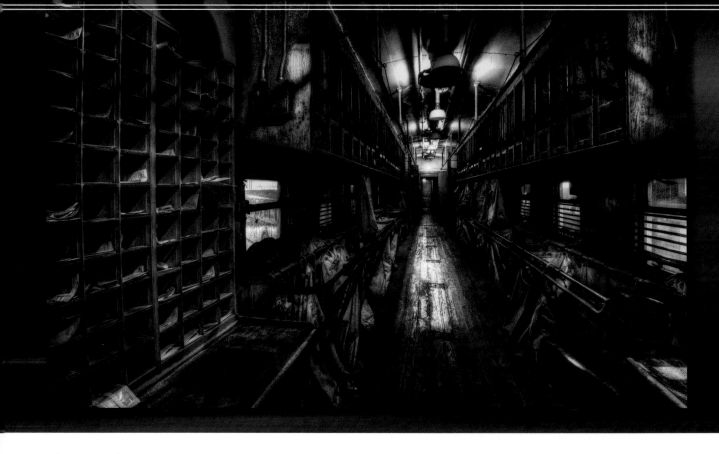

The "Sound" in HDR Software?

One of the most common questions I'm asked is, "Which is the best software to use for making HDR images?" Many people are surprised when I say, "All of them," as if I were trying to be cagey about sharing what my true favorite is. The fact of the matter is that it's a lot like listening to someone playing the guitar.

Take B.B. King, for example. B.B. is considered "The King of the Blues." Listen to "Every Day I Have the Blues" or "The Thrill Is Gone" and you'll hear a very distinct sound, and that sound is made by his guitar, Lucille—a custom-built Gibson ES-355. Now, listen to Metallica covering "Whiskey in the Jar" from their *Garage Inc.* album. James Hetfield (the lead singer) is also playing a guitar, but that sound is very different. His guitar is usually an ESP Explorer. While these two instruments are both guitars, they can sound completely different. The same can be said about HDR software. They essentially do the same thing, but are designed differently.

When software grabs a series of images and makes a tone-mapped file, it uses a specific algorithm to make this happen. Photomatix has its own algorithm; Photoshop does, as well. Obviously,

these algorithms are their "secret sauce" to creating a file, and they have their own interpretations of how to make it, making the results you see different from software to software. Photomatix files have a specific look—much in the same way Metallica has a very specific sound—and if you like that look, then that's the software you're going to use.

Photomatix Is My Main Sound

When I wrote the first edition of this book, I really thought that Nik Software had something great up their sleeve with HDR Efex Pro 1. The ability to have more than one algorithm available to you to tone map a file felt like you had multiple programs at your disposal—more "sounds," if you will. More was certainly better in this respect.

When HDR Efex Pro 2 was released, I felt like a lot of those options were removed, and the whole experience felt counterintuitive and limited. At the same time, better versions of Photomatix came out, and I found myself liking the straightforwardness of what they

THREE

Creating a Tone–Mapped File

HDR Is Tone Mapping

While many people see the HDR effect and say, "Oh, that's a really cool HDR," that's not entirely correct. "HDR" is actually the term for the overall technology behind what you see. What you generate out of HDR-processing software is technically known as a "tone-mapped file," but it just doesn't sound as sexy.

HDR is all about making sure you make an image where you see all the details in the shadows, as well as the highlights, capturing an entire range of tonality. The problem here is that the file that comes out has so much range, your monitor has no way to show you all that detail. All of the meat is there, but on your monitor, all you see is a big, hot mess.

That's where the process of tone mapping begins. You start by using software to take areas of tones in your image that you can't see and map them to areas that you can see. The parts of the image that become visible, textured, etc., are completely within your control. This is why there are so many different varieties of HDR images and why there are so many arguments about it (I'd start getting used to the following three sayings: [1] The pulling of the sliders is the artwork in HDR. [2] You are the artist. And, [3] everyone argues over what is art and that's okay). The final file has those areas of the image that you couldn't see tone mapped, so you can see them. Voilà!

were doing. Photomatix even included a new way of processing called a Contrast Optimizer, giving you even more options.

I still use both of the programs now and again. I just tend to use Photomatix now as the main one. If you have purchased this book, I'm making the assumption—as crazy as this may sound, though grateful—that you are interested in how I achieve my HDR "sound." To get that, you'll need Photomatix.

Create Tone Map Presets

You'll find that creating tone-mapped files is largely an experimental process. You'll spend more time dragging sliders around thinking to yourself, "Yeah, I think this looks good. No, wait, how about this?" than you will referring to some technical settings for working with files. So, I think it's a great idea for you to save all of that work that you do as a preset. Photomatix gives you the option of saving presets and calling them up whenever you want. This gives you a quick jump-start to a look and can even help you take an image to a level you may not have considered.

Remember to Experiment

Once you have your way of processing an HDR file down, I would still encourage you to get out there and experiment a little. Download a trial of another piece of HDR software. Scan through the presets to see if something jumps out at you. If you are a fan of a very natural look in your images, experiment with a little surreality. You never really know what it's going to look like until you try. Sometimes the best techniques are born out of this experimentation.

In this chapter, we'll go over how to use Photomatix to process the HDR from Photoshop and Lightroom, as well as talk about some of the new features that have been released with Photomatix 5. This should give you a good strategy for working with the bracketed set of images from your camera.

USING PHOTOMATIX PRO FROM LIGHTROOM, BRIDGE & AS A STANDALONE

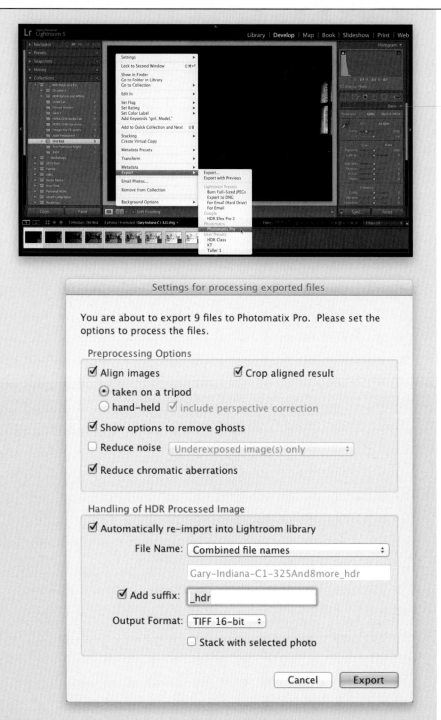

Entering the world of HDR tone mapping, the first program outside of Photoshop that you'll probably run into will be Photomatix by HDRsoft. So, it's a good idea for us to go through the tone mapping process using this software, as this is what I'll use throughout the book. The results that Photomatix can bring out are quite outstanding. I'll start by showing you how to process an image from Lightroom and then I'll show you how to access Photomatix from Adobe Bridge, as well as how to use it as a standalone application.

STEP ONE:
Here, I've selected a series of images inside of a collection in Lightroom by Command-clicking (PC: Ctrl-clicking) on them in the Filmstrip. This gives you a good idea as to what the individual images look like in the bracketed series. Right-click on the image in the Preview area or any of the images in the Filmstrip (or the grid in Grid view), go under the Export menu, and choose **Photomatix Pro**.

STEP TWO:
Once you choose Photomatix Pro, you'll get the Settings for Processing Exported Files dialog, where you'll be able to choose to have your images aligned (in case your camera moved), and whether they were taken on a tripod or hand-held. Then, I usually turn on the Show Options to Remove Ghosts checkbox (these are things that may have moved when you took the images, like clouds, water, etc.), and the Reduce Chromatic Aberrations checkbox.

STEP THREE:

The Handling of HDR Processed Image section at the bottom of the dialog is the most important. I usually turn on the Automatically Re-Import into Lightroom Library checkbox, and then add "_hdr" to the end of the file-name to make it easier to find the file later. Once you've made your selections, click the Export button.

STEP FOUR: GHOST REDUCTION

If you choose to see the ghost reduction options, once you click the Export button, your images will be exported and will appear in the Deghosting Options dialog. Photomatix has two different ways for you to deal with ghost reduction: One option we have is automatic reduction. In this mode, you are shown thumbnails of the images on the left side of the dialog. You can select which one of these images you want to use as the "base" for ghost reduction. Clicking-and-dragging the Deghosting slider above the Base Photo list will change how strong the ghost reduction is. If you find that the ghost reduction isn't to your liking, you can select another image in the thumbnail list or decrease the strength.

If you would like to base the ghost reduction on a specific area, click the Selective Deghosting radio button. There you can draw a selection around the area you want to remove ghosting from. Right-click on the area that you've selected and choose **Mark Selection as Ghosted Area**, and the image is quickly adjusted. Click OK. (*Note:* You can select and mark as many areas as you want.)

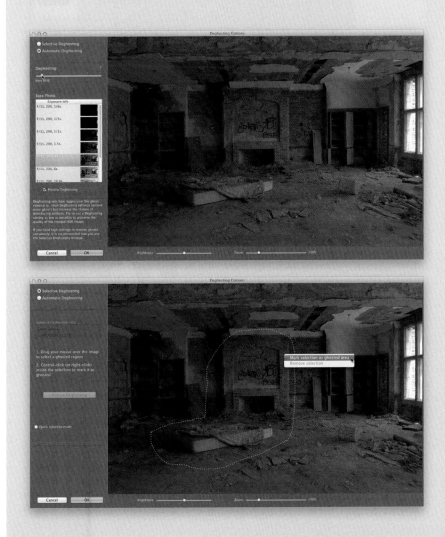

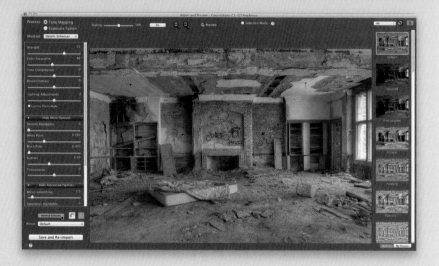

STEP FIVE:

At this point, your tone-mapped file will open in Photomatix. The image preview window will show you either the default tone map or the previously used settings (in this book, we'll always start from the default), and in the Preset Thumbnails panel at the right, you'll see a series of presets that you can use for your image. For the most part, you'll be spending a lot of time in the Adjustments panel on the left, experimenting with the sliders to make your HDR creation. (*Note:* Photomatix 5 for the Mac now has all of these panels in one single window as opposed to a bunch of floating mini panels. A welcome change here, although if you prefer floating panels, simply choose that option at the bottom of the Workflow Shortcuts panel, which opens when Photomatix first opens.) Just to make sure we're starting from the same place, click on the Method Defaults button at the bottom left.

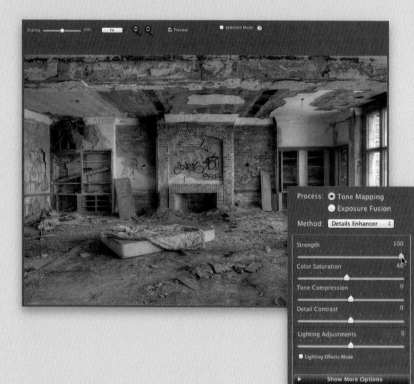

STEP SIX:

Drag the Strength slider to the right (as shown here), and you'll immediately see a change in the image. If you're using floating panels, close any panels you're not currently using to make things easier to see, leaving only the Adjustments panel and Preview panel visible. This will also allow you to make the Preview panel a little bigger. If you are using a Unified window, simply click-and-drag out the bottom-right corner of the window. Then, click on the Fit button at the top of the Preview panel to make sure you are using as much real estate as possible.

STEP SEVEN:

There are several ways for you to tone map images in Photomatix. You can select either Tone Mapping or Exposure Fusion at the top of the Adjustments panel. Both of these have several options in a Method pop-up menu that you can explore. On average, most people creating HDR will explore three of them: the Exposure Fusion choice that matches their image style, Tone Mapping Details Enhancer, or (new to Photomatix 5) Tone Mapping Contrast Optimizer. Let's quickly talk about each of the three:

Exposure Fusion is a method that's used when you want to make something look really natural. The fusion of the images can reduce noise, and the sliders are a lot friendlier. That said, I believe that most of the images tend to look a little too plain. You definitely need a little more control in your HDR file.

Contrast Optimizer, under Tone Mapping, is something that is new to Photomatix 5. As with Exposure Fusion, the sliders are a little more approachable and the results of images tend to have fewer halos than the tried-and-true method. This method does have some localized contrast, which is okay, but after a couple of months of playing with it, I think the results are negligible.

Details Enhancer, also under Tone Mapping, is the tried-and-true method of working with your HDR files. While the sliders are many (click on Show More Options and Show Advanced Options to see them all), you'll find that this mode allows the most control over your image. Besides, I'll give you a quick way to go through the sliders to get you started. You can then vary your approach from there.

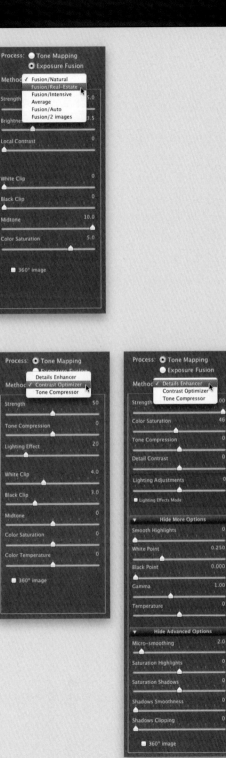

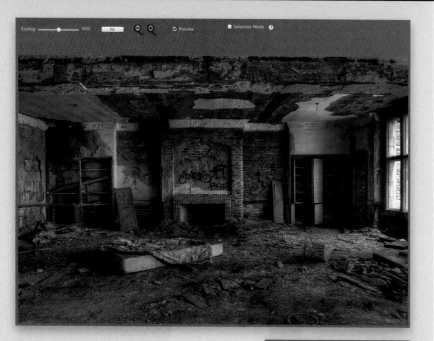

STEP EIGHT:

With Details Enhancer, three sliders generally control the overall HDR effect that you see the most: Strength, Detail Contrast, and Lighting Adjustments. Generally, I keep the Strength setting at 100% and play with Detail Contrast and Lighting Adjustments for different looks.

Detail Contrast takes areas of fine detail and makes them more contrasty. This affects the overall texturing of the image. So, if you want the textures to be really "crunchy," drag this slider to the right (here, I dragged it to 9.4). Lighting Adjustments is the main effect slider. Drag it to the right, and your image starts looking more realistic (here, I dragged it to 0.4). Drag it to the left, and you start applying the typical HDR effect.

By dragging Detail Contrast to the right, and keeping Lighting Adjustments in the middle, you get a little bit of that HDR look, and definitely a texture boost, but it still stays within the realm of the realistic.

TIP: Name Changes from Photomatix 4
There are a series of sliders that have changed names in Photomatix 5. Now is probably a good time to show you what they were and what they are now. It'll make working with the new version easier.

Old Name	New Name
Luminosity	*Tone Compression*
Microcontrast	*Detail Contrast*
Smoothing	*Lighting Adjustments*
Light Mode	*Lighting Effects Mode*
Highlights Smoothness	*Smooth Highlights*

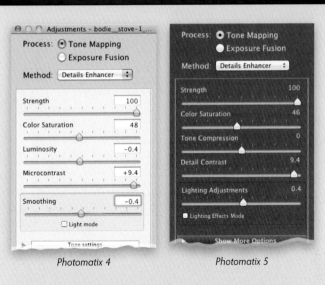

Photomatix 4 *Photomatix 5*

STEP NINE:
The Tone Compression slider adjusts the dynamic range of the tone-mapped image. Moving it to the right opens up shadows and decreases highlights. Moving it to the left brightens highlights and darkens shadows.

Color Saturation is pretty straightforward. It adds color. Here, I increased the Color Saturation a little (to 73) and decreased the Tone Compression (I set it at –0.6). Be careful not too add too much color here. It's better to not have enough and add it in Photoshop later than to try to remove a color mess.

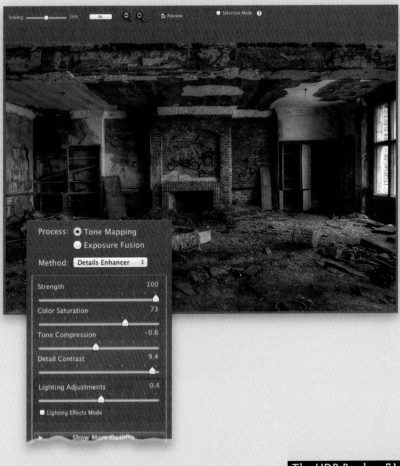

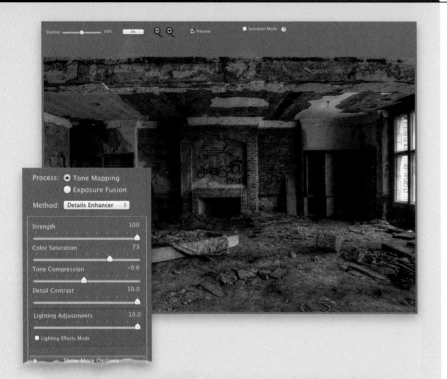

STEP 10:
Here's an example of what it looks like with both Detail Contrast and Lighting Adjustments set all the way to the right. It starts looking a lot like an underexposed image. You lose a lot of the detail that you were able to see in the cabinets on the right side of the image.

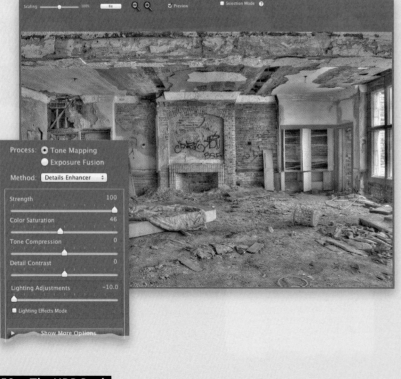

STEP 11:
Setting the image back to the Method Defaults, and then dragging the Strength to 100 and the Lighting Adjustments slider all the way to the left (as seen here) gives you more of a surrealistic look. It's a lot brighter, but you'll also see that the cabinet frames and door frame look like they are radiating too much. This weird glow is known as a halo, and is very undesirable in HDR photography. Halos are single-handedly responsible for giving HDR the bad name that it has, so you want to avoid them. (*Note:* Before moving on to the next step, be sure to increase the Lighting Adjustments setting. I increased it to −0.7.)

STEP 12:

So, after adjusting the Strength, Color Saturation, Detail Contrast, and Lighting Adjustments, here's how the file looks and my settings:

Strength .. 100
Color Saturation............................. 66
Detail Contrast............................... 10
Lighting Adjustments –0.7

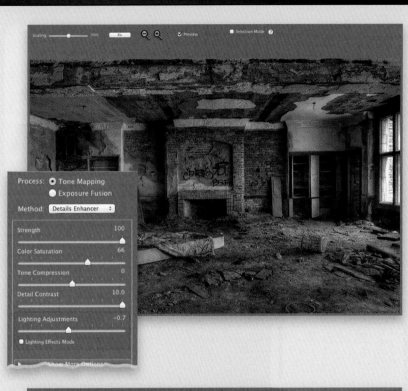

STEP 13:

To balance out the effect with a little realism, you can play around with the Black Point, White Point, and Gamma settings (click on Show More Options). The Black Point slider takes the darkest areas of the image and makes them darker as you drag to the right; the White Point slider takes the brightest areas of the image and makes them brighter as you drag to the right; and the Gamma slider controls the overall brightness in the image. Think of Gamma as the slider that changes the proportions of the dark and bright areas—dragging it to the left makes the overall scene darker (something I always seem to do). By playing with these tone settings, you can get something that's visually pleasing without being overdone (here, I've adjusted all three sliders). Texturally, the image looks good, but tone-mapped files can also suffer a little bit from electric colors.

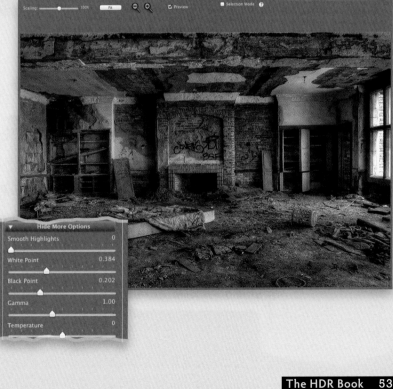

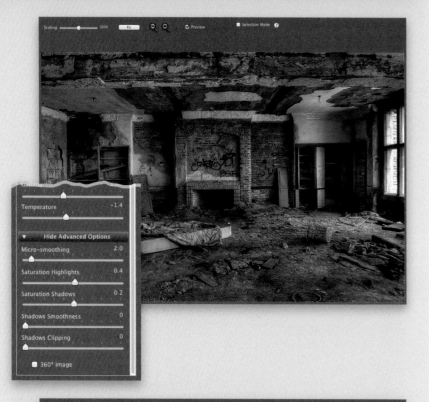

STEP 14:

Usually, I tell people not to worry about the color settings here, since we're all about getting good texture. That said, the Temperature slider (in More Options), and Saturation Highlights and Saturation Shadows sliders (in Advanced Options) can really cancel out a lot of the neon-looking colors in the image, and save you a step in post-processing. You might want to tweak them a little before you move on. Here, I the decreased the Temperature and increased the Saturation Highlights and Shadows settings.

Saturation Highlights controls how saturated the bright (highlights) areas of the images are. Saturation Shadows controls how saturated the colors are in the dark (shadow) areas. Temperature controls the yellow/blue mix in the image, similar to the Temperature slider in Camera Raw. Make small adjustments to these, knowing you can hit them a little harder later.

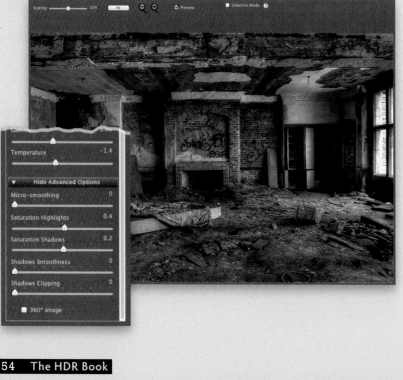

STEP 15:

Also in the Advanced Options is an option that serves as a counterbalance for all of the contrast you create with the sliders in the sections above. If you added a high Detail Contrast amount, you can soften it by adding a little bit of Micro-smoothing. Sometimes it's used for softer, more ethereal HDR images, but I personally tend not to use it much. By default, you get a small amount of Micro-smoothing, so I'll just set that down to 0 here.

Here's what the image will finally look like with all of the Tone Mapping changes added to it in the Adjustments panel.

STEP 16:

What I do like to use, however, are saved presets. A good deal of time can go into experimenting with these sliders to find something creative. While we can't really expect one setting to work wonders on everything, keeping a set of presets handy serves as a good starting point for an effect, and it cuts down the amount of time you'll have to work on a file.

So, at the bottom of the Adjustments panel, click on the Preset pop-up menu and choose **Save Preset**. Give your preset a name and, once you click Save, you'll see your preset in the My Presets tab of the Presets panel.

Note: I'll be saving presets for all of the images we'll be working on and I'll make them available for you to download on the book's companion website. You can find the address in the book's introduction.

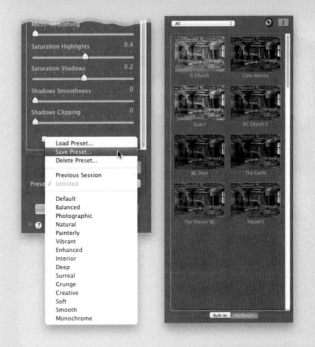

STEP 17:

We're done working on this file now, so to save it back into Lightroom, click on the Save and Re-Import button at the bottom of the Adjustments panel.

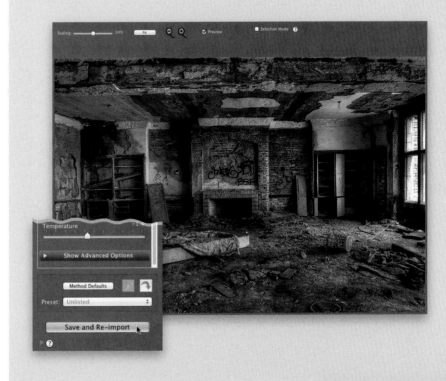

STEP 18:
Now, if you're in a collection in Lightroom and you export a series of files to make a tone-mapped file, when you save and re-import, that file will appear in the middle of your collection (as seen here).

STEP 19:
If you want to use Photomatix as a stand-alone application, most of the steps are pretty similar to what you just learned, but getting it up and running and saving the file is a little different. So, let's take a look at those differences. First launch it, then click the Load Bracketed Photos button at the top left.

STEP 20:

The Select Bracketed Photos dialog will appear, where you'll click the Browse button and select the images you want to process from a folder on your computer. If you want to bypass the 32-bit image (the one that looks like nothing happened to the file—see the following tip), just leave the Show 32-Bit Unprocessed Image checkbox turned off. After you've selected your images, click OK.

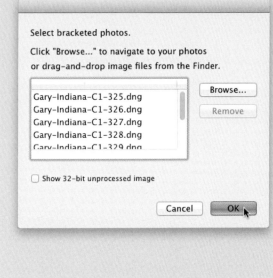

TIP: The Show 32-Bit Unprocessed Image Option

If you turned on the Show 32-Bit Unprocessed Image checkbox in the Select Bracketed Photos dialog, you may get an image that, well…doesn't look all that good. This option used to confuse a lot of people, because after they clicked OK, they thought the resulting file was the exported HDR image. Not the case. This file is actually the super-huge, 32-bit image that contains all of the tonal range, including what you can't see onscreen. This is why the image looks the way it does. So, if you chose this option, you'd have to choose **Tone Map/Fuse** from the Edit menu (or press **Command-T [PC: Ctrl-T]**) to make the adjustments to the image.

ANOTHER TIP: Save It as a 32-Bit Radiance File

You could also choose **Save As** from the File menu and save the file as a 32-bit radiance file (just make sure **Radiance RGBE [.hdr]** is selected from the File Format pop-up menu). This would give you a large file that you could open in Photomatix that could serve as a source file for the HDR. The 32-bit radiance file is to a finished HDR image what a RAW file is to a JPG file.

STEP 21:

Next, you'll get the Merge to HDR Options dialog (similar to the Settings for Processing Exported Files dialog in Step Two). Here, though, because we have selected the option to remove ghosting, the button at the bottom of the dialog reads Align & Show Deghosting (otherwise, it says Align & Merge to HDR). We'll click on that to get to the Deghosting Options dialog (which we looked at in Step Four) where we can either manually or automatically adjust the image should something in the frame have moved.

STEP 22:

Again, in Automatic Deghosting mode, you are shown thumbnails of the images on the left side. You can select which one of these images you want to use as the "base" for ghost reduction. Clicking-and-dragging the slider above the Base Photo list will change how strong the ghost reduction is. If you find that the ghost reduction isn't to your liking, you can select another one of the images in the thumbnail list or decrease the strength.

If you would like to base the ghost reduction on a specific area, click the Selective Deghosting radio button. There you can draw a selection around the area you want to remove ghosting from. Right-click on the area that you've selected and choose **Mark Selection as Ghosted Area**, and the image is quickly adjusted. Click OK.

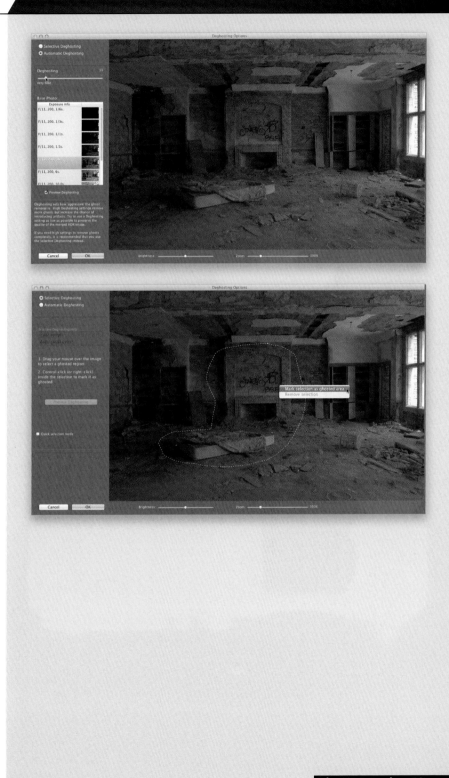

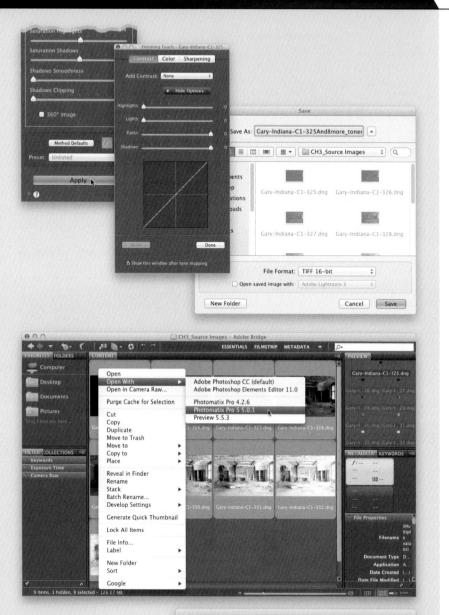

STEP 23:

Once you have processed the file in Photomatix (like you learned earlier), you're going to need to save those changes to the file, so at the bottom of the Adjustments panel, click on the Apply button. Then, in the Finishing Touch panel, choose any Contrast, Color, or Sharpening you want added to the image, and click Done. From the File menu, choose **Save As**. Give your file a name and specify its location. This is also where you'll want to add "HDR" to the end of the filename, which will make it a lot easier for you to locate your HDR file later.

STEP 24:

To process files in Photomatix from Adobe Bridge, the process is just as easy. Simply select your images, Right-click on one of them, choose Open With, then choose **Photomatix Pro**. You'll get the dialog shown at the bottom here, where you'll want to choose Merge for HDR Tone Mapping and Fusion, and click OK. Then, you'll get the same dialogs shown in Steps 20 and 21. The process is the same from there.

HEADS UP: DUPLICATE OR MISSING EXPOSURE INFORMATION

There might be times when you see the Setting of Exposure Values dialog in Photomatix. This asks you to specify how much of an exposure gap there is between the images you are processing. You will only see this in two instances:

(1) You are trying to create an HDR with files that do not have any camera data (EXIF) in them. You're likely to run into this problem when you export JPG files out of Lightroom and do not include the camera data as part of the export. You will not see this problem with a RAW file.

(2) The more likely scenario for this is that you have several shots in the bracketed series that are duplicates of one another. This tends to happen to people when they are shooting at a high f-stop/low ISO. When this occurs, you'll likely run into the 30-second exposure limit for a bracket, and the last image(s) in your series are 30-second duplicates of one another. In a case like this, I would just look through the bracketed series and omit any images that have a similar shutter speed (more on this on page 19).

Setting of Exposure Values

Photomatix could not find exposure information in the metadata of your images.

Please check in the right column the Exposure Values (EV) that Photomatix estimated. If they are incorrect, either:

Set an EV Spacing: 1

Or edit each EV directly

	EV
Gary-Indiana-C1-333.jpg	+4.33
Gary-Indiana-C1-332.jpg	+3.67
Gary-Indiana-C1-331.jpg	+2.50
Gary-Indiana-C1-330.jpg	+1.00
Gary-Indiana-C1-329.jpg	+0.33

Cancel OK

Setting of Exposure Values

Three of your images have the same exposure information according to their EXIF metadata.

If the exposures do differ, please adjust the Exposure Values (E.V.) listed in the right column. To do this, either:

Set an EV Spacing: 1 1/3

Or edit each EV directly

	Read from EXIF	EV
Gary-Indiana-C1-378.tif	30 sec – f/20 – 200	+1.67
Gary-Indiana-C1-377.tif	30 sec – f/20 – 200	+1.67
Gary-Indiana-C1-376.tif	30 sec – f/20 – 200	+1.50
Gary-Indiana-C1-375.tif	20 sec – f/20 – 200	+1.00
Gary-Indiana-C1-374.tif	10 sec – f/20 – 200	+0.33
Gary-Indiana-C1-373.tif	6 sec – f/20 – 200	-1.00

Cancel OK

THINGS YOU'LL DO A LOT IN PHOTOSHOP

When you're working on the post-processing side of the following projects in Photoshop, you'll notice that there are a number of steps that just keep coming up. Rather than have you re-read the same steps over and over, I figured we could talk about them now, let you know what they are, and focus on just playing with the image.

DEFAULT COLORS/SWAP COLORS

When you're working with layer masks in Photoshop, it's all about painting in black to hide an area and painting in white to show an area. Because you're not always sure what color you have as your Foreground or Background color, I always do this:

Press the letter **D**—Normally, this switches your Foreground and Background colors to the default of black and white, but when you add a layer mask (or an adjustment layer, which automatically comes with a layer mask), Photoshop switches the Foreground color to white and the Background color to black. If it doesn't, pressing D will get you the same white/black colors.

Press the letter **X**—This swaps the Foreground and Background colors.

Now, when you're retouching, you don't have to move your mouse and select a color. Two keys, and you're all done.

CREATING LAYER MASKS THAT SHOW AND HIDE BY DEFAULT

A lot of post-processing in Photoshop includes creating a layer mask to hide or show something. Clicking on the Add Layer Mask icon (the third from the left) at the bottom of the Layers panel automatically adds a white mask to a regular layer, revealing the content of that layer. (*Note:* Adjustment layers automatically come with a white mask. We'll talk about them on the next page.) To hide a part of that layer, and reveal the layer below, you'll paint in black with the Brush tool.

If you want to create a layer mask that hides the entire layer, press-and-hold the Option (PC: Alt) key and click on the Add Layer Mask icon. This creates a black mask. To reveal parts of the layer, you'll paint in white.

USING ADJUSTMENT LAYERS

Oftentimes, when you're working with an HDR image there will be corrections needed that relate to color and tone. In early versions of Photoshop, users had to create a duplicate layer and make the adjustments on this layer. Doing this repeatedly can really increase the overall file size of the image. Adjustment layers allow you to do the same thing without as large a file size, because an adjustment layer does not contain any of the image—it only contains the adjustment (hue/saturation, curves, etc.) and a layer mask to hide the effect from a portion of the image.

If you click on the Create New Adjustment Layer icon at the bottom of the Layers panel (it looks like a half-white/half-black circle), you'll see a menu of adjustments to pick from. Once you select the adjustment you need, it will be created as a separate layer with a white layer mask, which reveals all of the effect, and the adjustment options will appear in the Properties panel. If you add an adjustment layer and want to hide the adjustment, simply press **Command-I (PC: Ctrl-I)** to Invert the layer mask and make it black.

ADJUST YOUR BRUSH ON THE FLY

It's really easy to adjust your brush in Photoshop. Press Control-Option (PC: Alt-Right-click) and drag right or left: drag to the left, and your brush will be smaller; drag to the right, and the brush gets larger. If you drag up and down, it changes the hardness of the brush: drag upward to make the brush softer; drag downward to make the brush harder. You'll never go back to changing your brush settings in the Brush Picker again! (*Mac users:* This is the actual Control key, to the left of the Option key.)

MERGE UP!

Whenever I can, I think working nondestructively is the way to go. However, there are times you'll need an actual image layer with all of the changes in it. Instead of flattening all your layers and losing the ability to make changes to them, you can select the uppermost layer and press **Command-Option-Shift-E (PC: Ctrl-Alt-Shift-E)**. This will make a new layer from all of the layers directly underneath it, while keeping those layers intact. The great part about this is that if you don't like the changes you've made after this point, you can always get rid of this merged layer and you still have all the layers with changes you made up to that point.

NEW SMART OBJECT VIA COPY

Let's say you have an image as a Smart Object layer in your document, and you want to make a change, like a really high Luminance Noise Reduction, to only part of the image. If you simply make a copy of the Smart Object layer, any change you make to the copy will also appear in the original Smart Object layer. Instead, Right-click on the Smart Object layer and select **New Smart Object Via Copy**. This will make a copy of the Smart Object layer, but break the link between the two, so you can change the settings on one without affecting the other. Then, you can add a layer mask and hide the part of the adjustment you don't want.

OPEN A FILE IN CAMERA RAW

There will be times when you'll want to open your tone-mapped image in Camera Raw. Perhaps you just get along with the develop settings there better than adjustment layers in Photoshop, or maybe you're trying to access features that are only available in Camera Raw. Either way, to take that image into Camera Raw, click on File>**Open (PC: Open As)** in Photoshop. Select the image and, from the Format (PC: Open As) pop-up menu, select **Camera Raw**. Now when you click Open, it will open the image in Camera Raw.

If you use Adobe Bridge, it's simpler: just navigate to the file, Right-click on it, and select **Open In Camera Raw** from the pop-up menu. To save yourself a step, use Mini Bridge right from inside of Photoshop to open the file: just Right-click on it, and select Open With>**Camera Raw**.

USE PHOTOSHOP CC? CHECK OUT CAMERA RAW AS A FILTER

One of the best new features in Photoshop CC is that you can select individual layers and run Camera Raw as a filter. Just click on the layer in the Layers panel to select it, and then choose Filter> **Camera Raw Filter** and you're good to go! This has been a boon to production, as I tend to use Camera Raw a lot for noise reduction, sharpening, and temperature control. While it doesn't seem big on the surface, the amount of time this little filter can save you is immeasurable!

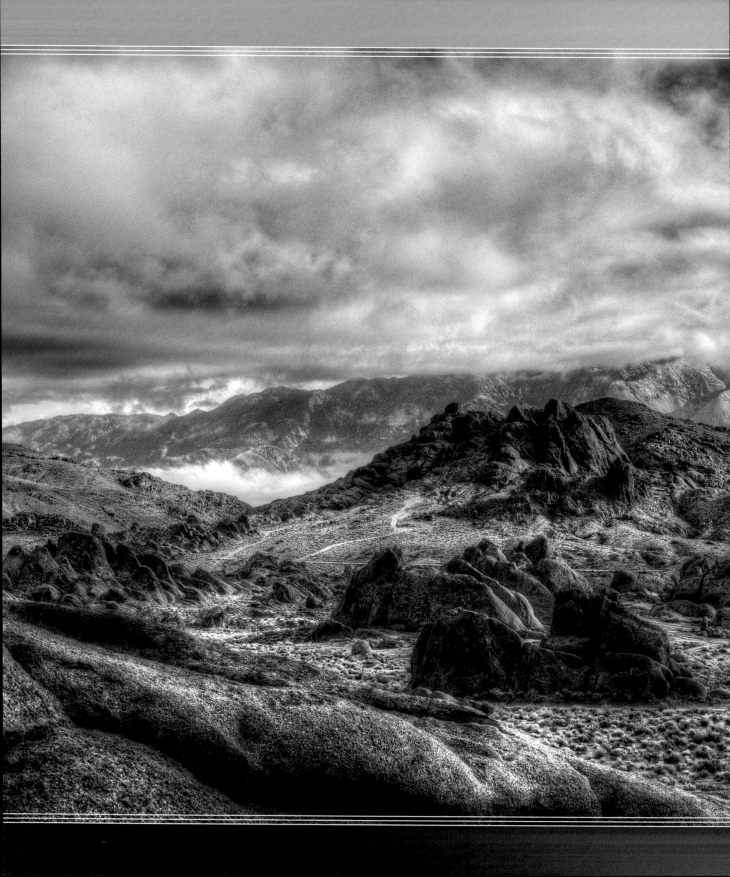

FOUR

Project: Alabama Hills

A couple of years ago, I spoke at a couple of workshops based in the eastern Sierra Nevadas (California) for famed wildlife photographer Moose Peterson. Driving up and down the Sierras would come to be one of my most treasured memories. That said, when you are making landscape images there is no bigger wrench that can be thrown into your plans than the weather.

We initially set out to visit the Alabama Hills—a great rocky area just south of Mammoth, CA. As we were driving to the area, I noticed that the clouds started increasing. More and more clouds appeared the further we drove into the Alabama Hills. By the time we got to the location, clouds covered 85 percent of the area. To everyone there, the shoot was a bust.

Now, it's completely okay for you to spend a lot of time getting to a location for a shoot, be skunked out of the shoot due to weather, and just head back home. Most photographers, however, will stick around for a little while and see if there are any breaks in the weather that offer pockets from which to shoot. The overcast gray skies didn't really provide for much, but man did we try.

I've always hedged my bets when I am out shooting at a location by bracketing shots. This is something that I did prior to HDR—you just never know when you need something a little more underexposed (or overexposed). So, I shot brackets of the area and headed back to the camp.

Much later, I would come back to those brackets and think, "You know, by themselves the pictures don't really do much, but what if I used all of them in HDR?" The results really surprised me.

TONE MAPPING THE IMAGE

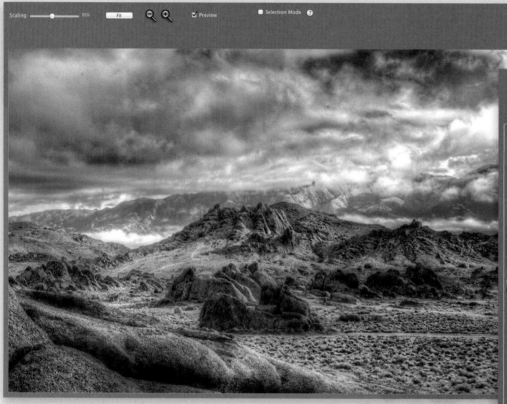

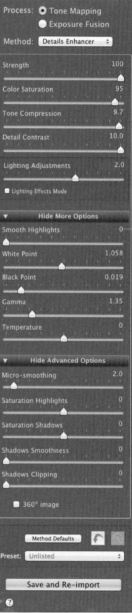

The default setting needed a little bit of work, so I moved my Strength and Detail Contrast settings to their maximum values. Once they were set, I added some Color Saturation to taste—my taste usually borders a little bit on the oversaturated side here, but I'll tone it down a little later. With that set, I dragged the Lighting Adjustments slider to the right and then increased the Tone Compression, and you can see the clouds and mountains start popping in.

The clouds are a little dark here and I don't have enough contrast in the mountains. So, to counteract that, I'll drag the Gamma slider to the left (giving me contrast), and increase the White Point (helping the clouds). While it's not exactly what I would want in the clouds, I know I can fix them a little bit better in Photoshop.

POST-PROCESSING IN PHOTOSHOP

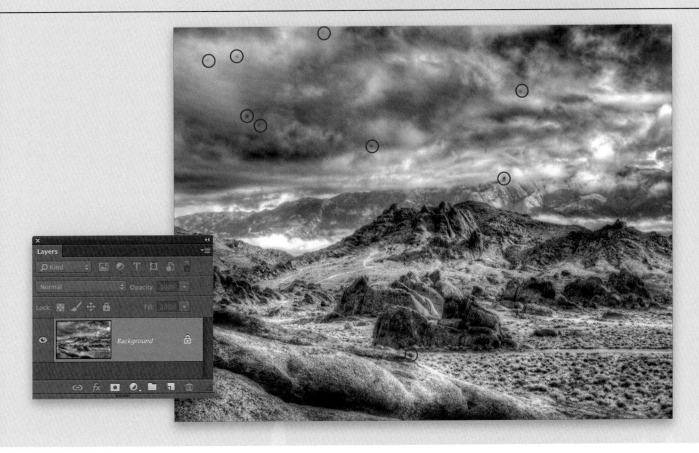

STEP ONE:

Whether it's a dusty sensor or rain on the front of your lens (as was the case here), spots or specks in your photo will immediately appear magnified in the tone-mapped image. While they're distracting in an otherwise normal picture, they scream, "Look at me!" in a tone-mapped image. So, let's take care of those first. Now, when you look at a photo full screen, it may look good, but you also may see a host of problems when you zoom into it. So, you should always zoom in to 100% to get the best idea of whether the image needs a little bit of spot work. When I zoomed in here, I saw all of the distracting areas shown circled here in red. Ouch!

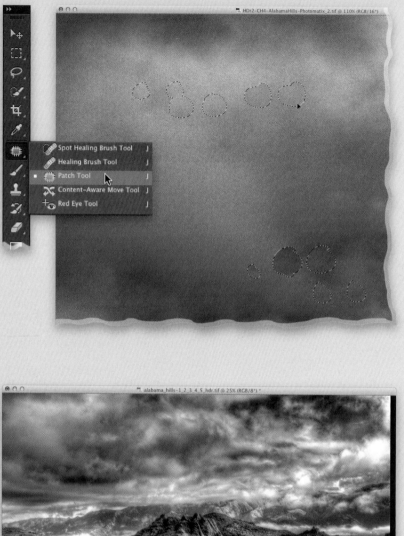

STEP TWO:

For fixing spots on a background, the Patch tool (press **Shift-J** until you have it) does very well. Sometimes, it can be a little repetitive, though, so here's a quick tip to help you: Instead of making one selection and dragging it immediately to patch, press-and-hold the Shift key after your first selection is made and then make another selection around another spot. This way, you can select a series of spots and, once you have all of them selected, you can then drag them in one fell swoop to get rid of them.

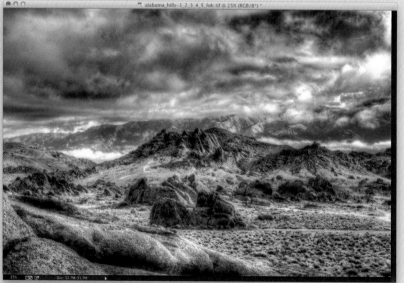

STEP THREE:

Now, you'll notice that tone mapping an image can introduce a bit of color contamination in some areas. When things you expect to be a certain color look different, it automatically makes the viewer question the authenticity of the image. So, a small adjustment can go a long way here. In this image, the color in the mountains is looking a little electric, so we're going to need to fix that.

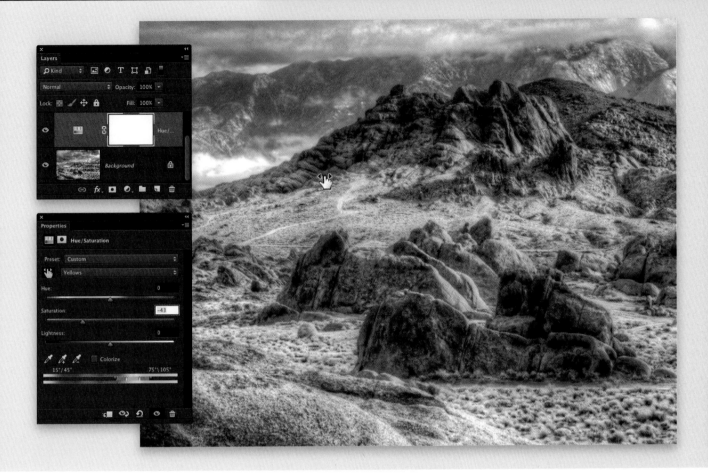

STEP FOUR:

Go ahead and add a Hue/Saturation adjustment layer (we covered this on page 64). In the Properties panel, click on the Targeted Adjustment tool (TAT, for short; it's the hand icon near the top left of the panel). With this tool, you can click-and-drag on any area in your image that you think needs a color change. So, click on the mountain and drag to the left. You'll see that the yellows in the image are desaturated, making the mountain color look a little more believable. The overall color of the image was still a little too saturated, so I then switched the pop-up menu back to **Master** and dragged the Saturation slider to the left a little.

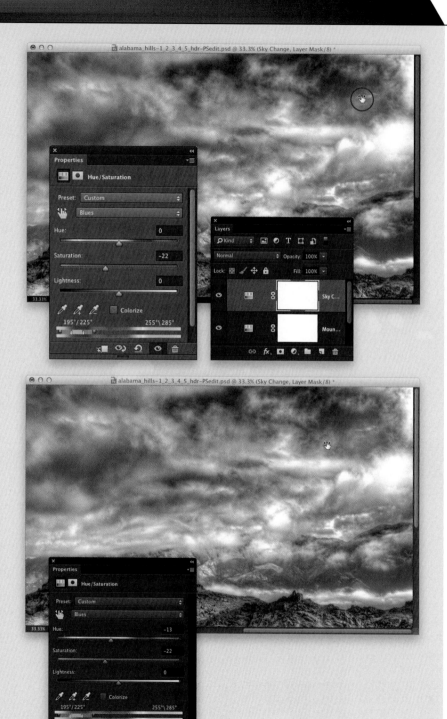

STEP FIVE:
While it's easy to make this hue/saturation change to the color, keep in mind that this color change is global—the white layer mask that appears in the adjustment layer reveals the color change throughout the image. Now I want to make a change to the sky color, but I only want to apply it to that portion of the image. So, create another Hue/Saturation adjustment layer and click on the TAT in the Properties panel. Now, click on any of the blue sky area in the image and drag to the left to desaturate it.

STEP SIX:
Next, let's change the hue of that blue a little bit by pressing-and-holding the Command (PC: Ctrl) key and dragging to the left. You'll see the Hue slider change, affecting the sky color.

STEP SEVEN:

Once that's set, make sure the top Hue/ Saturation adjustment layer's layer mask is selected in the Layers panel (it should have a border around it), and then press **Command-I (PC: Ctrl-I)**. This will invert the mask to black, hiding the entire effect. Get the Brush tool from the Toolbox **(B)**, choose a soft-edged brush from the Brush Picker in the Options Bar, and then set it to a low Flow (also in the Options Bar). Now, press **X** to set your Foreground color to white, then paint the color change back in only in the sky area.

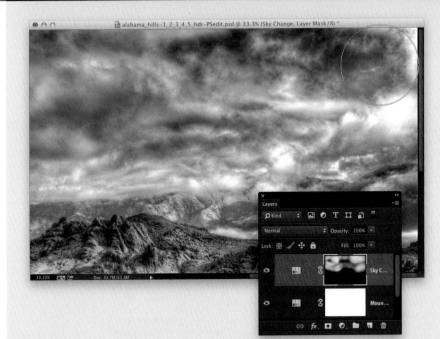

STEP EIGHT:

While a tone-mapped file can certainly provide a lot of contrast in images, there are times when you'll want some portions of the image to pop out more than others. Curves adjustment layers are a great way to do this. A simple S-curve and a layer mask, and you're good! In this image, I'd like to brighten up the cloud areas, as well as darken up some of the mountains to provide a little bit of texture. We'll start with the clouds. So, create a Curves adjustment layer. Then, in the Properties panel, you'll see the TAT near the top left of the panel. Click on it, and then click on a portion of the image you want to lighten—in this case, the dark area of the clouds. Drag up and the clouds will brighten.

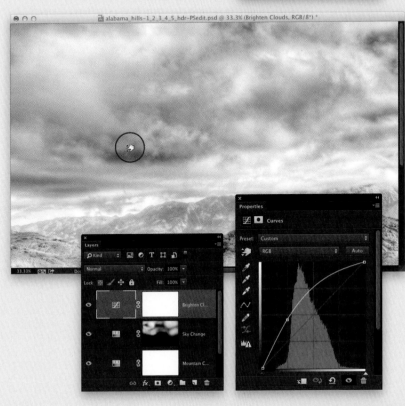

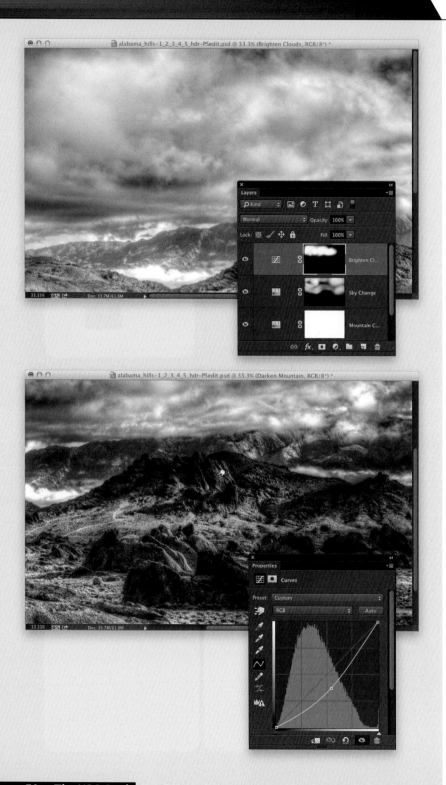

STEP NINE:
Like before, invert the layer mask and paint back in the effect only on the darkest portion of the clouds by using a soft-edged, white brush with a low Flow setting.

STEP 10:
We used a Curves adjustment layer to brighten a portion of the sky. Now, let's apply the same concept to darken the mountains. Create another Curves adjustment layer, and then click on the TAT in the Properties panel. Click on a portion of the image you want to darken—in this case, the bright part of the mountains. Drag down and the mountains will get darker.

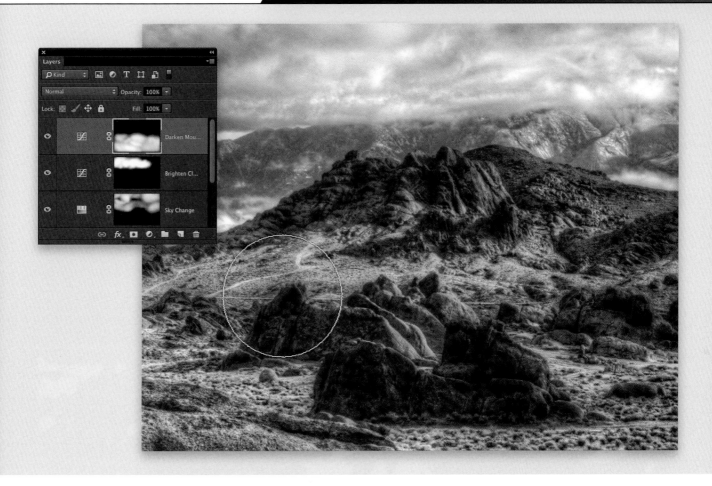

STEP 11:

Then, invert your top Curves adjustment layer's layer mask and paint back in the effect on some of the mountains. Don't paint over too much of them—you want there to be patches of dark and light to match the sky above. This will also give the picture a lot more texture. Save the file, and you are finished.

If you got this far and thought to yourself, "Is it this easy?" Surprise! It absolutely is. The techniques are the same, but the results you get will be transformative!

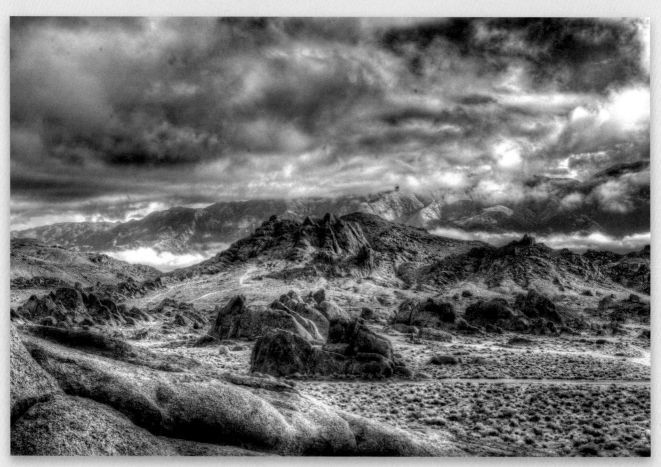

BEFORE

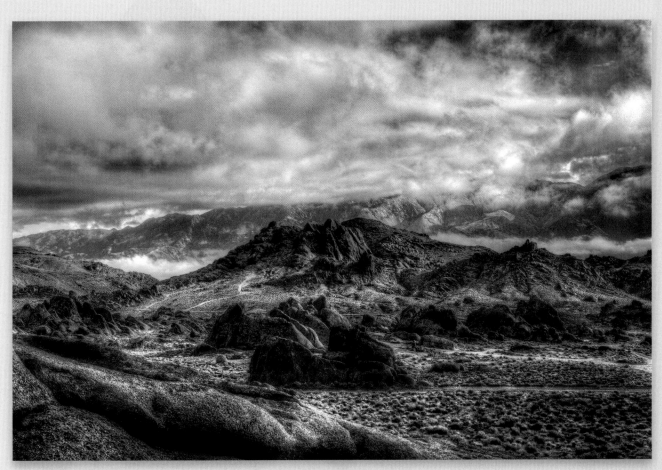

AFTER

It's Your Turn:
The China Grill

In Chapter 2 of the first edition of this book, we took a look at another image from this shoot that I made at a Photoshop World Conference several years ago. While I was pretty happy with that image, I think that it had a lot of competing elements in it (if you haven't seen it, take a look at the first edition—it's got all different examples for you to work with).

This image has always been more of my favorite as it has simpler shapes and tones to it. The problem with making this image has always been just how electric the colors are to begin with. The chairs in this restaurant are a very deep red. Try adding those exposures together in HDR, and you're going to get something that's going to look really unrealistic.

Try to be a little more conservative in how much color saturation you apply to the tone map. You'll notice that you will overshoot the color very quickly. From there, make sure that you use Hue/Saturation adjustment layers liberally to correct those colors. Also, keep in mind that the walls have color, too, and those will need to be controlled. Some Curves adjustment layers will add some mood to the shot. Let's see what kinds of images you come up with!

⬇ Download this preset at: www.kelbyone.com/books/hdr2.

FIVE

Project: The Pit

So there I was, at Disney World, hanging out with my brother-in-law Tim Ruymen, his wife Merri, my wife Jenn, and our daughter Sabine. We had been planning this trip to Disney for a very long time—my daughter's first. To say that everyone was excited is an understatement.

So, you can imagine how many dirty looks I would get from my wife should I decide to take this special time as a moment to collect images for HDR. We were standing in line in front of a great ride. Jenn has absolutely no time for me to get my tripod, set up my cable release, and wait for people to get out of the way. We had seconds. The line was moving, and her patience was very short. (I'm probably guilty of over-exaggerating here. She's actually very cool about this stuff. Most times.)

Fact of the matter is this: because of time and light constraints, you will need to make some shots that will require changes in your camera you do not want to make—specifically, higher ISO changes and shallower depth of field changes—to get that shutter speed below 30 seconds. When you do, you will introduce problems in your images: soft spots and noise.

It's important to note that *every* image needs to be sharpened for maximum effectiveness, so the tips in this chapter really apply to all images. However, we will use them to not only attack the high ISO and soft spots, but also to bring that picture to the next level.

Come on...Jenn's waiting. Let's go!

TONE MAPPING THE IMAGE

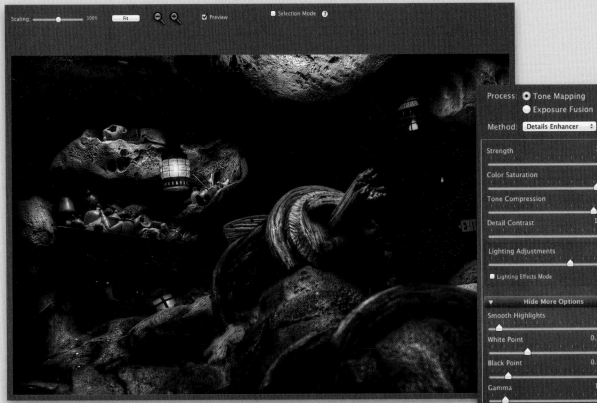

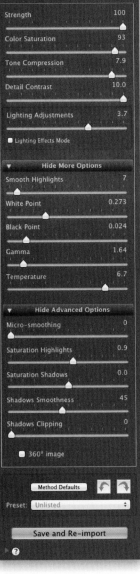

I used the Tone Mapping Details Enhancer settings for this image. Starting off from the defaults (press the Method Defaults button at the bottom of the Adjustments panel), I increased the Strength and the Detail Contrast, dragging them all the way to the right, to give me the overall look. Once they were set, I moved the Lighting Adjustments around to get myself a little more realistic of an image—here, I dragged a little to the right to 3.7. Then, I added a bit of Tone Compression, which rounded out the texture of the image. I wanted to see a little bit of color here, so I also boosted the Color Saturation to 93.

The image was shot with the temperature off a little bit. So, I added a lot of warmth to it by dragging the Temperature slider to the right to 6.7. I then focused on getting a better amount of contrast in the image by adjusting the White Point and Gamma sliders. To really get a great amount of detail in the rocks, I set the Micro-smoothing option down to 0, which further darkened the image.

To finish it up, I increased the Smooth Highlights to 7 and the Black Point to 0.024, and then, I increased the Saturation Highlights to 0.9 and the Shadows Smoothness to 45.

Photomatix really gave me an ethereal look that I was looking for in this cavern, but the high ISO and choice of f-stop created problems in detail and noise. We can easily correct these issues in Camera Raw or Lightroom.

POST-PROCESSING IN PHOTOSHOP

STEP ONE:
When you need to work on getting rid of noise in your image, Lightroom and Camera Raw have a great tool in their Luminance Noise Reduction feature. To access this feature, you'll need to edit your tone-mapped image in the Develop module in Lightroom, or open it in Camera Raw:

Lightroom Users:
In the Develop module, go to the Noise Reduction section in the Detail panel and process your tone-mapped image for noise reduction using the Luminance slider. Make sure you zoom in to 100% on the image to be able to see what the noise reduction looks like. The Develop module in Lightroom has exactly the same controls as Camera Raw does in Bridge and Photoshop.

Bridge Users:
To open your tone-mapped image in Camera Raw from Bridge, Right-click on the image and select **Open in Camera Raw** from the pop-up menu.

Photoshop Users:
To open the image in Camera Raw within Photoshop, from the File menu, choose **Open (PC: Open As)**. Navigate to the image and click on it to select it. In the Format (PC: Open As) pop-up menu at the bottom, select **Camera Raw**. When you click the Open button, the image will open in Camera Raw. You can also find the image in Mini Bridge, Right-click on it and, from under Open With, choose **Camera Raw**.

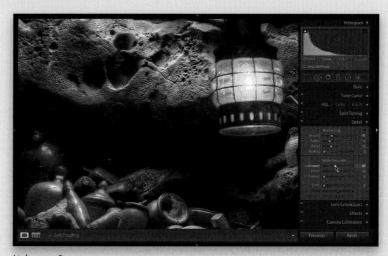

Lightroom 5

Bridge CC

Photoshop CC

STEP TWO:

Once you're in Camera Raw, click on the Detail icon (the third icon from the left beneath the histogram) and process your tone-mapped image for noise reduction using the Luminance Noise Reduction slider directly below the Sharpening section. Zoom in to view the image at 100% to make sure you are okay with the changes you're making here.

STEP THREE:

Oftentimes, when you are working with HDR images, you'll only want to reduce noise in certain portions of the image. Because the Luminance Noise Reduction affects everything in the image, to better control which portions of it have noise reduction and which portions don't, open the image in Photoshop as a smart object. Here's how:

Lightroom Users:

Right-click on the image that you have applied the noise reduction to and, from under Edit In, choose **Open as Smart Object in Photoshop**.

Camera Raw Users:

Press-and-hold the Shift key to turn the Open Image button at the bottom right into the Open Object button. If you find that you prefer to have all of your images open as smart objects from Camera Raw, you can click on the link directly below the Preview area and, in the Workflow Options dialog, turn on the Open in Photoshop as Smart Objects checkbox. That changes the Open Image button to Open Object, and pressing-and-holding the Shift key will convert it back to Open Image instead.

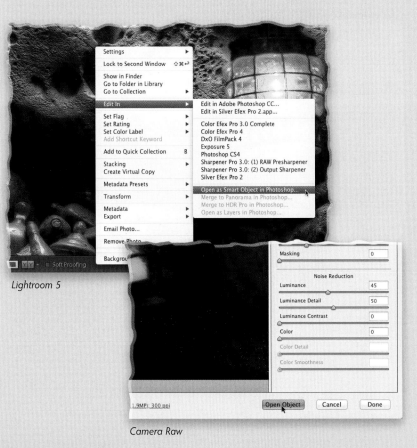

Lightroom 5

Camera Raw

STEP FOUR:

We now have an image that has Luminance Noise Reduction applied to all of it. If I simply made a copy of this smart object layer and double-clicked on one of them, any changes I made to it would be reflected on both layers—that's the benefit of using them. What I'm looking to do instead is create a second smart object, where the settings differ from the first smart object. To do this, Right-click on the layer and select **New Smart Object via Copy** (you learned about this back on page 66). Double-click on the original layer's thumbnail to open the smart object back in Camera Raw, where you can reset the Luminance Noise Reduction to 0, and click OK.

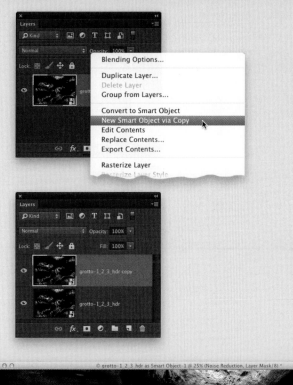

STEP FIVE:

Now we have two layers: one with Luminance Noise Reduction applied, and one with no noise reduction. Rename them, so you know which is which (double-click on the name to highlight it, then type in your new name). I named mine "No Noise Reduction" and "Noise Reduction." Then, make sure the No Noise Reduction layer is at the bottom of the layer stack. Now, make sure the Noise Reduction (top) layer is selected and add a black layer mask (you learned this back on page 63), hiding the top layer and revealing all of the noise in the layer below. Select the Brush tool **(B)**, and choose a soft-edged, round brush with the Flow set to about 35% up in the Options Bar. Set your Foreground color to white (see page 62), and paint with white on the layer mask to reveal the noise reduction only in the areas you want it (as shown here). If you paint too much, you can always switch your Foreground color to black and paint over it to hide that area again.

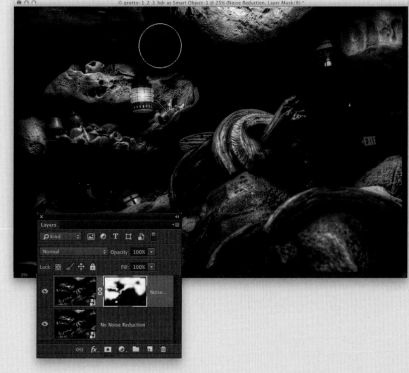

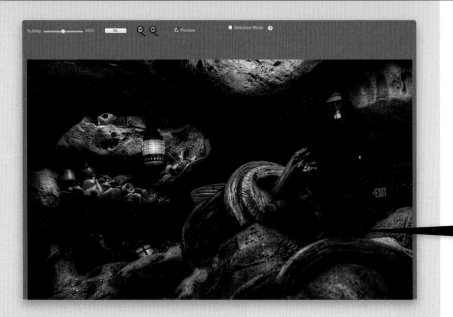

STEP SIX:
Because of the high amount of noise in the image, you'll see that there are white dots appearing in the shadow areas. This will immediately attract attention from anyone looking at the picture and suspend belief for the image. You're best off fixing this as quickly as possible.

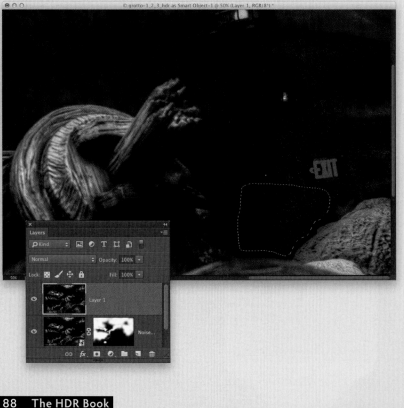

STEP SEVEN:
Rather than try to use the Patch tool to clean this up, Content-Aware Fill should do a good job here. (Remember, it's a largely dark mass with little spots of white. Photoshop should see the spots as the problem and get rid of them.) First, let's perform a merge up (see page 65) of all of the changes that we've done to the image so far. Then, use the Lasso tool **(L)** to make a selection around the problem spots in this portion of the image.

STEP EIGHT:

Once the spots are selected, go under the Edit menu, and choose **Fill**. Then, choose **Content-Aware** from the Use pop-up menu and click OK to fill the area up quickly. If you don't like the way it fixed the area, press **Command-Z (PC: Ctrl-Z)** to Undo and try it again. If it fixes only part of the selection, deselect, make a new selection, and try again. If you have a few stray white spots or your selection is too close to the edge of something and Content-Aware Fill is picking that up, just use a small Spot Healing Brush (**J**) with the Type set to Content-Aware to fix it. We can even use that same technique to get rid of the Exit sign. I mean, if you were in a cave, would you *really* see an Exit sign?

STEP NINE:

When you fix a large selected area in an image, like the Exit sign, you'll notice that two other problems may emerge: First, the area may have a bit of a tonal shift and look a little brighter than the area around it. Second, the area may be a little "softer" than the noisier area around it. We'll correct for the darker area by painting with the Burn tool (**Shift-O**), with the Range set to **Midtones** in the Options Bar, and the Exposure set at a relatively low flow. This will let you "step in" to the amount of darkening you need. Now, paint over the brighter spot until it matches the surrounding area.

STEP 10:

Let's work on adding some detail back into the soft area now. Get the Lasso tool again and make a selection around the soft area left behind by Content-Aware Fill. Once you have that selected, press **Command-J (PC: Ctrl-J)** to move that selection onto a new layer. Go under the Filter menu, under Noise, and choose **Add Noise**. Input a low Amount for the noise, and I'd also recommend turning on the Monochromatic checkbox for this., then click OK.

STEP 11:

Once you add the noise, add a black layer mask to hide the entire layer. Now, switch back to the Brush tool and paint the noisy area back into the picture using a soft-edged, white brush with a low Flow setting.

STEP 12:

Now that we've taken care of some of the noise problems in the image, let's go back and look at the sharpening we need to do on the image. Keep in mind that when you shoot in RAW, the images are not as sharp as they can be if they were shot as JPG. So, many photographers add sharpening to their images. In this instance, HDR is no different than regular photography. I'll give you a few ways to sharpen your files: First, create another merge up layer. Then, go under the Filter menu, under Sharpen, and choose **Unsharp Mask**. To start, set it to something like 100 for the Amount, 1 for a Radius, and a Threshold of 3. This should give the image a good amount of sharpness, all on a separate layer.

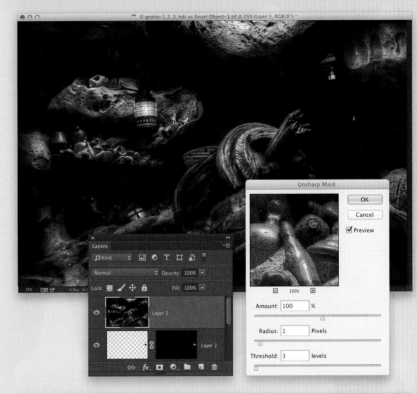

STEP 13:

Here's another really cool option for adding detail to an image, instead of using Unsharp Mask. With the merge up layer active, go under the Filter menu, under Other, and choose **High Pass**. Drag the Radius slider all the way to the left. This will turn the image into a gray layer. Now, as you drag the slider back to the right, you'll start seeing the edges of the image begin to appear. Adjust the image to a point where you can just see the very edges of the rocks and the lantern.

STEP 14:

Once you've clicked OK in the High Pass dialog, switch the blend mode of the High Pass layer to **Soft Light**. You'll notice that you'll now have a lot more detail across the image. Check it by showing and hiding that High Pass layer. Now, with both the Unsharp Mask technique, as well as the High Pass technique, it's best to isolate how much sharpness you want to have in specific areas. So, hide the sharpened layer behind a black layer mask and paint in the sharpness that you'd like with a soft-edged, white brush with a low Flow setting (you're starting to see a pattern here, aren't you? :).

STEP 15:

Now, my preferred method of adding sharpness to date is to use the RAW Presharpener in Google's Nik Collection (this goes on every image I use, HDR or not). If neither of the sharpening techniques we just discussed suit you, I'd encourage you to give this plug-in a shot (you can download a free, 15-day trial of the entire Google Nik Collection). Once installed, simply go under the Filter menu, under Nik Collection, and choose **Sharpener Pro: (1) RAW Presharpener**. There are only two sliders that you need to adjust to taste here—Adaptive Sharpening and Sharpen Areas/Sharpen Edges—and the results will be good. The point here is to sharpen. Every time. Period. Once you do, again, hide the sharpened layer with a black layer mask and only paint in the areas where you need it.

STEP 16:

When you try to shoot an HDR image and you don't have a tripod, you'll likely increase your ISO. We've already tackled that problem. However, one of the other things you'll attempt to do is open your aperture, thinking that the increased light coming in will make that shutter speed a lot faster. You're right. This will happen, however it will happen at the cost of depth of field. Take a look at the wooden structure to the right, here. It is soft. At f/6.7, I thought that I would have enough depth of field, but sadly, I did not. So, in an instance where you are going to be shooting below f/8, I would recommend that you make a careful decision on what is going to be out of focus. I knew that I had to pick between the jars and that wooden structure. I figured that if I got the jars in focus, I could add a little bit of detail back in to the bigger things easier than to the smaller things using Unsharp Mask. Adding the Unsharp Mask to the jars really would have called attention to them as being soft, so I threw caution to the wind, focused on the jars, and here we are.

STEP 17:

So, create another merge up layer and apply a really heavy Unsharp Mask to the image. Don't pay attention to what it is doing to the rest of the image, just focus on the wooden structure on the right. Once you have the detail that you want, hide the layer with a black layer mask and use a soft-edged, low-flow, white brush to paint the sharpness back into that section of the image alone.

SHAKE REDUCTION IN PHOTOSHOP CC:

If you are using Photoshop CC, there's a new feature called Shake Reduction. When people first saw this feature, many believed that it would overcome any problem with blur. While Shake Reduction aims to take away the blur from an image due to someone hand-holding a camera and introducing shake, that is very different from the blur that you get from a depth-of-field shift. That said, in a pinch, you might be surprised how much help it can give you. Let's take a look at it:

Once again, create a merge up layer, then go under the Filter menu, under Sharpen, and choose **Shake Reduction**. In the Shake Reduction dialog, you can drag out an Estimation region to have Photoshop attempt to recover detail. After a few seconds of waiting through some rendering, you'll see the finished result. Adjust the Smoothing and Artifact Suppression sliders to control how noisy the adjusted results are.

Again, hide the results with a black layer mask and only paint them back onto the large wooden structure.

STEP 18:

Now that all of the detail and noise problems have been resolved, we can go back and address color and finishing for the image. You'll see that the pots have a little bit of blue on them from the lights coming in from above. Yet, the pots are in front of a yellow light. The pots should have, at best, a little bit of a yellow cast to them. At worst, they should not have that blue color. A Hue/Saturation adjustment layer that eliminates some of the saturation for the blues (I used the Targeted Adjustment tool) should do the trick here.

STEP 19:

Let's wrap up this image by adding some contrast with a Curves adjustment layer. In the Properties panel, click on the middle of the curve and drag downward, and the whole image will become darker. Hide the effect with a black layer mask, and then paint back in several areas on the image to offer some depth.

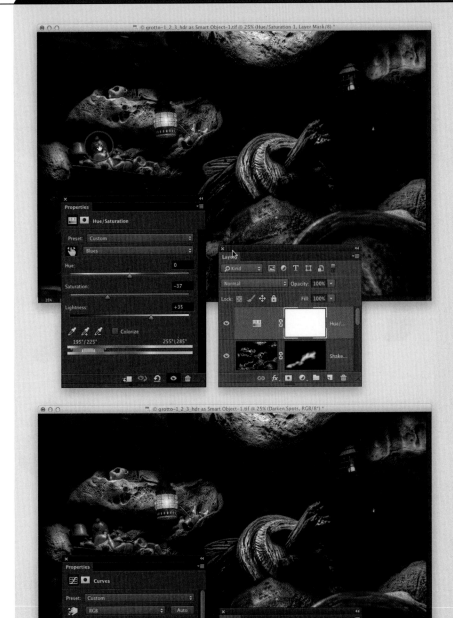

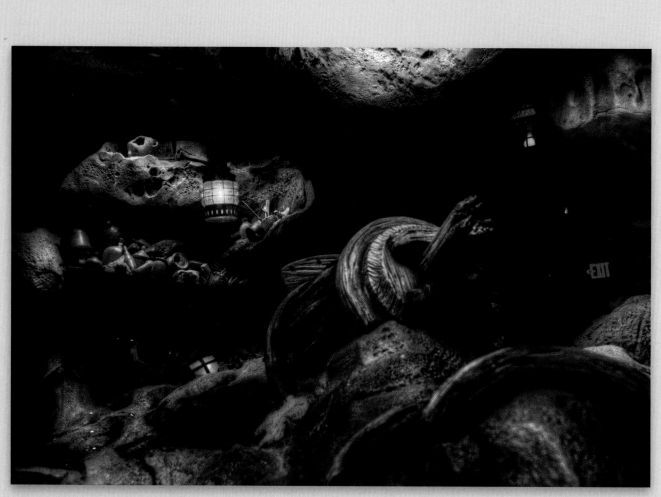

BEFORE

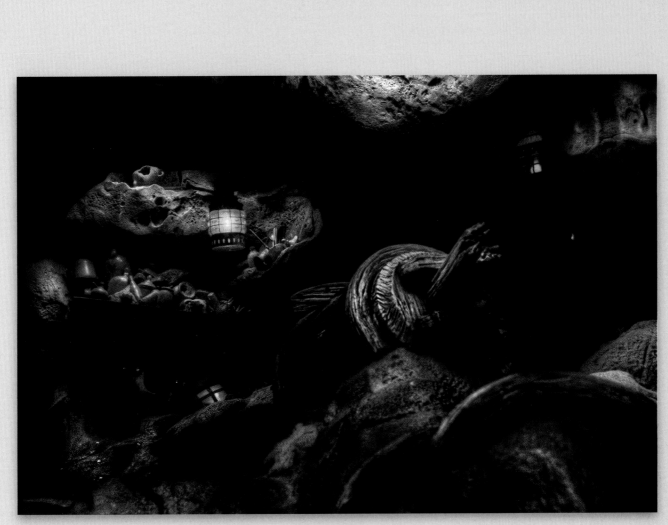

AFTER

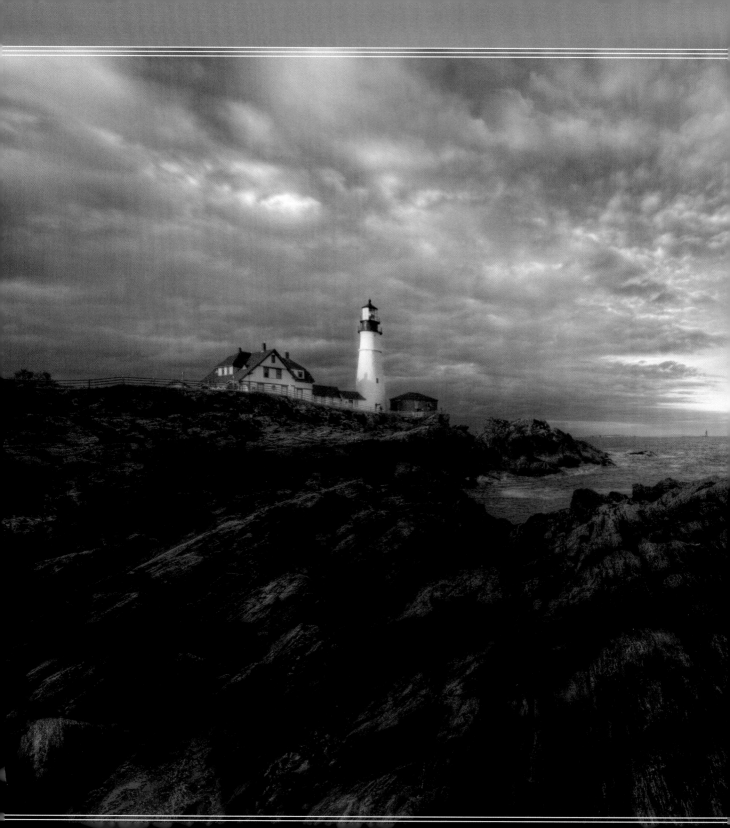

SIX

Project: Portland Head Light

Not too long ago, I was asked to speak at a conference in Maine for one day. Since I live in Tampa, Florida, I would fly up for one day, speak at the conference, and then fly back down.

Now, one thing about Maine in the fall: it is absolutely gorgeous. What I was looking for was that picturesque lighthouse and having some beautiful clouds streaming by. The chances of getting that are next to none if you're just going up there for one day. Thankfully, my friend Julia convinced me to get in the car and go and we were able to find an interesting shot.

I traveled all the way down to the bottom of the rocks to be able to get a shot that showed an example of what naturalistic HDR can look like. The problem we have here is that if you try to expose for rock elements in the foreground, you're going to lose elements in the sky. Conversely, if you try to expose for sky elements, you're going to lose a lot of the details in the rocks.

What HDR can do for us here is to work this and bring the best of all of these files together inside one shot. How many shots do you take for this? It's entirely up to you. What I would say is: take as many as you can with your camera. This is not a contest to see how hard you can make it to produce a good piece of work. If your camera does nine brackets, do nine; if your camera does three, do three.

The most important part of it all is to make sure that, at the shadow end of detail, there's almost no brightness. You want to keep this as dark as possible. Remember the entire concept of shooting for the basement. If you do that, chances are you're probably going to get enough of the highlight detail and you'll have a really good capture. Make sure that you're shooting for the basement, and everything else will take care of itself for you.

TONE MAPPING THE IMAGE

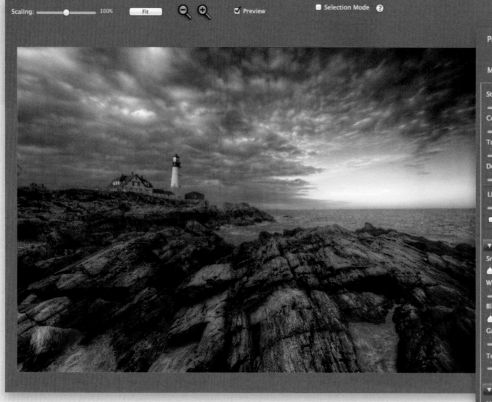

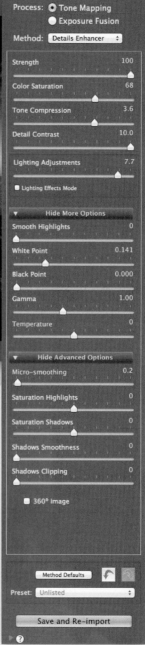

The first thing that I'm going to do here is increase the Strength to 100, and I'm also going to increase the Detail Contrast to 10. That's going to immediately darken the file. Then, I'm going to drag the Color Saturation about three-quarters of the way to the right to make sure that I have some color to work with in the image.

Next, I'll increase my Lighting Adjustments until I get a really naturalistic look. This slider will control whether or not something looks really natural or has that "Elvis on velvet" look. Immediately that makes the picture look a lot better.

From here, we can play with the Tone Compression slider—moving it to the right will make things brighter, and moving it to the left will make things a little bit darker (I ended up moving it a little to the right). Now, I'll brighten up the scene a little bit more by decreasing the White Point and then decreasing the Gamma to taste.

To finish the image off, I'll just go ahead and decrease the Micro-smoothing (under Advanced Options), and you'll notice that when you do that, it's going to make the image a little darker. So, you might have to compensate for that by readjusting your Gamma and White Point.

POST-PROCESSING IN PHOTOSHOP

STEP ONE:

Once we have the image opened in Photoshop, it's time to go ahead and move some of the original brackets into the tone-mapped file. So, first, let's open up one of the images that has a nice, white-looking sky (here, I chose the +1 EV image). Using the Move tool **(V)**, click-and-drag the nice sky image directly on top of the tone-mapped image. Once we have the two layers on top of one another, with the Move tool still active, Shift-click on the Background layer in the Layers panel to select both layers.

STEP TWO:

With both layers selected, click on the Auto-Align Layers icon up in the Options Bar. Although you may have used a tripod, the merging that occurs during the HDR process could have shifted one of the images in one direction or another. You never really know whether or not one of your original brackets is going to match perfectly with the tone-mapped file. So, I do recommend doing an alignment when you're bringing in an original image. In the Auto-Align Layers dialog, leave the Projection set to Auto and click OK.

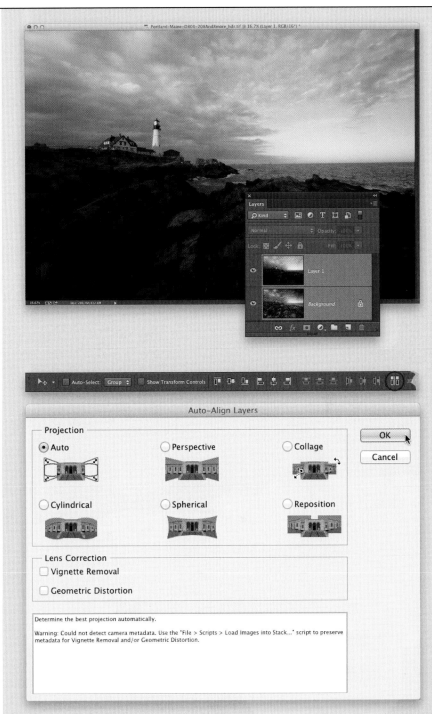

STEP THREE:

Once that's done, hide the original bracket layer with a black layer mask (see page 63). Then, get the Brush tool **(B)** and, with a soft-edged, white brush with a low Flow setting, paint on top of that mask, revealing a portion of the bracketed image's sky on top of the tone-mapped file.

STEP FOUR:

Because skies can be somewhat problematic when working with an HDR file, it is not uncommon for me to have multiple original brackets on top of a tone-mapped file to get the balance of nice skies and interesting tone mapping that I need. So, here I added another bracketed image (this time, I chose the normal exposure), selected the top two layers, and aligned them like we did back in Step Two. Then, I added a black layer mask to the top layer, and painted in some of that image's sky.

STEP FIVE:

While I like what we did here with the tone-mapped file, we do want to add a little bit of contrast to the image. Now, I don't need all of the rocks to be completely bright, but I'd like to break it up, and I'd also like to get some detail back into the lighthouse. So, let's add a Curves adjustment layer to the top of our layer stack. In the Properties panel, click around the center of the curve and drag down. This will darken the entire image.

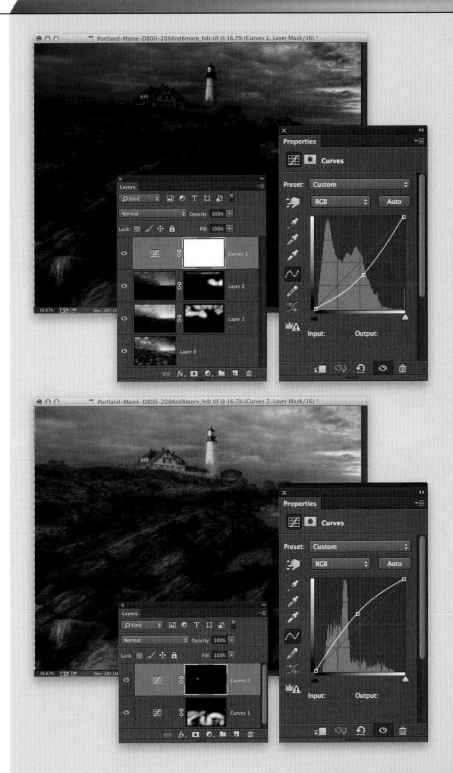

STEP SIX:

Press **Command-I (PC: Ctrl-I)** to Invert the layer mask, which will hide the darkened effect. Now, you can use the Brush tool and, with a soft-edged, white, low-flow brush, paint in the darkness only in the areas that you'd like. Then, add another Curves adjustment layer, click on the center of the curve and drag upward, which will brighten the image. Invert the layer mask and then use the same brush to paint in only the portions that you'd like to see brighter—in this case, the house and the lighthouse. At any point in time, if you want to adjust how bright or how dark one of these elements is, you can always click on one of the Curves adjustment layers' icons (they look like a small curve on each of the layers) and adjust the curve as needed.

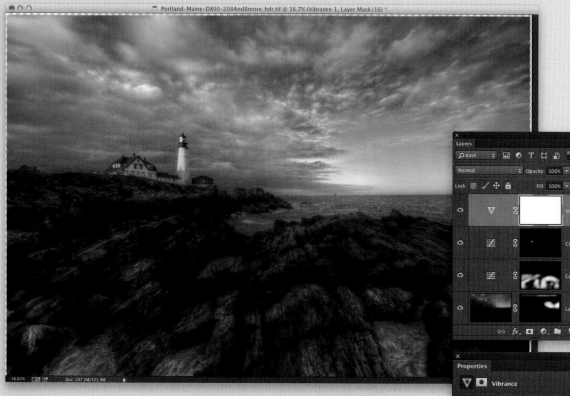

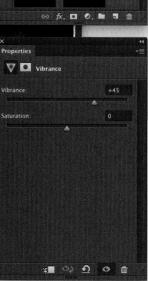

STEP SEVEN:

The portions of the rocks that we darkened in the image could also use a little bit more color. To do this, we'll add a Vibrance adjustment layer. In the Properties panel, increase the Vibrance amount to around +45, which will increase the vibrance inside of the rocks (as well as in some other areas). Vibrance only affects colors in an image that are underrepresented. So, if a color has too much intensity, it will usually be left alone. Now, since this adjustment is applied to the entire image, we'd normally invert the layer mask and then paint back in where we want the adjustment. But, we're going to do something easier here to apply the adjustment where we want it.

STEP EIGHT:

There will be times when you apply an adjustment layer to an image that you'll want to affect the exact same area as a previous adjustment layer. In instances like this, you don't have to paint the area over again. Here, we want to apply vibrance to the rock area—the same place that we darkened earlier. So, with the Vibrance adjustment layer created, press-and-hold the Option (PC: Alt) key and just click-and-drag the layer mask from the first Curves adjustment layer (where we made the adjustment to the rocks) onto the Vibrance adjustment layer's white layer mask. You'll get a warning asking if you'd like to replace the existing mask. Click Yes, and the mask is copied over to the new area.

STEP NINE:

Once I do all of my color adjustments and toning for the image, I want to be able to add a little bit more detail. But first, I'll do a merge up (to merge all of the layers into one; see page 65), and then I'll bring that merged layer into Camera Raw. So, press **Command-Option-Shift-E (PC: Ctrl-Alt-Shift-E)** to merge the layers, and then choose **Camera Raw Filter** from the Filter menu.

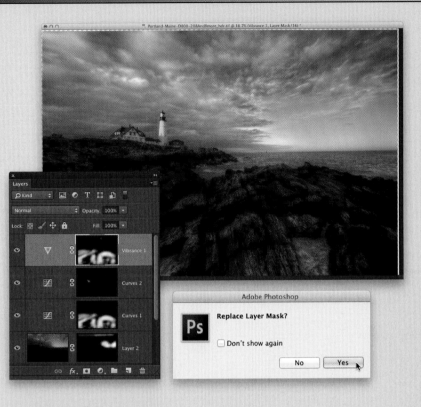

STEP 10:

When the Camera Raw window appears, click on the Detail icon below the histogram and adjust your Sharpening Amount and Detail according to the type of image that you have. In this case, I really want to add some detail to the rocks, so we'll drag these sliders pretty high. HDR works with texture, but it doesn't give you detail. So, for that, you'll need to use Camera Raw or some other program that will accent the detail that you've lost by shooting in RAW.

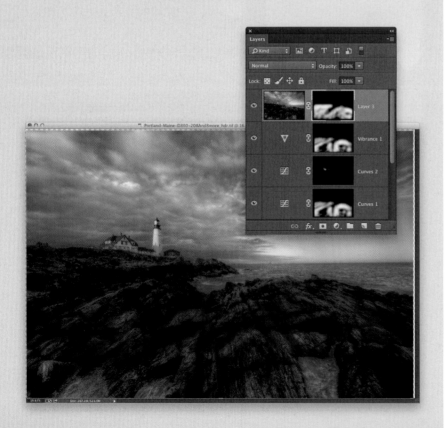

STEP 11:

Once that's set, click OK, and then add a black layer mask to the merged layer to hide the detail. Now, paint with the same brush as before, only over the areas that you want to have detail. In this case, I want a lot of detail in the rocks, but don't want that detail in the clouds. So, I've only painted it into the bottom portion of the image.

STEP 12:

The last thing left to do is a quick crop of the image to get rid of some of the transparent space that the alignment brought us. So, first, choose **Flatten Image** from the Layers panel's flyout menu, then grab the Crop tool **(C)** from the Toolbox and crop the image to get rid of the transparent edges.

STEP 13:

After looking at the finished image, I think we still need a little more contrast. So, let's darken the rocks a little bit more in the foreground by adding another Curves adjustment layer, inverting it, and painting only in those rocks.

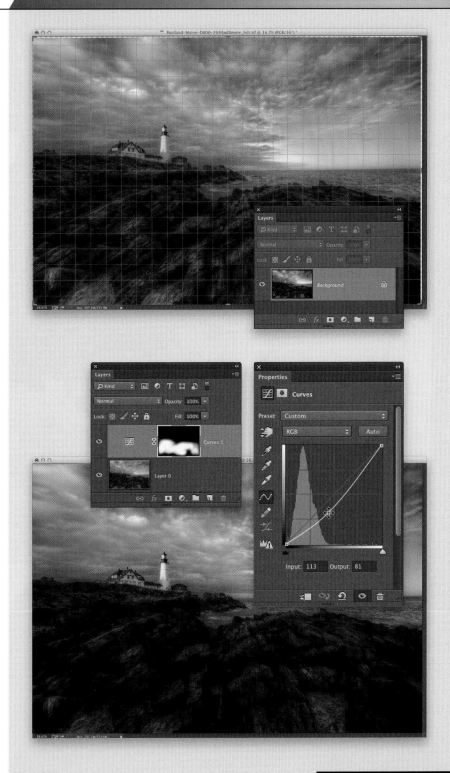

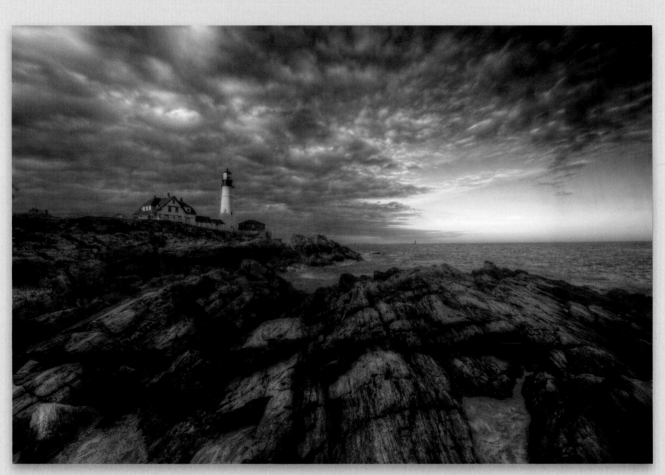

BEFORE

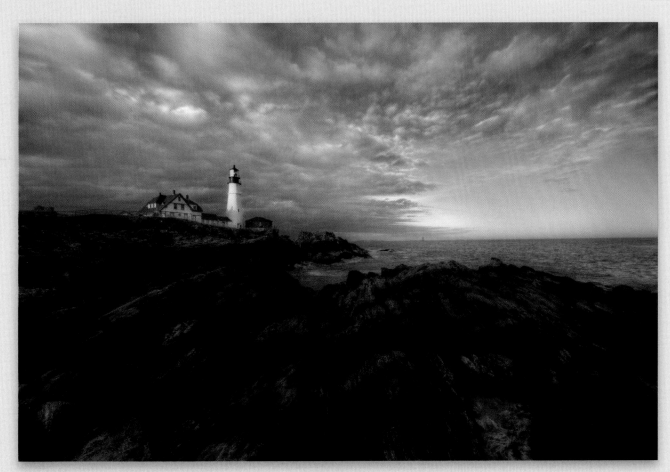

AFTER

HDR Spotlight: Klaus Herrmann

Q: Tell me a little bit about yourself.

For 14 years, I was a researcher and a lecturer in computer science at different universities in Germany. In 2008, I started picking up photography as a hobby. As a part of my job, I was frequently traveling, mainly across Europe. On those travels, I started spending my spare time photographing, and I quickly realized that, above all, I enjoyed shooting landscapes and architecture.

Most of my family members do something artistic (painting, videography, photography, music—you name it). Having spent most of my youth making music, I guess I was infected early on with this artistic virus.

When I got into HDR photography, I was fascinated with the possibilities that it gives you in post-processing. Being quite savvy with computers and software, I mastered this craft rather quickly. Then, I realized that lots of people have a really hard time with those things—they find it difficult to use computerized tools to express themselves. When I started uploading my images to Flickr, more and more people started asking me about the techniques I used.

Being a teacher at heart, I decided to start a little blog where I would write tutorials about those techniques. A year later, this blog turned into a website and more and more people started following what I was doing.

In 2012, my contract with my university ended, and I had to decide what to do next. The timing was perfect, and everything fell into place just nicely in order to combine my passion for teaching with my love for photography and venture on to new territory: building a business in photography education.

Q: What got you into HDR photography?

I have to confess that I am probably one of the five people on this planet who did not get into HDR photography because of Trey Ratcliff. Initially, I was fascinated by lesser-known artists.

When I started on Flickr and began looking at other people's photos, I noticed that some photographers had a distinct style that got me hooked immediately. At the time, I did not know what this style was, or how to create such images. I was just fascinated with the amount of details, the light, and the colors in those images.

I found out that those photos were HDR images, and when I dug a bit deeper, I got even more fascinated about the workflow that led to these images. There was so much to learn, so much to find out,

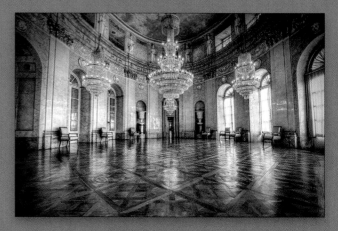

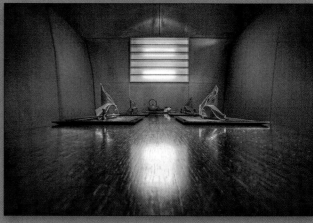

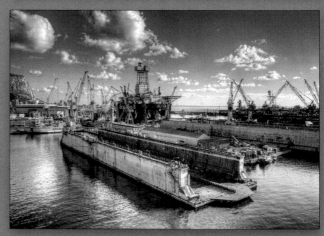

Images Courtesy of Klaus Herrmann

and so many different ways of creating HDR images. So, I started practicing and developing what then became my own style.

Q: How does HDR help you achieve your photographic vision?

HDR lifts the technical limitations of today's cameras and gives me complete freedom to work with exposure. It puts me in charge of lights and shadows, whereas without HDR, I would always be limited by the dynamic range of my camera. HDR gives me the raw image material that I need to build my images.

For me, the process of merging my photos into an HDR image and tone mapping it is never the final step—it is only the first one of a potentially very long list of steps toward the final image. Today, when I create an HDR image, I typically spend about 10% of my time preparing the images, 10% in the HDR software, and 80% in Photoshop working on all the different aspects of the image separately until it looks right to me.

Q: Is there a specific style you find yourself shooting?

Over the past few years, I have developed a technique that I call HDR Vertorama Photography. This technique is a combination of classical HDR and panorama photography: I shoot a vertical panorama consisting of several overlapping sections, where each section is an exposure series that is turned into an HDR image. Those HDR images are then stitched together to create an image that appears to be opening toward the viewer.

In my normal HDR work, I love shooting architecture, interiors, and landscapes. Those are the types of photos that can benefit the most from the HDR technique. I am not sure how one would describe my post-processing style. I guess, for some, it's very colorful and maybe on the edge of being overdone. I love playing with that edge, and I find that stepping just slightly onto the other side makes images most interesting. But in most cases, I don't get those results from the HDR process itself. As I said, HDR simply provides me with the raw material I need to create the final images in Photoshop. I work on the details, the colors,

and the contrasts in an image using many selective adjustments. That's really where the art comes in.

Q: What kinds of experimentation do you find yourself doing now with the HDR?

I experiment all the time. I think continuous experimentation helps you develop your own style. Stop imitating somebody else and discover the possibilities. Sometimes it's little things, like really finding out when and how best to do noise reduction through a series of (almost scientific) experiments. Sometimes it's more radical things, like using a whole new workflow on some images. Most of these experiments are driven by problems I encounter when I edit certain images. If my current workflow cannot solve them, I try something different. If that's successful, I include it into my repertoire. If not, I have at least learned another way how not to do things.

Q: Where can we find out more about you?

Visit my webpage at: farbspiel-photo.com.

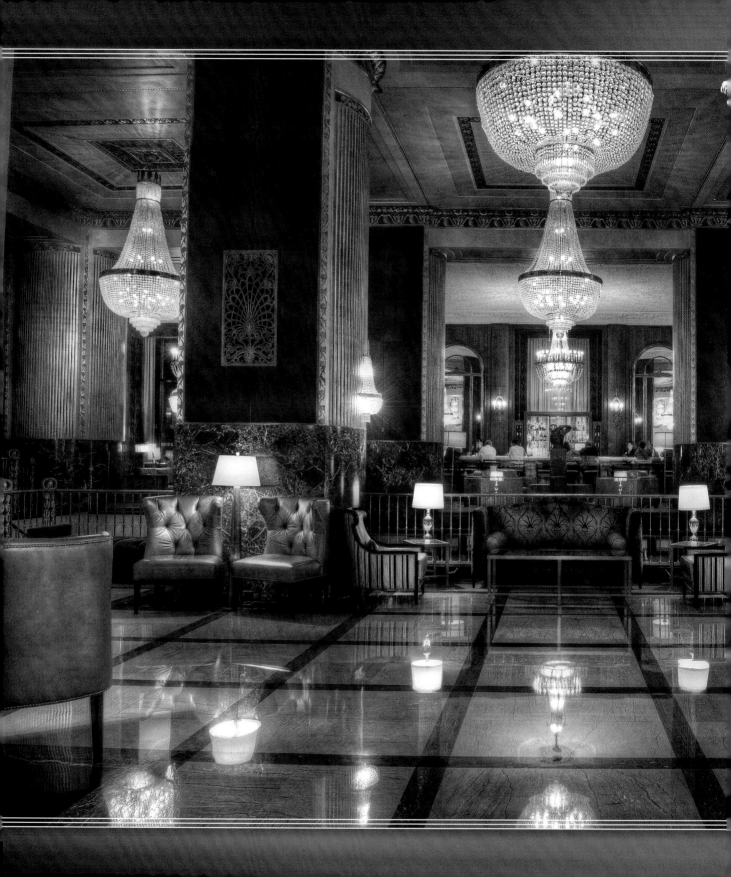

SEVEN

Project: Hilton Milwaukee City Center

There's something about dimly lit interiors that really does well when making an HDR image. That's why I always make sure that I attempt to make a picture inside of churches, as well as the front lobbies of hotels. Both are always in pristine condition to make an impression (or show respect, in a church scenario), and both have great attention to detail.

Being on the road a lot allows me plenty of opportunities to test my theory out in hotel lobbies. I usually check into my room first, striking up a conversation with the front desk person. I'll tell them I'm a photographer and that I would like to possibly come back and make a picture of the interior of the hotel. While I believe that they usually really don't mind, I think it's a good idea to make sure that they are saying yes to a "guest" rather than someone who just walked in off the street.

Once I have permission, I try to return to the lobby area well after I think traffic has stopped (usually after midnight). This allows me to set up my tripod, use a low ISO, use a high f-stop, and ensure no one is going to mess up my shot.

Once I have the image completed, I immediately go upstairs and work on the file. Having a good image set, I'll transfer it to my smartphone and make my best attempt to talk to someone in a management position at the hotel to show them the image. There have been times that this exchange has got me in contact with a corporate office of a hotel, and given me opportunities to shoot interiors as a job or (in some cases) a trade. Hey, you need to travel to get great pictures. At the bare minimum, a few free nights is worth the time you put into a shot many would dismiss.

TONE MAPPING THE IMAGE

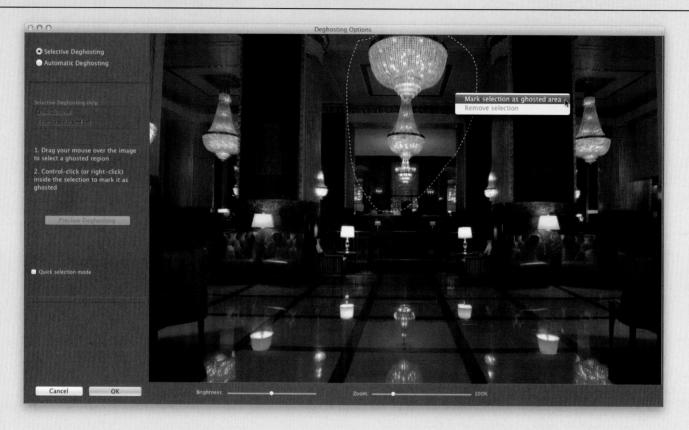

One of the first things that I did when I was working on this image was to use the Selective Deghosting feature in Photomatix to straighten out the chandelier in the center. It looks like, at some point in the bracketing series, the camera moved a little bit and it caused a little bit of blur in the chandelier. So, using Selective Deghosting, trace the area around the chandelier, then Right-click inside your selection and choose **Mark Selection as Ghosted Area**. That'll snap everything right into place.

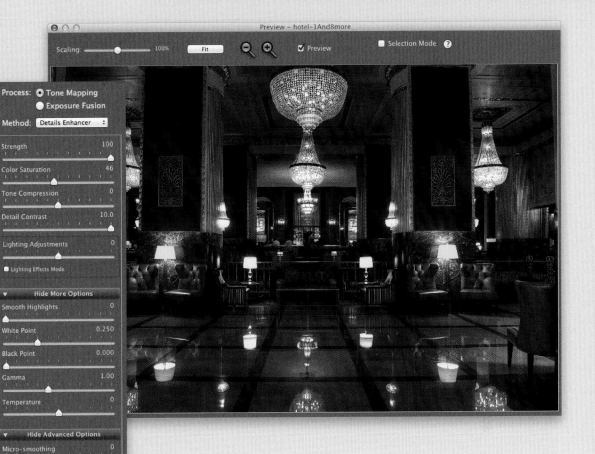

Right off the bat I know that I'm going to want to have a lot of detail in this image, so I'm going to increase the Strength to 100 and I'm also going to increase the Detail Contrast to 10. That will bring out the most amount of detail that you'll see inside of the chandeliers. From here, I want to make sure that I don't miss any detail, so I'm going to decrease the Micro-smoothing (under Advanced Options) to 0. You'll automatically see that we have a lot of tonality and a lot of detail inside of those chandeliers.

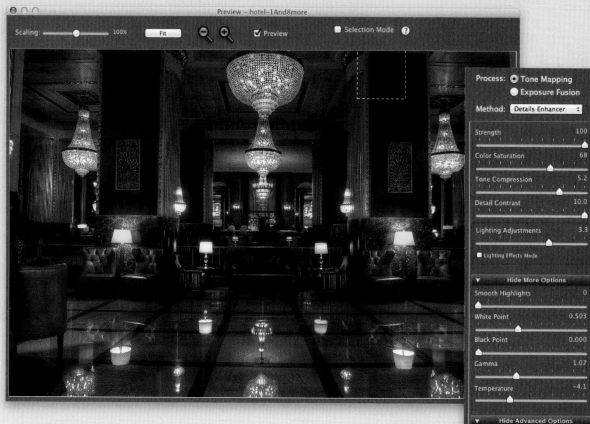

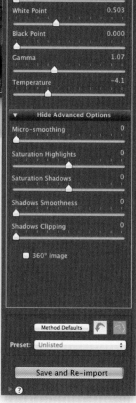

Next, I'll go ahead and bring my Lighting Adjustments over to the right a little bit to 3.3, keeping it a little bit natural. I'll also drag the Color Saturation slider about three-quarters of the way to the right to 68. Then, I'll drag the Tone Compression slider over to the right to 5.2, and you'll notice that you'll get even more detail inside of those chandeliers. We'll finish it off by increasing the White Point a little bit to 0.503 to make the area brighter, and decreasing the Gamma to 1.07, so that we can get some nice shadows inside of the image.

It's important to note that you're not going to be able to solve every single problem with this HDR file. You're going to notice

that there are going to be light sources to the left and to the right that are going to get blown out. When working with an HDR file, this is another hidden secret: HDR does not solve everything. You're going to need to go back and get some of the original files and overlay them on top of this tone-mapped image to be able to provide a really nice transition between those lights and the environment around them.

Finally, you're also going to want to make sure you decrease the Temperature a little bit here (to –4.1) because this room is a little yellow, and you don't want to introduce too much into it.

POST-PROCESSING IN PHOTOSHOP

STEP ONE:

The first thing that we're going to need to do here is take one of the underexposed shots of the bracketed series and place it on top of the tone-mapped file in Photoshop. Here, I took the shot that was 1-stop underexposed and, with the Move tool **(V)**, clicked-and-dragged it on top of the tone-mapped image. You're going to notice that they don't necessarily align with one another, so Shift-click on the Background layer to select both layers. With both layers selected, click on the Auto-Align Layers icon in the Options Bar. In the resulting dialog, leave the Projection set to Auto and click OK.

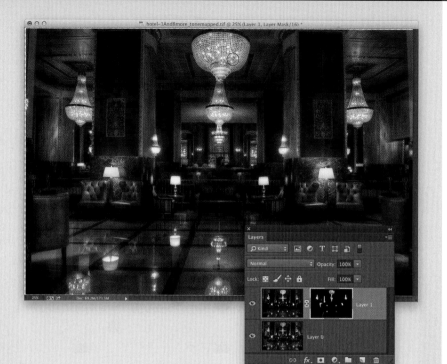

STEP TWO:

Once the two layers are aligned, click on the top layer so that only it is active, and then hide that layer with a black layer mask. Get the Brush tool **(B)** and, with a soft-edged, white brush with a low Flow setting, only paint back in the sections of the lights that you want to make a little bit sharper. You'll also use it to paint in the lights in the center of the image that were blown out with the overexposure.

STEP THREE:

Once you finish masking some of the original highlights of the image back into the tone-mapped file, you're going to need to merge the two together into a new layer so that you can do some additional work to it. So, press **Command-Option-Shift-E (PC: Ctrl-Alt-Shift-E)** to create that merged layer.

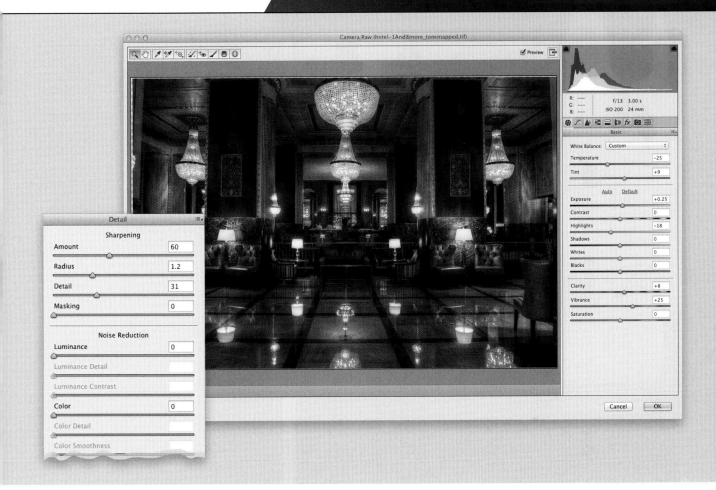

STEP FOUR:

From the Filter menu, choose **Camera Raw Filter** to bring this layer into Camera Raw. Here, you can adjust the Temperature, Tint, Exposure, and Highlights to make a more balanced picture. In this case, I wanted to cool the picture down a little bit to remove some of the yellow color cast (so I decreased the Temperature to –25 and increased the Tint a little to +9). I increased the Exposure a bit (to +0.25), and then I decreased the amount of Highlights (to –18), so that I could see more detail in the chandelier. I also wanted to add a little bit of Vibrance to bring some of the under-represented colors back into the image (I increased it to +25). I ended up increasing the Clarity just a bit (to +8) while I was here, too. The Detail panel of Camera Raw is also a great place for you to add a little bit of fine detail to the image. Remember, if you're shooting in RAW, you don't have sharpening applied to an image by default. You need to add that in post. So, click on the Detail icon (the third icon from the left) beneath the histogram and increase your Sharpening Amount to 60, Radius to 1.2, and Detail to 31. This is going to be a great addition to the file.

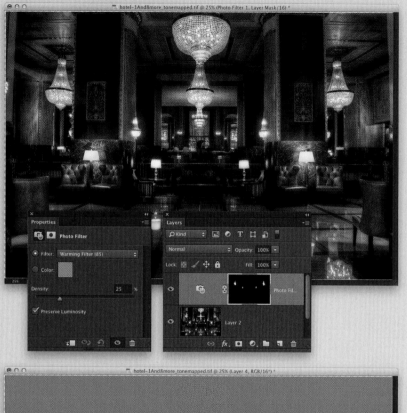

STEP FIVE:

Now, it looks like we took a little too much color off the chandeliers to the left and to the right, so let's add a Photo Filter adjustment layer to warm them up (choose **Warming Filter [85]**). Immediately after adding the adjustment layer, press **Command-I (PC: Ctrl-I)** to Invert the layer mask, hiding the adjustment. Then, using a soft-edged, white brush with a low Flow setting, paint the correction back in to the left and right chandeliers, as well as into the lights on the inner columns. You can always control how warm this photo filter is against these lights by adjusting the Density slider in the Properties panel.

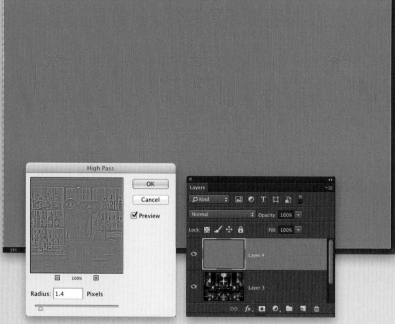

STEP SIX:

Let's work on giving this image a little extra detail. Press Command-Option-Shift-E (PC: Ctrl-Alt-Shift-E) twice to make two copies of a merged layer. With the top layer active, go under the Filter menu, under Other, and choose **High Pass**. This will make the entire layer gray and bring up a dialog that allows you to specify how much of an edge you want to see in the image. Move the Radius slider all the way to the left, then slowly drag it to the right to a point where you start seeing a little bit of edge in the picture. Click OK.

STEP SEVEN:

Set the blend mode of this gray layer to **Soft Light** and you'll instantly get more texture along the edges of the picture. Hide this layer with a black layer mask, then paint with the same brush as before only in the areas where you want the added texture.

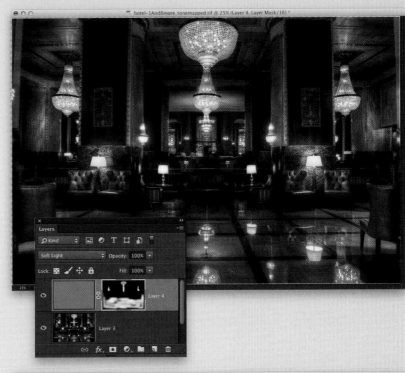

STEP EIGHT:

Next, let's add a Curves adjustment layer to darken the entire image. In the Properties panel, click on the center of the curve to add a point, and then drag downward. You'll see that the entire image gets darker.

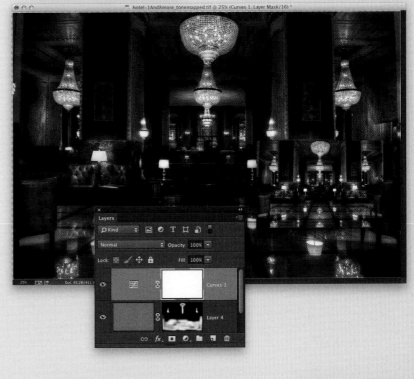

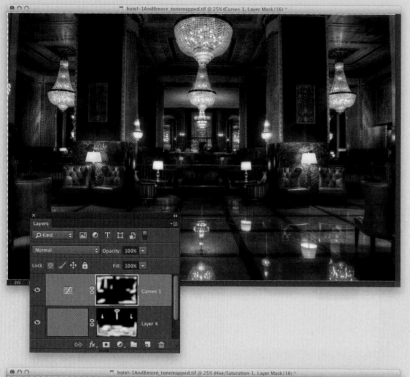

STEP NINE:
Invert the Curves adjustment layer's layer mask and then paint with the same brush as before to add a little bit more dimension to the picture—darkening specific areas, rather than creating a vignette.

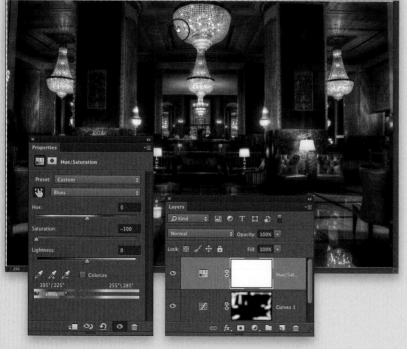

STEP 10:
There are a couple of spots in the image where a hint of blue is appearing, which I want to remove. So, let's add a Hue/Saturation adjustment layer to get rid of it. In the Properties panel, click on the Targeted Adjustment tool near the top left (its icon is the little hand). Now, click-and-drag to the left on a blue area, removing that blue from the picture. It will remove the color blue from the image as a whole.

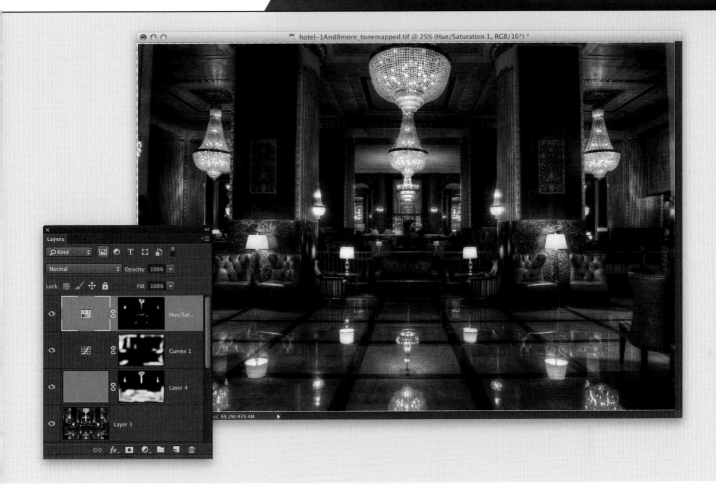

STEP 11:

Invert the Hue/Saturation adjustment layer's layer mask and, again, use a soft-edged, white brush with a low Flow setting to make sure that you're only removing the blue color in the areas that you need it removed. I would go and make a quick pass at the lights to make sure that there is no blue inside of them, as well. Finally, all we need to do here is choose **Flatten Image** from the Layers panel's flyout menu, then get the Crop tool **(C)** and crop away the little bit of extraneous information on the edges of the picture, and we're good to go.

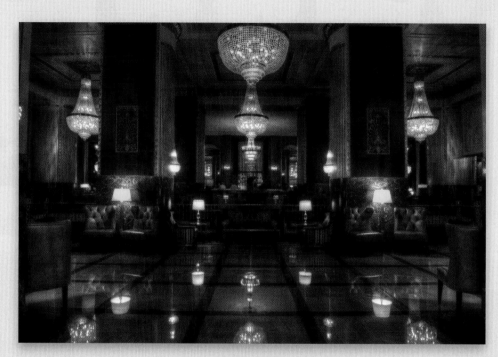

BEFORE

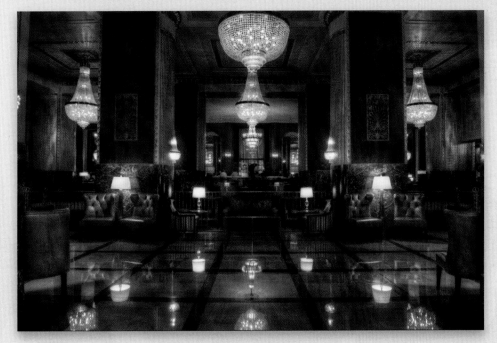

AFTER

EIGHT

Project: Utah House

I was out in Salt Lake City not too long ago, chasing a panoramic image that I wanted to make of the city. While I was doing this, I drove around the side of a mountain with my friend, Tiffany Powel, and we stumbled onto a beautiful apartment that was being rented in the area.

Pretending to be a husband and wife couple, we walked in and told them that we were interested in taking a look at the apartment. Truth be told, I wasn't really all that interested in looking at the apartment and it probably made Tiffany very uncomfortable to be my fake wife in this scenario, but I wanted to get a shot of an interior model home to be able to use for this book.

HDR photography is increasingly used in the real estate scene to be able to show a home at its best. Because of that, a lot of people believe that a naturalistic approach in using HDR is very appropriate, and I happen to agree. One of the things that I like about HDR is that it has such a wide gamut of intentions: you can create everything from a naturalistic look to an "Elvis on velvet" look.

The key point with all of this is that there is a time and place for everything. For a picture like this, we try to go as natural as possible. Photomatix 5 does have an option under Exposure Fusion that is built a little bit more for real estate. It doesn't have as many sliders as the settings that we've been using and produces some *okay* results. That said, I've never been a big fan of "okay" results.

I think that if we stay away from adding detail and an excessive amount of color in an HDR, you'll usually get something that people will agree is a bit naturalistic.

TONE MAPPING THE IMAGE

When someone says, "I don't want an HDR look to my image. I want it to be natural" they're not really talking about HDR, per se. What they're talking about is texture and detail. Texture, detail, and, in some instances, color are really the three hallmarks of what people see as this kind of surrealistic HDR. So, I wanted to try to keep something as natural as possible, and I thought this would be a good example for us to play with.

Now, to keep our HDR as natural as possible, move the Lighting Adjustments over to the right to 6.2. Once that's done, you'll see that the image looks a little bit more natural, but the sky could use a little darkening. So, drop the White Point a little bit to 0.059, increase the

Color Saturation slightly to 65, and add a tiny bit of Detail Contrast (I set it to 1.9). Increasing the Black Point to 0.003 in the image lets you get rid of some of the noise problems that you have in the ceiling. The interior is a little dark, so brighten the image by dragging the Gamma slider to the right a little to 0.94.

Also, increase the Shadow Smoothness to 58, so that we can smooth out the shadow portion of the image and get rid of a little bit more noise in this area. There's a conflict of white balance in the image—outside is nice and warm; inside, the shade is casting a cool color across the image—so increase the Temperature just a slight bit to 1.7.

POST-PROCESSING IN PHOTOSHOP

STEP ONE:
The first problems that we're going to want to solve with this image are noise and color. To do that, press **Command-J (PC: Ctrl-J)** to make a duplicate copy of this layer. Then, from the Filter menu, choose **Camera Raw Filter**.

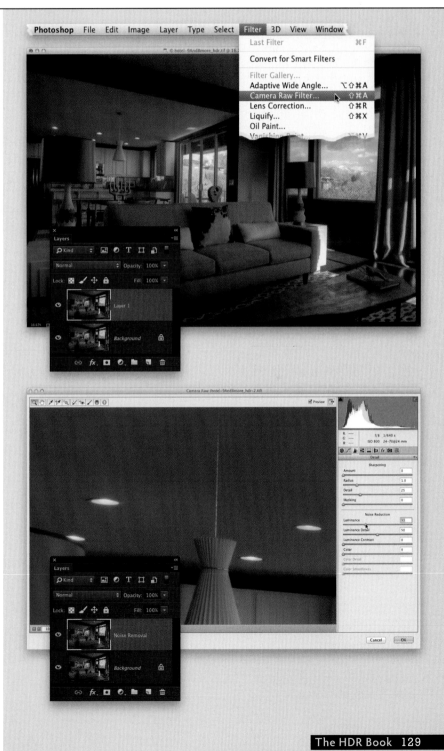

STEP TWO:
The Luminance Noise Reduction in Camera Raw is one of the best noise reduction algorithms out there. So, click on the Detail icon (the third icon from the left) near the top right, beneath the histogram. Zoom in to 100%, then under Noise Reduction, drag the Luminance slider over to the right, and you'll see that the noise in the ceiling is now removed. While you might be tempted to add sharpening at this point, it's probably better to separate noise reduction and sharpening on two separate layers and attack it that way. Once the noise removal is complete, click OK, then double-click on the layer name and rename it Noise Removal.

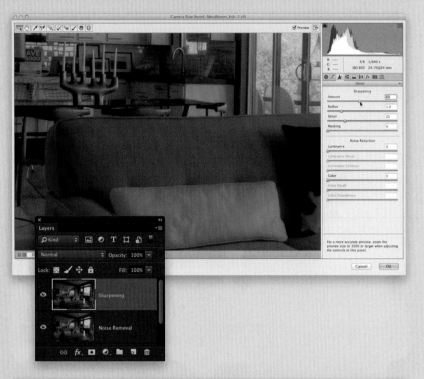

STEP THREE:
Make a duplicate of the Noise Removal layer, and change the layer's name to Sharpening. Run Camera Raw as a filter again, this time to add sharpening. Click on the Detail icon and, in the Sharpening section, drag the Amount slider to the right. When you're done, click OK.

STEP FOUR:
Create a layer mask on both the Sharpening and the Noise Removal layers and then invert the masks to hide the layers (we learned about this on page 63). Then, use a soft-edged, white brush with a low Flow setting to paint back in sharpening in the areas you need it, and noise reduction in the areas where you need it.

STEP FIVE:

The pillows seem to have a bit of a blue color cast to them still, so create a Hue/Saturation adjustment layer. Now, in the Properties panel, click on the Targeted Adjustment tool, and then click-and-drag to the left on one of the pillows, removing the blue color cast in them.

STEP SIX:

Invert the Hue/Saturation adjustment layer's layer mask and, again, paint only in the areas that need that blue color removed.

STEP SEVEN:

The image could use a little bit of brightness on the inside of the room to match the brightness on the outside. So, create a Brightness/Contrast adjustment layer. In the Properties panel, increase the Brightness to about 75 and the Contrast to about 20. Then, invert the mask and only paint in the areas inside of the apartment. If I had painted along the windows or left the mask completely open, the sky and the mountains in the background would be blown out.

STEP EIGHT:

The area outside the windows is a little bright, even though we didn't include them in the Brightness/Contrast adjustment. So, merge the document up (see page 65). Now we'll bring in one of the darker original images (I used the –2 shot; just use the Move tool [V] to drag-and-drop it onto your image). Once it's in your document, Command-click (PC: Ctrl-click) on the merged layer to select them both, then click on the Auto-Align Layers icon in the Options Bar to make sure the images line up. In the Auto-Align Layers dialog, leave the Projection set to Auto, and just click OK.

STEP NINE:

All we want to see of this darker photo is the part outside the windows, so add a black layer mask to hide it. Then, using the same brush we've been using, paint over the windows.

STEP 10:

There are a couple of bright spots along the edges of the image that are a little distracting (like below the coffee table in the bottom right). So, add a Curves adjustment layer, then in the Properties panel, click in the center of the curve, and drag down and to the right a little. Invert the layer mask, and use that same low-flow brush to paint over those areas.

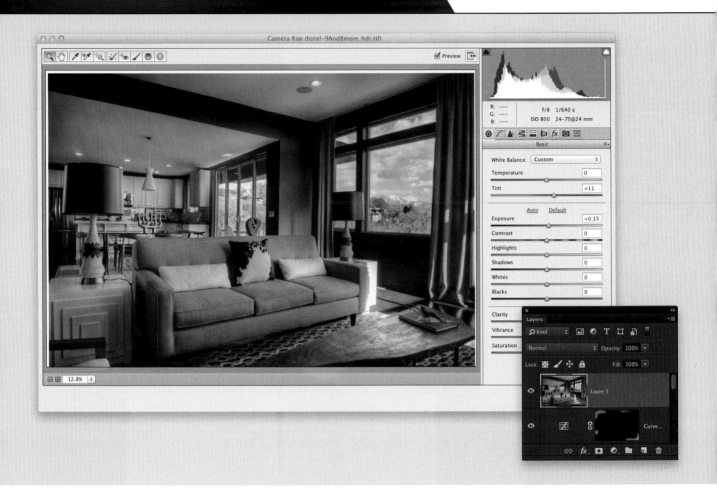

STEP 11:

Let's perform one last merge up for this image. Then, go under the Filter menu and choose **Camera Raw Filter** to apply Camera Raw as a filter, again. In the Basic panel, increase the Tint on the image to +11. You'll notice that it'll remove a little bit of the green color cast that the image has and bring it more into a natural tone.

Let's also take this opportunity to increase the Exposure just a tad to +0.15, the Clarity to +32, and the Sharpening Amount (in the Detail panel) to +33. Then, if needed, make any other final edits, like those detailed on the next page.

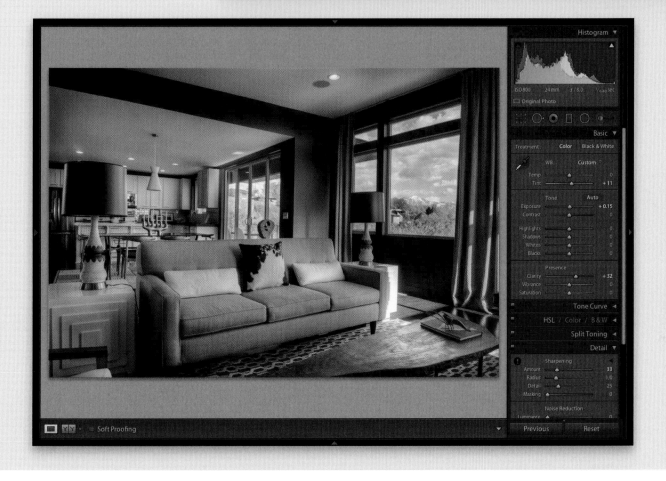

If you're a Lightroom user, I wouldn't merge the document up for this last step. I would just close the file, return to Lightroom, and add these finishing touches inside the Develop module. Truth be told, there isn't a single HDR file that I do that has post-processing in Photoshop that doesn't get a tweak here or there inside the Develop module in Lightroom. It's just one of those finishing touches that,

depending on the image, I think everything needs: a slight Exposure push, a slight Highlights recovery, a slight Shadows tweak, a little bit of Clarity, some Sharpening at the very, very end—you could tweak it for hours—and then cropping off any white space left after aligning the images. For this image, I just made the four adjustments previously mentioned and then cropped the image.

BEFORE

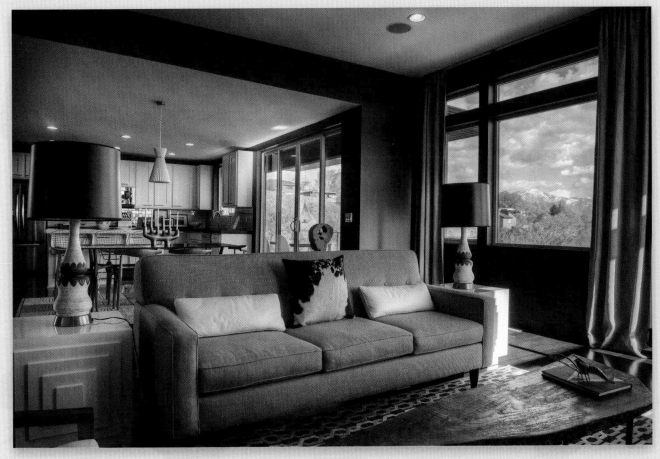

AFTER

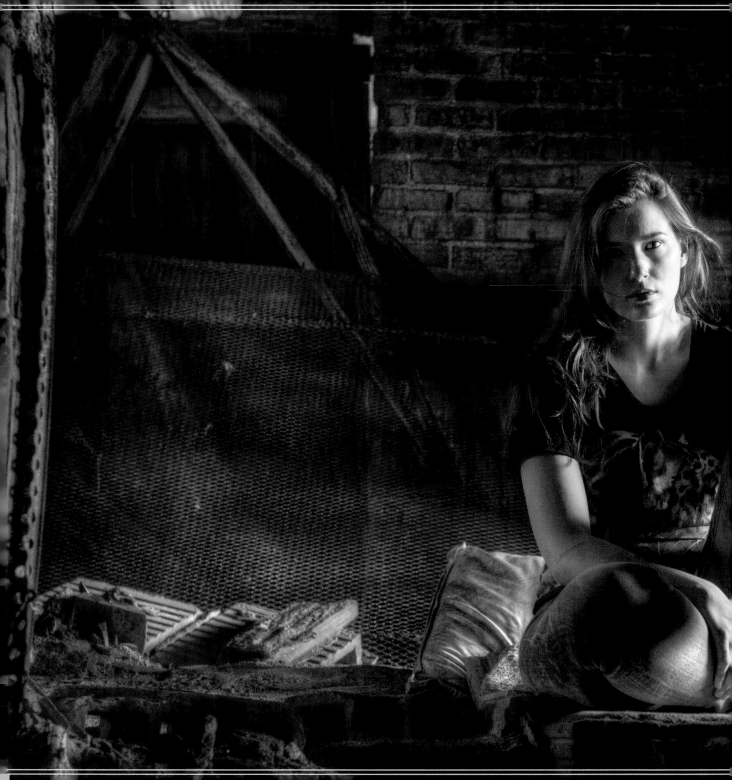

NINE

Project: Kena Part 2

One of the things that I am really getting into with HDR is the exploration of HDR portraits. Generally, when someone talks about making high dynamic range pictures, they always talk about a litany of things that you should and shouldn't do. Do shoot at a low ISO. Don't shoot into the sky. Do shoot with a tripod. When it comes to portraits, you generally get one response: "Do not make HDRs of people. They look bad."

A lot of the time, the problem is that HDR creates a very textured file. Those textures really wreak havoc on the face of a person. Unless you are a biker (mostly), this is not a good thing. That said, it made me think that there are so many other benefits to HDR that it would be a shame to let something like a problem with skin tones get in the way of making some art. That's largely the reason I asked my friend Kena to pose for the cover of the first edition of this book. I thought that this served two purposes: First, it showed that you *can* work in HDR with portraits. Second, it asked that you consider taking something that you've learned, and implement it in interesting and curious ways.

For the writing of this second edition, and an HDR class I was doing for KelbyOne, I asked Kena to come along and help. Aside from being a kick-butt photographer in Chicago, she can easily double as a model. So, I figured it would be a good idea to revisit her portrait, in part to show how to apply the technique in a new environment, but also as a tribute to a friend who's always willing to help. For that, I thank her.

TONE MAPPING THE IMAGE

I knew that when I started working on this file, there was no way that I was going to be able to bring the skin tones and the beautiful parts of Kena out in an HDR image. But, I knew I could try to use a lot of HDR technique for the area around her, and then overlay another bracket on top of this image.

So, let's go ahead and just work on the outside areas of the image. First, I'm going to increase the Strength to 100, and then I'm going to take my Detail Contrast to 10. I'm then going to decrease the Micro-smoothing to 0, and that's going to allow all of the texture in the image to pop out.

From there, we'll increase the Color Saturation three-quarters of the way, to 73, and we'll bring

our Lighting Adjustments up very slightly to the right to 0.9. Next, let's decrease the Gamma by dragging it over to the left to 1.17, and then increase the White Point a little bit to 0.237.

You'll notice that the face seems to be really blown out in this space. So, let's increase the Tone Compression to 6.4, which will bring back some of the detail on the face and counteract any changes in tone compression from changing the white point. This will give us good texture around her pants and shirt, and on her hair. I know that her arms and her face are suffering, but we're going to take care of that a little bit later in post.

POST-PROCESSING IN PHOTOSHOP

STEP ONE:
Right off the bat, you'll notice that the image is going to need some work in the skin tones. So, if you're a Lightroom user, go into Lightroom and select one of the underexposed images in the bracketed series (here I selected the shot that's 2-stops underexposed).

STEP TWO:
Bring that image over to the Develop module and make some tonal corrections to the face, so that it looks a little bit more realistic. Here, I dropped the Highlights to −38, increased the Shadows to +100, and then I increased the Exposure a little bit to +0.90, so that I can see a little more of the face. Now, I'm not looking for something completely realistic here—again, it is HDR and it's going to get blended in—so I do like the fact that this is a little contrasty. I also ended up decreasing the Whites a bit to −20.

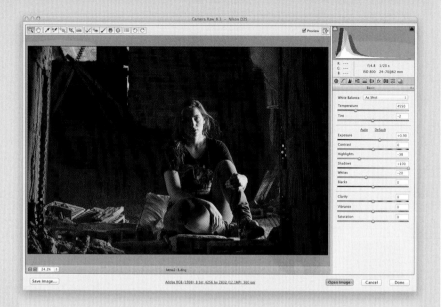

STEP THREE:

If you're a Camera Raw user, you can do the exact same thing there. Just be sure to open up one of the underexposed images directly inside of Camera Raw, and then click the Done button when you're finished. This is the only time that I recommend that you do not use Camera Raw as a filter. The reason you don't want to use it as a filter is that the image will handle a lot better when it is a RAW image. When you are manipulating the image with Camera Raw as a filter, it has already been committed to a JPG image, and you might get a little bit more noise than you need. By manipulating the RAW image directly inside of Camera Raw, you will minimize that risk.

STEP FOUR:

Now, we'll open our tone-mapped image and the underexposed shot we just made adjustments to in Photoshop as layers. I'm a Lightroom user, so from within Lightroom, I'll select both of the images that I want to work with, then Right-click on one of them, and under Edit In, choose **Open as Layers in Photoshop**.

STEP FIVE:

If you are a Bridge user, you can open both of the files right from inside of Bridge as layers. Just select the two files, then go under the Tools menu, under Photoshop, and choose **Load Files into Photoshop Layers**.

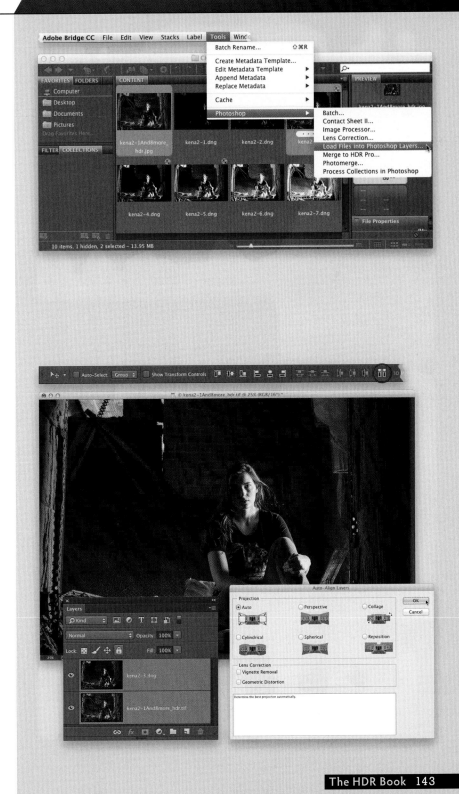

STEP SIX:

Once we're in Photoshop, we'll first need to align these two layers. So, with the Move tool **(V)** selected, Shift-click on the bottom layer in the Layers panel to select both layers. Once they're selected, click on the Auto-Align Layers icon in the Options Bar. In the Auto-Align Layers dialog, leave the Projection set to Auto, and click OK.

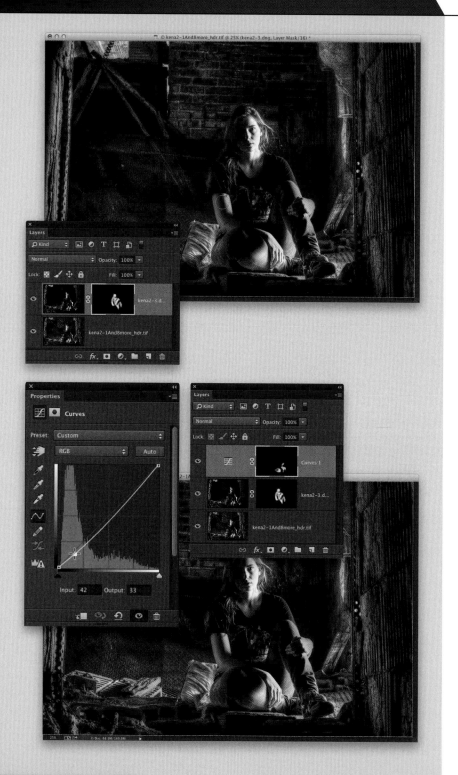

STEP SEVEN:
Once the two layers are aligned, add a black layer mask to the top layer to hide the underexposed layer. Then, get the Brush tool **(B)** and paint back in the face, neck, arms, and a little bit of the jeans and shirt area using a soft-edged, white brush with a low flow setting.

STEP EIGHT:
Next, let's darken up and lighten portions of Kena. First, create a Curves adjustment layer specifically to darken the jeans. Hide this adjustment layer with a black layer mask, and then paint back in the portions of the jeans that we want darker using the same brush.

STEP NINE:

Create another Curves adjustment layer that brightens a portion of the face. Hide this adjustment layer with a black layer mask, and then, again with the same brush, paint back in the portions of the face that we want brighter.

STEP 10:

Let's create another Curves adjustment layer to darken everything in the scene around Kena. Just follow the same steps we've been doing with these adjustment layers: darken the scene, then hide the adjustment layer with a black layer mask, and then paint back in the background area we want darker using a soft-edged, low-flow, white brush. (*Note:* I renamed all of the Curves adjustment layers, so that it was easy to quickly see which one was which.)

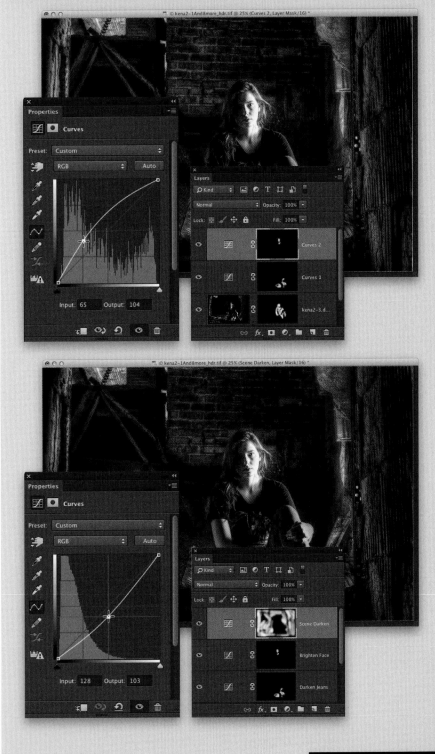

STEP 11:
One of the ways that I like to get great detail inside of an image is by using a plug-in. One of my favorite plug-ins for adding detail to an image is Nik Sharpener Pro. So, what I'm going to do is press **Command-Option-Shift-E (PC: Ctrl-Alt-Shift-E)** to create a merged layer of all of the work we've done so far, and then go under the Filter menu, under Nik Collection, and choose **Sharpener Pro: (1) RAW Presharpener** (you can download a free, 15-day trial of the entire Google Nik Collection). I'm a big fan of using the RAW Presharpener option because the sliders are a lot easier.

STEP 12:
The two sliders that I'll use in Sharpener Pro are Adaptive Sharpening and Sharpen Areas/Sharpen Edges. These are things that you would use to taste. Here, I'm going to set the Adaptive Sharpening to about 60%, and then I'm going to set the other slider around the halfway point between Sharpen Areas and Sharpen Edges.

STEP 13:

Now, just because you're sharpening an image, doesn't necessarily mean that everything needs to get sharpened. There are some cases where you don't want any kind of sharpening at all. Like here, for example, on her face, neck, and arms. So, what we'll do is add a white layer mask that reveals everything and then use a low-flow, black brush to hide the sharpening in those areas.

STEP 14:

While we're using plug-ins, I want to add a special touch to this image. For me, one of the things that I like to do with my HDR files is to give them a kind of soft, ethereal look. Now, it's no surprise—I'll tell anybody who asks—that I use a plug-in for this look. The plug-in I use is called Color Efex Pro (also part of the Google Nik Collection). First, though, we'll need to once again merge up the layers that we've been working with so far. Then, go under the Filter menu, under Nik Collection, and choose **Color Efex Pro**.

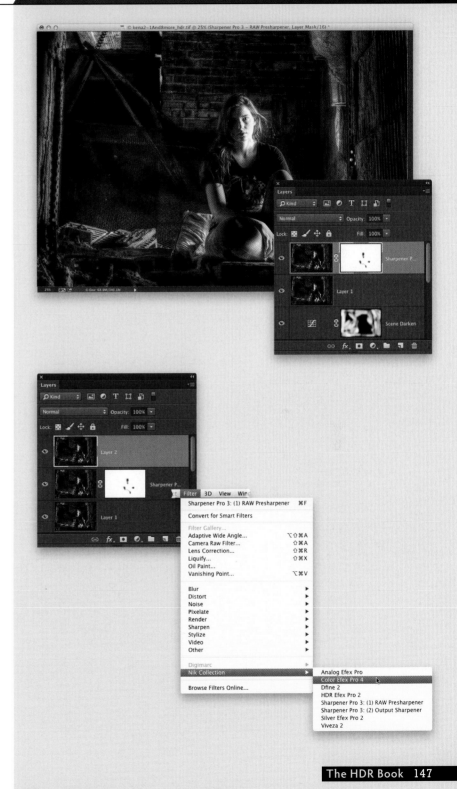

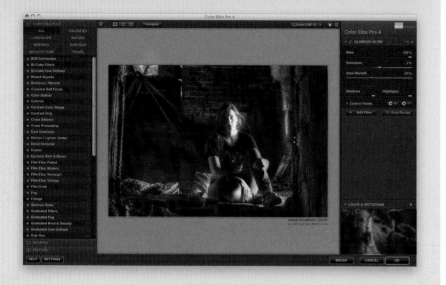

STEP 15:

Here's the secret to that ethereal look for an HDR shot: Select the Glamour Glow preset on the left side of the window. Then, on the right side, set the Glow to 100%, and increase the Saturation to taste, working with the Glow (here, I set it to 2%). But, the key here is to take the Shadows and the Highlights sliders and move them all the way over to the right. This will give you something that has a good amount of detail, with a touch of softness. Finally, decrease the Glow Warmth just a bit to –25%.

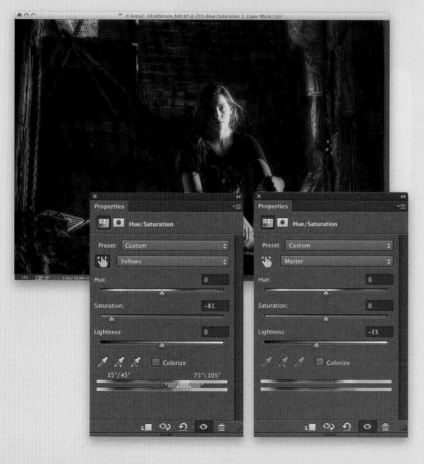

STEP 16:

The one last piece that I want to do for color correction here is to remove a little bit of the tinge of yellow that we see in her shirt. So, create a Hue/Saturation adjustment layer and, using the Targeted Adjustment tool, click right on her shirt and drag to the left. The yellows will automatically become selected in the Properties panel and will start to desaturate as we move over to the left. Once the desaturation is complete, switch the Yellows pop-up menu back to **Master**, and then drop the Lightness slider down to –15, so that not only does it pull the yellow from the image, it makes the overall area darker.

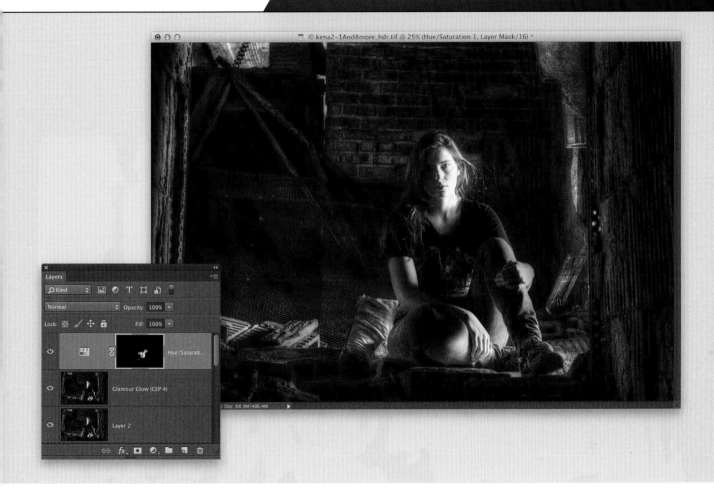

STEP 17:

Finally, hide this adjustment with a black layer mask and then paint it back in, just in the shirt area, with a soft-edged, white, low-flow brush. When you're done, go ahead and crop the edges with the Crop tool **(C)**, if needed, to finish things up.

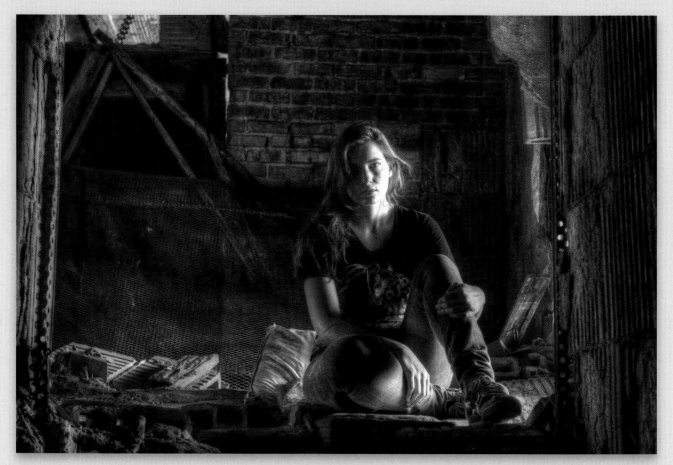

BEFORE

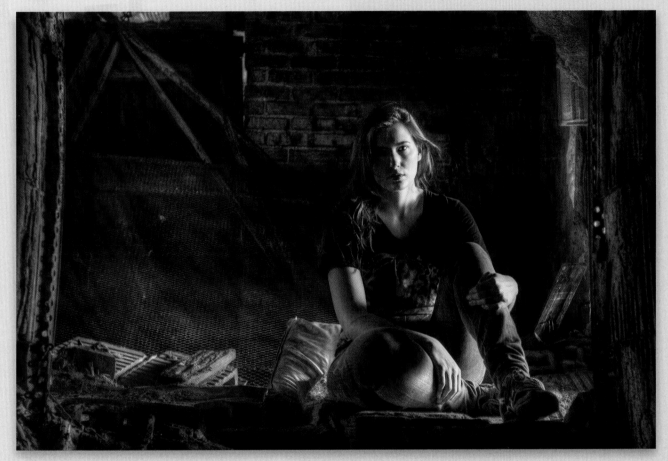

AFTER

HDR Spotlight: Jacques Gudé

Q: Tell me a little bit about yourself and what got you into HDR photography.

I've been interested in photography since I was a kid, although it was not until I was exposed to HDR photography, probably around 2006 or so, that my passion for photography was rekindled. Seeking to learn all I could about shooting and processing HDR, I devoured everything I could on the subject, including books, magazine articles, and online resources. I was quite intrigued by what I saw folks like Trey Ratcliff doing with HDR and picked up tips from his work, as well as from other HDR artists posting on the Internet, incorporating tidbits of what I had learned into my own continuously evolving HDR photography.

Q: How does HDR help you achieve your photographic vision?

My interest in and use of HDR photography soared to new heights when I discovered a genre of photography called Urban Exploration (UrbEx), which is basically the exploration (and often photography) of abandoned buildings. To me, HDR and UrbEx seemed a match made in heaven. How else could

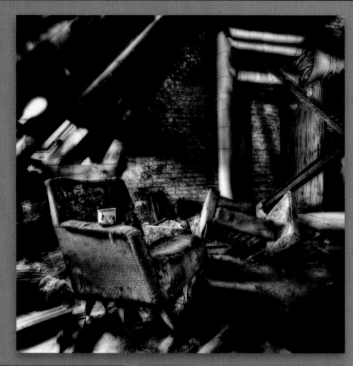

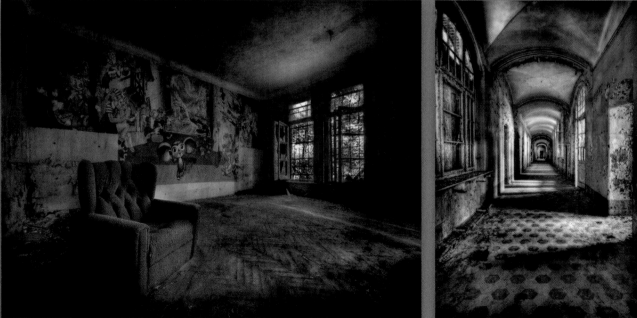

Images Courtesy of Jacques Gudé

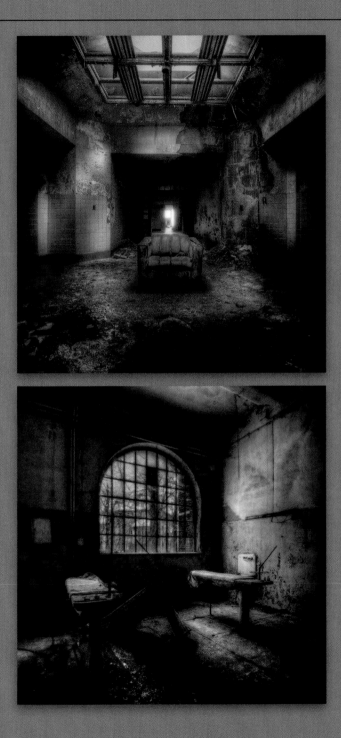

I capture the vast range of light and shadow I encountered, and then share that decaying beauty with people who might never otherwise have the opportunity to see it? With HDR, I had the latitude to tweak, in post-processing, every bit of beauty I saw out of the bracketed RAW files I shot to bring that hidden beauty to the computer screen or to print. I would certainly not be able to produce the work I do without HDR.

Q: Is there a specific style you find yourself interested in more than another?

While I will photograph architecture, landscapes, and even people, I gravitate toward UrbEx type photography more often than not. I think what I love about that style is the mood I can convey in my images with a well-composed and well-processed photograph of a single chair surrounded by an encroaching darkness, a set of mysterious stairs leading to who knows where, or a long hallway leading off to oblivion.

Q: What kinds of experimentation do you find yourself doing now with the HDR?

As far as my post-processing goes, I would define my approach as one of fine art rather than documentary. Proven tone-mapping software (in my case Photomatix), Photoshop, and a Wacom tablet are absolutely critical to my work. I do experiment a bit with software from onOne and Nik, but stick to maybe only a handful of filters between the two for my work.

Q: Where can we find out more about you?

You can find me at www.jacquesgude.com, as well as on Google+, Instagram, and 500px.

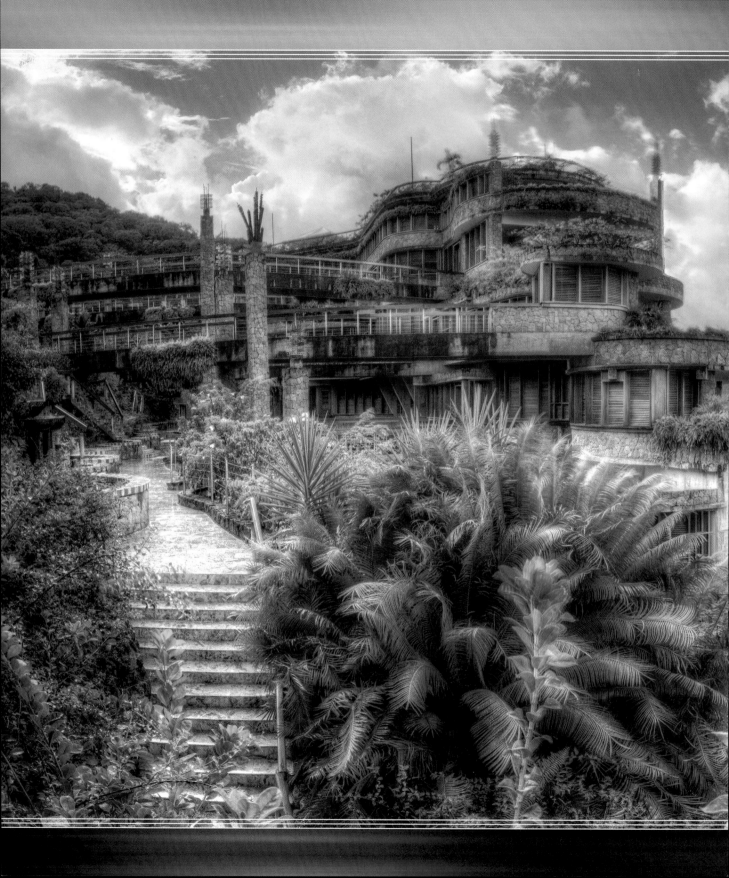

TEN
Project: Jade Mountain

One of the most beautiful places I have ever visited has got to be Jade Mountain in the Anse Chastanet resort on St. Lucia. For the last couple of years, I have gone out there as a guest instructor for Joe McNally at his Photo Workshop. While the workshop was originally dedicated to the use of advanced flash, it's now a wild mix of things to learn.

I was supposed to augment the team here by bringing in classes in post-processing, video, web, and HDR. Having the conversation with Joe, he simply told me "RC…you're not going to want to leave," and boy was he right.

While there are countless pictures of this place on the Internet (it has won a ton of awards, as it was all built by hand), I felt like I wanted to make something that really showed the vastness and lushness of the environment. You have this idea that it was built "into" the mountain and not on top of it, and I was looking for a shot that highlighted all of the details of the place. I was also looking for a place that highlighted the famous Pitons (two volcanic spires) in the scene (the guest rooms have only three walls—the fourth opens to see the Pitons!).

Setting my camera on a tin roof, I twisted the orientation to Portrait mode and made a panorama that was four frames wide. A wider lens could have covered the width of the area, but I wanted to show the staircase going down to the next level.

I also wanted this to be a piece that I printed *huge*—part as a gift to the resort and part as a memento for me (this image will easily be one of my 5-foot-wide prints for my dining room). It was an experience I really don't want to ever forget.

PANO TIPS

SHOOT PANORAMAS IN PORTRAIT

When you shoot a pano, you frame the image as a landscape image and pan to the right. Many times, after it's completed, you have too much missing information at the top and bottom of the image that you inevitably cut out. To counteract this, switch the orientation of the camera to vertical.

By placing the camera in portrait orientation, you are able to get more details of the scene in the picture, making it easier to crop it later in Photoshop.

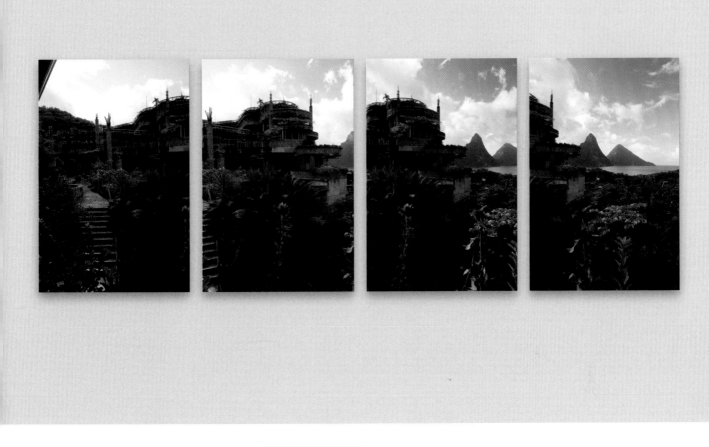

SHIFT YOUR FEET

Having a tripod when shooting a pano really takes away a lot of the pain when stitching the images together. A tripod's center column can rotate your camera while keeping its legs in place. Problem is, when we try to pretend to be a tripod, we leave our legs in place on the ground and rotate from our hips to make the image. We don't have the same range of motion as a tripod, so we end up seeing an arc as we go from left to right that causes merging problems.

Instead of standing with your legs apart, put them together and pretend to be the center column of a tripod. Shoot your first picture and turn your feet (keeping your waist straight), and that will better replicate what your tripod would be doing. The shots will be a lot better, but I'd still shoot from a tripod if possible!

HDR FIRST, MERGE LATER

When working with panos, you should always process first. There will be times when you're taking really wide brackets of images (on really sunny days, and trying to avoid halos), where your underexposed images will be very low (think −4 EV), and you will not see much detail in the image. If you can't see that much detail, you can expect Photoshop to have a bit of a time trying to merge the image.

CONSISTENCY: WHITE BALANCE & HDR PRESETS

You can sync your white balance in Photoshop or Lightroom pretty easily, but you can't really guess whether the HDR software will tone map your images consistently for the set of panos you are working on. To counteract that, process a test file of one of the sets in the pano, preferably one in the middle portion of it. Once you have the HDR toning exactly as you want it, save this as a preset. Now you can go back to the other sets of images and work through the series, using that preset as the basis for all of the processing. This will give you a more consistent look in the image.

AUTO AND GEOMETRIC DISTORTION ROCK

When you're ready to work with the image in Photoshop, you'll be using Photomerge. There are very few instances where Photomerge's Auto setting hasn't worked for me, so save yourself some time and leave it set to Auto. The Geometric Distortion Correction and Blend Images Together settings also work really well.

Now I'll walk you through how to process the Jade Mountain image, then we'll go indoors where you can use the same techniques for "Detroit Church," a panoramic image I made in an abandoned church.

HDR PANO PROCESSING

One cool thing about Photomatix is its ability to generate multiple HDR files for your pano processing. It has a "set it and forget it" type of functionality, where you tell it where your folder is and what preset you want, and it will take care of the rest.

STEP ONE:

In order to batch process the HDR images, you're going to need to create a preset that you'll base the images on. So, click on the Load Bracketed Photos button in the Workflow Shortcuts panel and then select a series of images from around the middle of the pano. This will let you work with tone mapping on the more visible portions of the image.

STEP TWO:

Take a quick scan around the image to make sure you're getting as much as you can for the file. In this case, I noticed that by moving my Strength to 87 and increasing the Detail Contrast to 7.4, the image immediately was darker than I needed it. So, to counteract this, I moved my Lighting Adjustments to 7.2—the "naturalistic" area on the right side of the slider—and increased the Tone Compression to 9.0 to brighten the image. From there, I experimented with increasing the White Point and Gamma to bring back the details in the cloud areas. To finish the image off, I added a ton of Smooth Highlights, in the event that I did not want to remix in some clouds, splashed some Color Saturation on the image, and increased the Saturation Shadows a bit (to 1.5).

STEP THREE:

Once you have the image looking the way you want it, create a preset. Click on the Preset pop-up menu at the bottom of the Adjustments panel, choose **Save Preset**, give your preset a name, click Save, and this preset will be saved in the Preset pop-up menu. Be sure to read the info in the Saving Current Settings as Preset dialog, as it lets you know what happens or what you'll need to do based upon where you save your preset. Now, close the file without actually processing it, because we just needed to create that preset here. *Note:* I've provided this preset on the book's companion website (you can find the address in the book's introduction). You can download it, choose **Load Preset** from the Preset pop-up menu to load it, and then apply it. If you don't create your own preset, be sure to load mine, because you will need one in a bit.

STEP FOUR:

Now, back in the Workflow Shortcuts panel, click on the Batch Bracketed Photos button to begin processing your pano. The Batch Processing of Bracketed Photos dialog has a lot of options, but it's pretty straightforward.

STEP FIVE:

In the HDR Settings section, choose the preset that you just saved from the Preset pop-up menu. If you are looking for alignment, ghost removal, and noise reduction, they are all located here. It's important for you to know how many images you bracketed for because you will need to select this number from the Process pop-up menu near the bottom of the section. In this case, I shot a bracketed series of nine exposures each, so I'll choose **9** from the menu.

STEP SIX:

Now, in the Source section, you'll select the source folder for the images that you will be working with. So, click on the Select Source Folder button to navigate to the set of images that you will be adding to the list.

STEP SEVEN:

In the Destination section at the bottom right of the dialog, you can specify where you would like the files to be saved. I tend to leave these in the same folder as my source images, so I can keep everything organized. The last thing to do here is to click on the Naming & Output Options button, make sure to add "HDR" to the end of the filename (as seen here on the right)—this makes it easier to find—and then click OK.

STEP EIGHT:

Now that all of the options we want have been selected, click on the Run button at the top right, and then go get yourself a good cup of coffee. Depending on how well-equipped your computer is, this process can take a bit. On my Macbook Pro, I processed these 30 files in about 5 minutes—give or take. (Hey, this could be a good time to watch the videos on the book's companion website, or check out the newest *Photography Tips and Tricks* episode on Kelby TV [http://kelbytv.com/photography-phytnt/]. Don't say I didn't try to keep you busy!) As Photomatix processes your images, you will see the section in the top right of the dialog update, letting you know what's going on.

STEP NINE:

Once the files have been processed, you will see a blue link letting you know that it's done. Click on that link and it will take you to the folder with the TIF images you created.

POST-PROCESSING IN PHOTOSHOP

STEP ONE:
Before we merge the panoramic files together, it's important to fix some of the clouds in the images to make them a little less crunchy. So, open the first tone-mapped image, and then open one of the original exposures. Here, I've opened the –2 2/3 EV shot in the series. Now, using the Move tool **(V)**, click-and-drag the original image on top of the tone-mapped image. To ensure the layers are aligned, Shift-click on the Background layer to select both layers, then go under the Edit menu and choose **Auto-Align Layers**. Leave the Projection set to Auto and click OK.

STEP TWO:
Once they're aligned, hide the original bracket image (the top layer) behind a black layer mask. Then, using a soft-edged, white brush with a low Flow setting, paint the sky back in from the original image. When you're done, flatten the image, crop as needed, and then save the file.

Now, do the same thing for the other three tone-mapped images (masking in the sky from the –2 2/3 shots from each series). When this is complete, you will have four new tone-mapped files, each with one of the original images mixed back in for the sky.

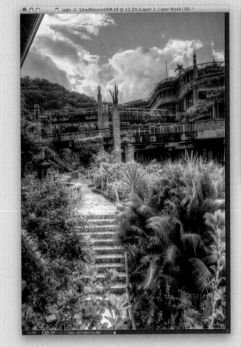

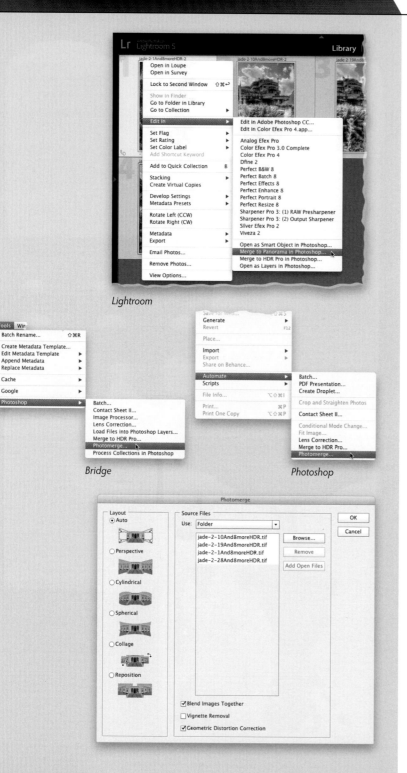

Lightroom

Bridge

Photoshop

STEP THREE:

Once you've processed all of your images, you're going to merge those into one panoramic file. Photoshop's Photomerge does a phenomenal job of merging the images, and you'll be surprised at how well the Auto setting does. You can access Photomerge a variety of different ways: Lightroom users can just select the series of images to be merged together, then Right-click on one and, under Edit In, choose **Merge to Panorama in Photoshop**. If you're a Bridge user, you can access Photomerge by selecting the files you want to work with, and then, from under the Tools menu, under Photoshop, choosing **Photomerge**. If you just want to select the files in Photoshop, go under the File menu, under Automate, and choose **Photomerge**.

STEP FOUR:

If you've already selected the images, the files will appear here in the Photomerge dialog. If you still need to select the files, click on the Use pop-up menu, select **Files** or **Folder**, and then click the Browse button to select the files or folder. The options in the Layout section, on the left, let you specify how you want Photomerge to treat the images when making the pano. There are very few times that I find using anything other than Auto is better, so I usually leave it set there. What's more important here is that you turn on the Blend Images Together and Geometric Distortion Correction checkboxes. These help a lot.

STEP FIVE:

Click OK and, after a couple of minutes, you'll see the result of the Photomerge. Photoshop brings in each of the images as its own layer, transforms and skews each one, then creates layer masks over the areas that overlap, creating the pano. It's very easy and pretty accurate. From here, choose **Flatten Image** from the Layers panel's flyout menu and then we can move on to cropping.

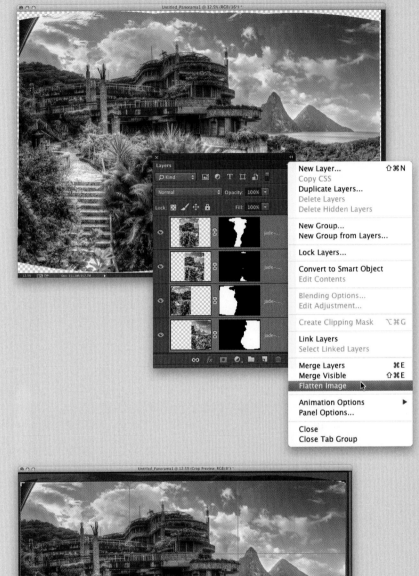

STEP SIX:

Grab the Crop tool **(C)** and drag out a cropping border on your image. When cropping an image, try to keep as much of the image as possible. Here, I was able to crop without losing too much. There's only a small portion in the top right that needs to be rebuilt using Content-Aware Fill. Don't worry about whether the panorama conforms to a specific ratio just yet. Here, we're just looking for maximum image. We can always trim it further later.

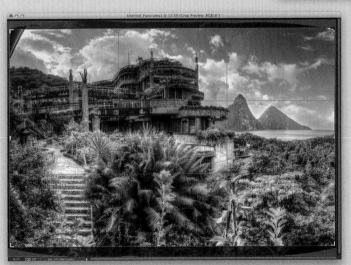

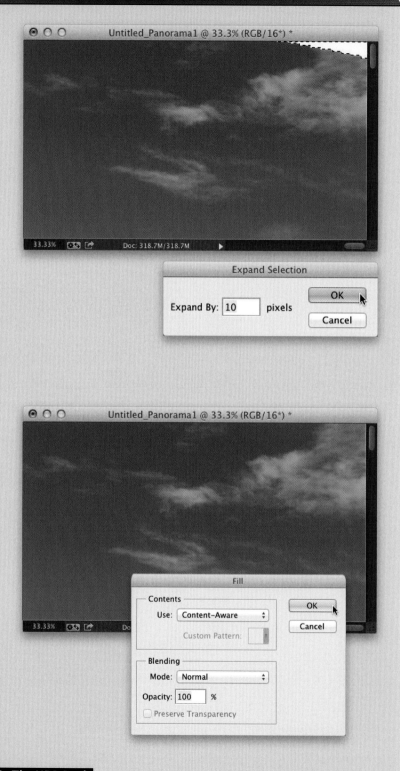

STEP SEVEN:
To fix the corner, we can fill it in with Content-Aware Fill. So, click in the corner with the Magic Wand tool (press **Shift-W** until you have it) to select that area. Then, go under the Select menu, under Modify, and choose **Expand**. Enter a small pixel expansion—around 10 pixels—and click OK. This will create a fill that looks a bit more real.

STEP EIGHT:
Press **Shift-Delete (PC: Shift-Backspace)** to bring up the Fill dialog. From the Use pop-up menu, choose **Content-Aware**, click OK, and the area will fill in. Press **Command-D (PC: Ctrl-D)** to Deselect. *Note:* Content-Aware Fill randomly fills in a selection. If you notice that the fill doesn't really look that good, just press **Command-Z (PC: Ctrl-Z)** to Undo and fill the area again. Now, go ahead and do the other corners, as needed.

STEP NINE:

Once the corner of the image is fixed, zoom into the image and just quickly pan through it using the Zoom **(Z)** and Hand **(H)** tools, checking for inconsistencies. Sometimes the image can look great when you're looking at it from afar. Up close can be an entirely different story. The tonality and detail in this picture is what really makes it sing!

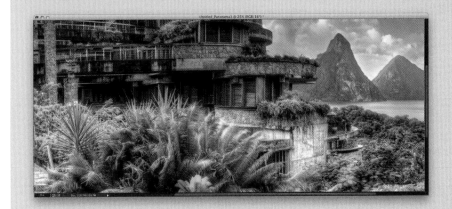

STEP 10:

On the left side of this image, there's a little bit of the overhang from where I was shooting. We're going to need to remove that. So, switch over to the Lasso tool **(L)** and draw a selection around the overhang (to ensure that you get to the very edge of the document, you can continue to draw past the image onto the canvas). With that selected, bring up Content-Aware Fill again to remove this.

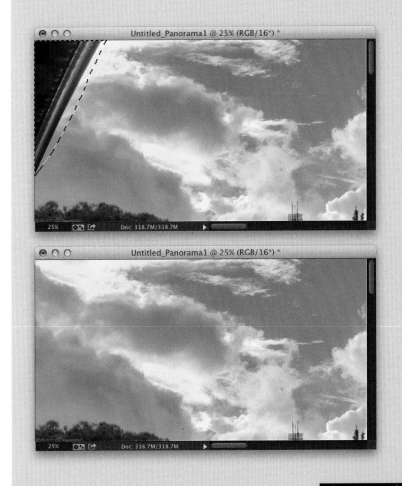

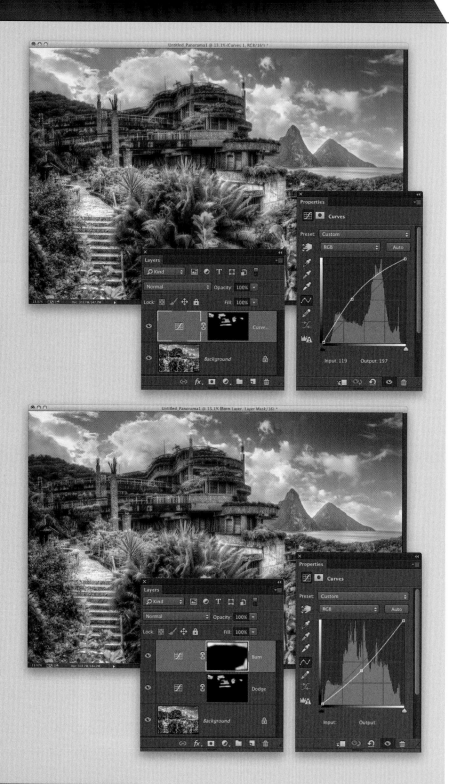

STEP 11:

Some of the clouds in the image, as well as the center of the hotel structure, could be a little bit brighter. So, create a Curves adjustment layer, click in the center of the curve, and drag upward to brighten the image. Hide the adjustment layer by inverting the layer mask, and then paint only over the areas you want to brighten with a soft-edged, white brush with a low Flow setting.

STEP 12:

Now, the image could also use a little darkening around the edges. So, create another Curves adjustment layer to darken the image and drag the center of the curve downward. Hide the adjustment layer by inverting the layer mask, and then paint only over the areas you want to darken with the same brush we just used.

STEP 13:

You'll notice that the foliage in the image looks a little too electric. This will be compounded in an effect we are doing later, so we're going to want to mitigate that now. Create a Hue/Saturation adjustment layer and, with the Targeted Adjustment tool (TAT), click on a green area of foliage. Whenever you have foliage that looks weird in HDR, it's almost always an abundance of yellow, never green. When you drag to the left, you'll see in the Properties panel that it starts desaturating the yellows. Once you're finished, invert the layer mask and paint the change only in the areas of foliage that you need it.

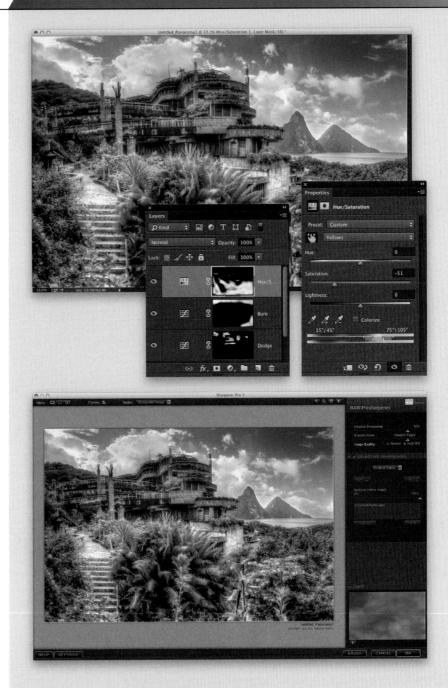

STEP 14:

Now, create a merge up layer of all of the adjustments that you have made to the image so far. At this point, I would add some sharpening to the file. You can use the Sharpening feature in Camera Raw or Lightroom, as we have in the past, or a third-party plug-in. Here, we'll use Sharpener Pro (it's part of the Google Nik Collection—you can download a free 15-day trial). Go under the Filter menu, under Nik Collection, and choose **Sharpener Pro: (1) RAW Presharpener.** Increase the Adaptive Sharpening to 82%, drag the Sharpen Areas/Sharpen Edges slider to the right, and then click OK.

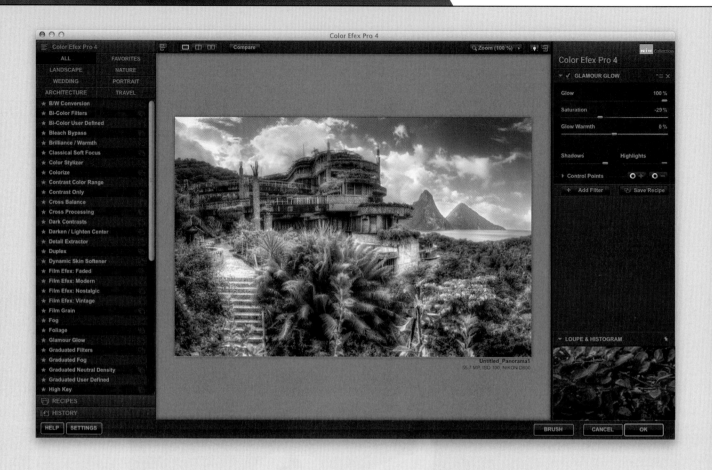

STEP 15 (OPTIONAL):

Finally, to add a little softness to the image, let's use the Glamour Glow filter in Color Efex Pro (also part of the Google Nik Collection). Go under the Filter menu, under Nik Collection, and choose **Color Efex Pro**. Click on Glamour Glow on the left, then on the right, increase the Glow to 100% and drag the Shadows and Highlights sliders all the way to the right. If the effect starts looking a little too overdone, you can always bring down the Glow amount or drop the Opacity of that individual layer.

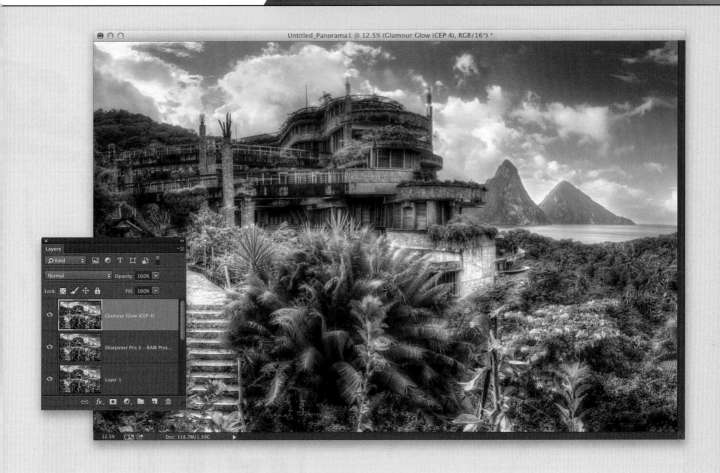

Once the image is completed, I might apply a Camera Raw filter for a little bit of temperature and tint finalization, but for the most part, it's looking pretty done here. So, flatten the file and save away!

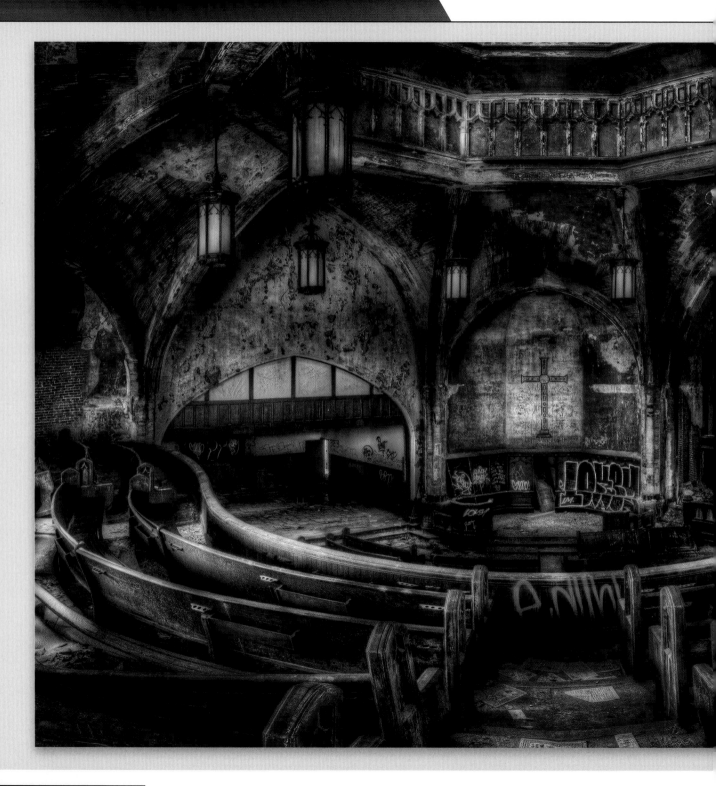

It's Your Turn:
Detroit Church

Now it's your turn to take the HDR pano technique out for a spin. On the book's companion website, I've provided you with source files for "Detroit Church," an HDR pano I made at an abandoned church in Detroit. Spend some time creating a preset that will best define how this image will look and generate a pano from it. There's one trick, though, that I'm adding to this one: the pano does not go from left to right. You'll be using the same techniques, but your tone-mapped images will stack vertically on top of one another! Enjoy!

⊠ Download this preset at: www.kelbyone.com/books/hdr2.

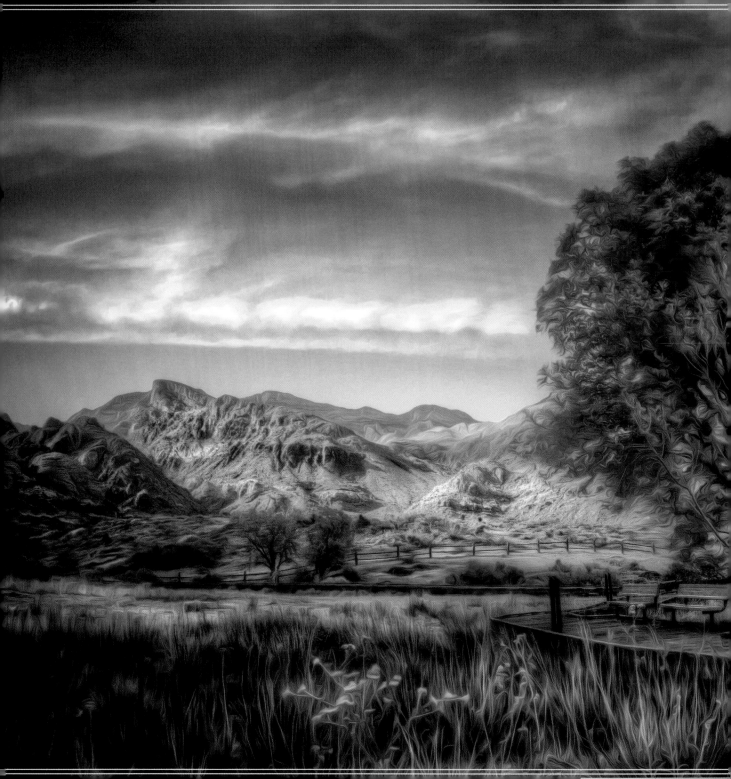

ELEVEN

Project: Oil Paint in Vegas

When working with HDR images, I often rid myself of any thought that the image needs to look a specific way. Shooting for this medium, I abandon any sense of "correctness" of what I am processing and largely rely on what "feels" right to do with the image. Shooting a commercial job, a wedding, a corporate client, I am thinking technical, correct, precise. In HDR, I see it as the equivalent of dumping a big bucket of crayons on a sheet of paper—I just want to explore and play.

The boundaries of play extend well past the tone mapping of the image and run into Photoshop. A couple of versions ago, Adobe introduced a filter into Photoshop called Oil Paint. The filter detected the edges in the image and attempted to blur them to create something that looked hand painted. While many dismissed the filter as a bit of a parlor trick, I found it to be very useful in creating a specific look.

If I tend to see most of the work that I'm shooting in this space as artistic, then why not tip a hat over to the painterly side of things? Why not combine this filter with a little bit of traditional painting by using Photoshop's Mixer Brush? Add one splash of the original layer back into the scene and you can have a creation that blurs the line of realism and fantasy even further.

While the technique works great for landscapes, it's something that I've employed on metallic images, decrepit interiors, night shots, and even portraits. The technique is exactly the same as it's explained here, but produces such varied results. Oh what a joy to play!

TONE MAPPING THE IMAGE

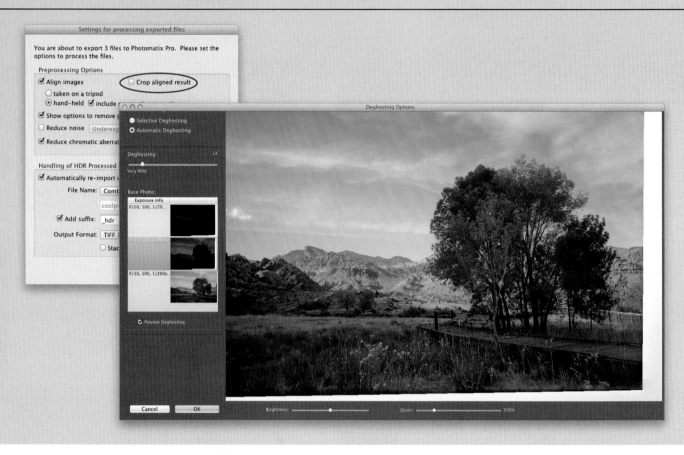

When exporting (or opening) the files for this project, be sure to turn off the Crop Aligned Result checkbox near the top of Photomatix's Settings for Processing Exported Files dialog (or the Merge to HDR Options dialog, depending on how you're opening them) because we don't want the overall size of the image to change just yet.

In the Deghosting Options dialog, choose the Automatic Deghosting option here, and click-and-drag the Deghosting slider to 14. Click OK.

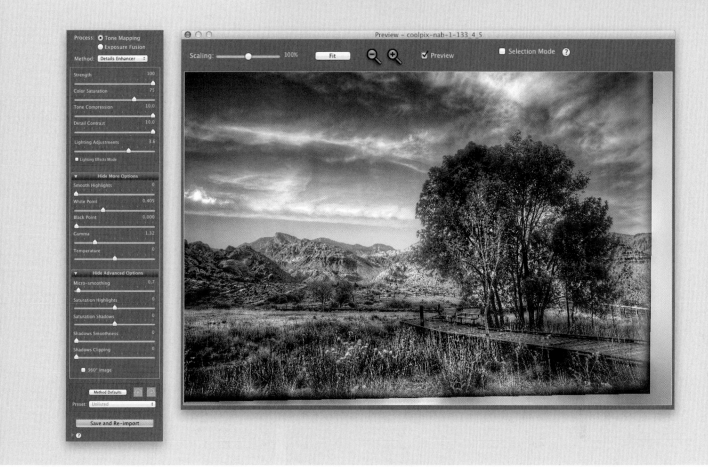

I first dragged the Strength, Tone Compression, and Detail Contrast sliders all the way to the right, as I was looking for a very tone-mapped image. Increasing the Color Saturation slider three-quarters of the way, to 75, definitely made the image feel a little overcooked, but gave me enough color to pull out later. I then dragged the Lighting Adjustments slider to the right to 3.6 to offset the surrealistic look a little bit.

From there, the overall effect is created by using Gamma, White Point, and Smooth Highlights. The Gamma controls the overall scene—dragging the slider to the left creates a darker image; moving it to the right makes a much brighter image. This feels like a more general brightness, so I tend to make it a bit darker than normal. Then, I adjusted the White Point to get the brightest portions of the image to be brighter.

When you run into a problem with halos in your image, Smooth Highlights can really help. Think the edges of a building against a sky, the leaves on a tree, clouds. A lot of those problems can be solved by moving this slider a little bit to the right to remove the "bite" out of the halo.

The last thing I did here is drop the Micro-smoothing down to 0.7 to give me a little more detail (this makes the image a little darker, so be sure to go back and adjust the White Point a little bit more to compensate).

Earlier, we didn't turn on the Crop Aligned Result checkbox because we didn't want the overall size of the picture changed. While this gives us a gray area at the bottom and right of the picture, I think it makes it a little easier to mask back in one of the original brackets should we need it a little later.

POST-PROCESSING IN PHOTOSHOP

STEP ONE:
Once the tone-mapped file has been created, open it, along with one of the original brackets in Photoshop. Here, we'll use the 1/3 EV shot from the bracketed series to replace some of the sky in the tone-mapped file—I just think it looks a little less crunchy. Using the Move tool **(V)**, drag-and-drop the original bracket image on top of the tone-mapped image. With both images now in the same file, Shift-click on the bottom layer in the Layers panel to select them both.

STEP TWO:
To align these layers, click on the Auto-Align Layers icon in the Options Bar. I tend to leave the Projection set to Auto, because I have not had an instance where this has failed me. Remember that when we created the tone-mapped image, we prevented Photomatix from cropping it. In having all of the information in the file, I think Photoshop does a better job of aligning the two images. We can always crop later.

STEP THREE:

Hide the original bracket image (the top layer) behind a black layer mask. Then, use a soft-edged, white brush with a low Flow setting, and paint back in some of the sky in the upper right and top of the image. This will bring back some of the whites in the clouds and remove some of the crunchiness we don't expect to see in them. I almost always mask original clouds back into an HDR file. Not doing so just brings too much attention to that portion of a picture.

STEP FOUR:

At this point, let's crop the image to get rid of the extra areas on the right and bottom, as well as the top and left (created by the alignment). First, press **Command-Option-Shift-E (PC: Ctrl-Alt-Shift-E)** to create a merged layer, then simply use the Crop tool **(C)** to get rid of the extra areas (I usually wait until the end of my post-processing to do this, but it's fine if you want to do it here).

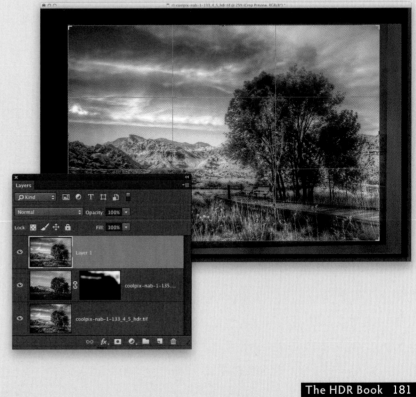

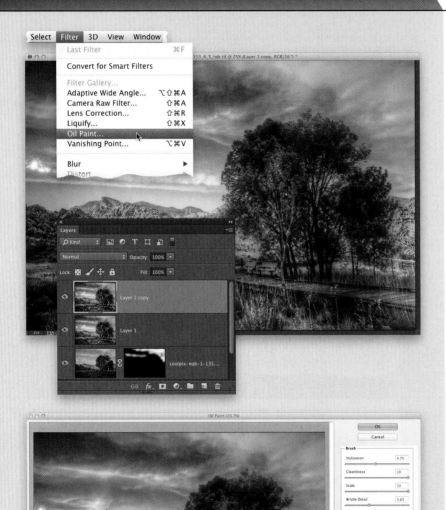

STEP FIVE:
Press **Command-J (PC: Ctrl-J)** to make a duplicate of the merged layer, because now we're going to use Oil Paint! Just go under the Filter menu and choose **Oil Paint**.

STEP SIX:
Oil Pant was one of those optional filters that was in earlier versions of Photoshop (through something called Pixel Bender). The filter worked so well that it was added into Photoshop CS6 and CC. Let's talk a little bit about what the options for your oil painting are here:

Brush
Stylization acts almost as if it were a brush type. The brush appears to get blockier as you move the slider to the right.

Cleanliness affects detail. More details are seen if you drag this slider to the left and fewer details are seen if you drag it to the right.

Scale is the size of your brush. Drag the slider to the left for a very small brush and to the right for a very large brush.

Bristle Detail affects the sharpness of the image. Dragging the slider to the left takes away bristle detail and dragging to the right adds it in.

Lighting
Angular Direction affects the shadows of the image. Think of this slider as changing the position of the sun over the image.

Shine controls how the light reflects on the picture. Dragging the slider to the left leaves it flat, and dragging to the right gives it an almost embossed effect.

For this image, I'm going to want a really flowy look. So, I'll use the following settings: Stylization: 4.75, Cleanliness: 10, Scale: 10, Bristle Detail: 3.65, Angular Direction: 0, Shine: 0.

STEP SEVEN:
Once you're done in the Oil Paint filter, click OK. Then, move this layer below the original merged layer in the layer stack. Hide the original merged layer with a black layer mask, and then start painting back in some portions of the image with a soft-edged, white, low-flow brush. I tend to want to add a little bit of realism back in the places where someone would see fine details. For example, the park bench here, the trees, and some of the mountains would be great places to add back some details. Just remember that you want to do this with a low-flow brush. You don't want to have it look like someone did a cutout of the original picture and placed it in the middle of the painting.

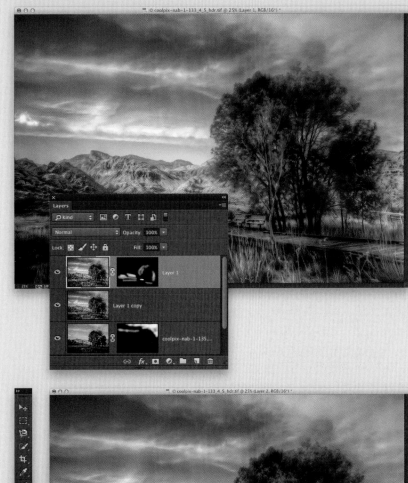

STEP EIGHT:
The Oil Paint effect really does make something great out of an HDR, but I think you can really take it to the next level by adding a little bit of your own hand to it. So, create another merged layer, then choose the Mixer Brush tool (press **Shift-B** until you have it) from the Toolbox. This tool doesn't use a Foreground or Background color to paint. Instead, it uses the colors that are in the image itself to create a blend (similar to the way paint would behave on a canvas).

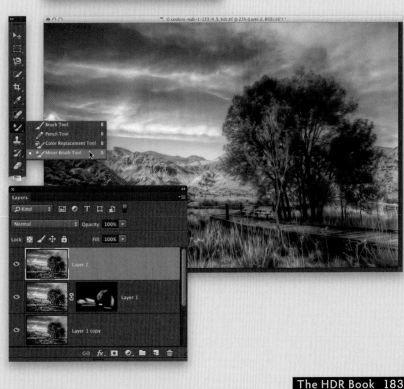

Before Mixer Brush

After Mixer Brush

STEP NINE:

In the Options Bar, choose a low Flow setting, and then click on the Clean the Brush After Each Stroke icon. Now, trace along the lines of the oil paint. You'll see that the two sections will be blended together, creating more of a smeared look. This is something you can do to taste. At any point in time, you can adjust how much of it you see by adjusting the merged layer's Opacity, or by hiding some of it with a black layer mask. Randomly going through the image and adding your own flair can really accent key portions of it, giving it less of a mechanical look (I painted a bit on the mountains in the center and to the top and right of the big tree). The images here show what the oil paint looked like on the mountains before and after using the Mixer Brush. Pay attention to the center area to see the change.

STEP 10:

Once all of the changes have been made to the image, it's time for some final touches. This is where I'll do some additional dodging (and burning, although we don't need to do that here), as well as add a little bit more detail to it. So, create a Curves adjustment layer to brighten the image. In the Properties panel, click on the center of the curve and drag up to make it brighter. Then, press **Command-I (PC: Ctrl-I)** to hide this adjustment with a black layer mask. Now, switch back to the Brush tool and paint back in some of the brightening with a soft-edged, white, low-flow brush.

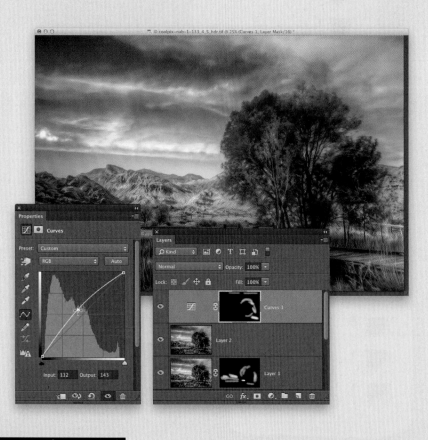

STEP 11:

If you're only working with Photoshop, you can flatten (or merge up) your image and apply a final Camera Raw filter. This time, we'll just add a little bit of sharpening to the image, as well as some vignetting to the edges (in the Lens Corrections panel).

If you're a Lightroom user, you can just save the file back into Lightroom. Once you're there, you can apply the final touches in the Develop module's Detail and Effects panels. This would also be a good time to do a final crop, if you haven't cropped already.

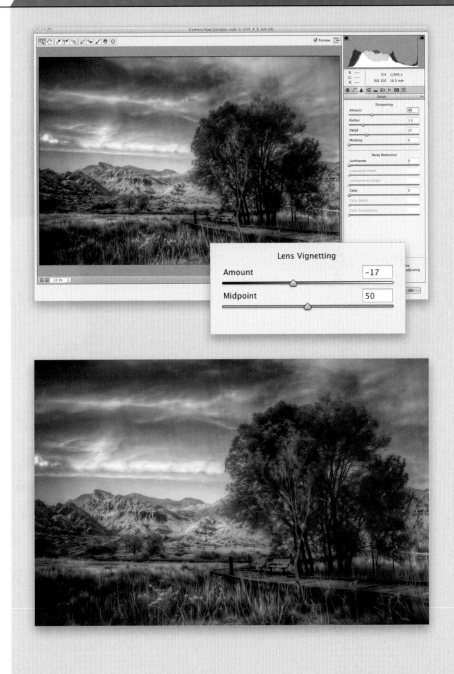

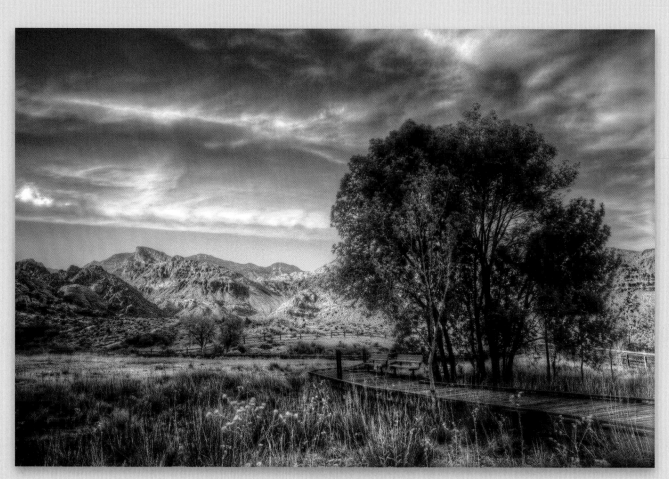

BEFORE

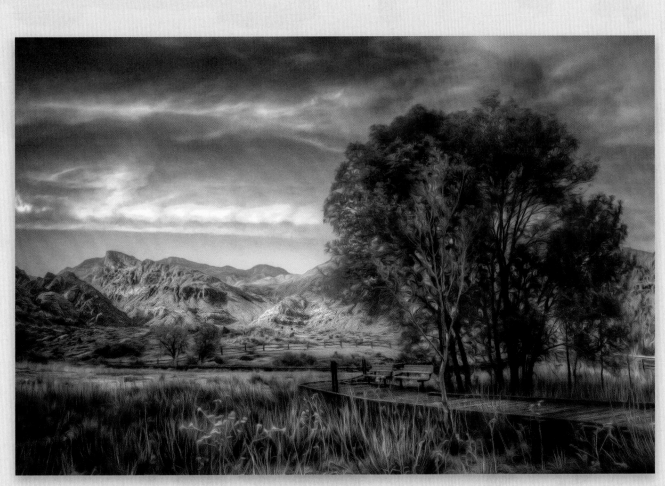

AFTER

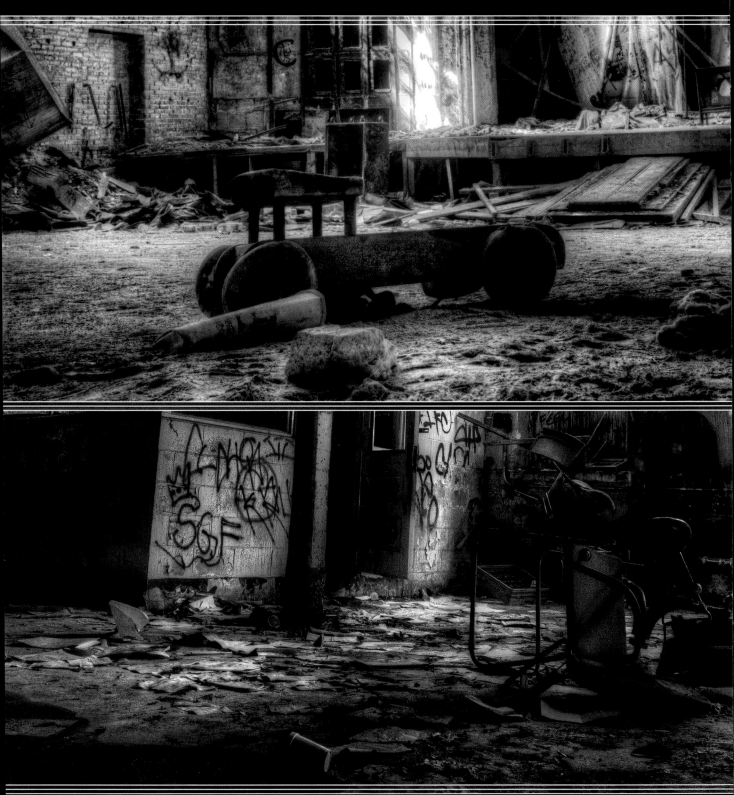

TWELVE

Alternative Approaches in HDR

This chapter is dedicated to a few techniques that I don't go to all that often, but that are definitely worth mentioning: single-image HDR, black-and-white HDR, and double tone mapping.

In making HDR files, I do my best to follow the things I've asked you to consider here in this book: I carry my tripod everywhere I go. I shoot as many bracketed images as I can for a given scene. I shoot at the lowest possible ISO that I can. There are times, however, when all of those rules are broken and all I have is a single RAW file. Does this mean that the moment is lost, and I need to get out there and try again?

Not at all. In fact, you would be surprised to see just how much data you can pull out of a single RAW file to make an HDR. It's at times like these that you start thinking about creative ways to get the most out of that single image.

These creative ways also fall hand in hand with something that I have found myself exploring a little bit more recently—the use of HDR for creating black-and-white images. If you think of the HDR software as a foundation for texture, you'll see that the crazy surrealistic colors that you can push with the sliders will actually yield you some really interesting tonalities in the black-and-white realm.

Lastly, double tone mapping is a technique that can take an HDR image to a completely different level or save one entirely. By tone mapping an image for one area, then creating a completely different tone map for another area, you can have the best of both worlds in one image. All you have to do is mask away.

USING HDR FOR BLACK & WHITE PHOTOGRAPHY

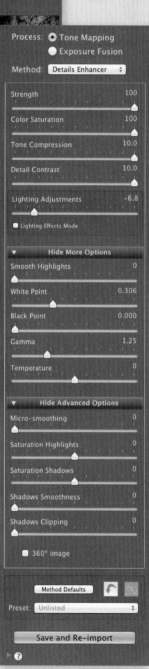

STEP ONE:

When I start looking at HDR images for black-and-white use, I tend to go a little crazy on the post-processing. I immediately bring Strength, Color Saturation, Tone Compression, and Detail Contrast to their maximum levels on the right and really ride the Lighting Adjustments slider into the "Elvis on velvet" area to the left.

The goal? To get really off-looking tones. In the extremes, I am looking for colors to shift, for different areas of tonality to pop out. I find that the software tries to make more contrast the crazier you get with it (I also adjusted the White Point, Gamma, and Micro-smoothing). The colors will go out of whack. That's okay. I'm looking for that to happen. Remember that those colors of red and blue and yellow, in their different intensities, are just going to become intensities of black and white. They are going to give you different shades of gray that you would not normally get on a single image. So, go ahead...let go a little bit.

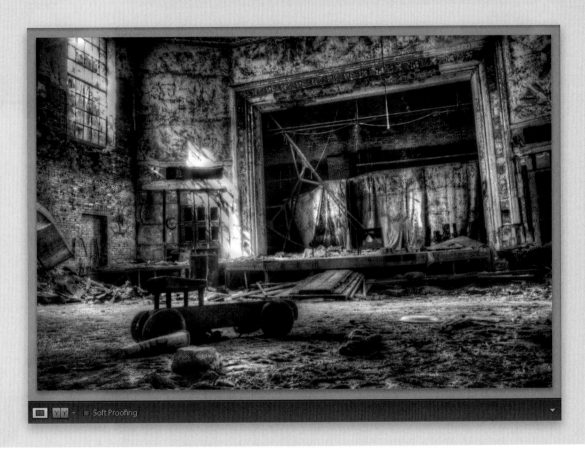

STEP TWO:

Whether you do it in Lightroom's Develop module (by clicking on Black & White at the top right of the Basic panel) or in Camera Raw (by turning on the Convert to Grayscale checkbox at the top of the HSL/Grayscale panel), you can experiment with converting the image into black and white. You'll notice that those colors and textures immediately make a more interesting black and white than you would have normally achieved using a single image. The textures are more pronounced and the gradations will look a lot more nuanced.

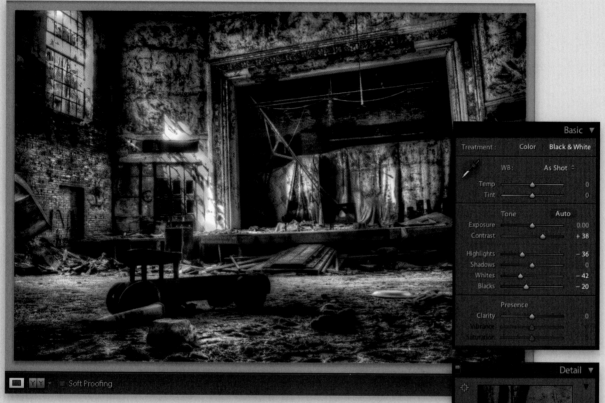

STEP THREE:

Now, does this mean that your job is finished? Not at all. While the HDR file will look great with a conversion to black and white, it's always a good idea to give it a little bit of finessing. Back in Lightroom's Develop module (or using the Camera Raw filter in Photoshop CC), make sure that you get a chance to modify things in the Basic panel, like the Contrast, Highlights, and Blacks sliders to really bring out the areas of detail you want. This is also a great time for you to add some noise reduction and sharpening to the tone-mapped file. The texture is something that will automatically call for this added detail. It gives the image an added pop. So, go ahead. Add some sharpening.

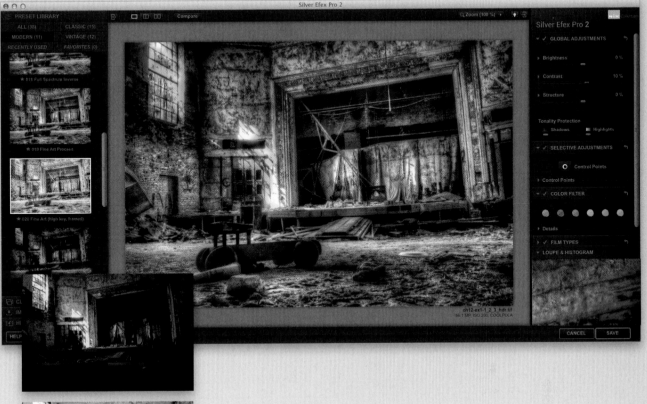

STEP FOUR:

Truth be told, as soon as I'm finished with the tone mapping of the file, I will send a copy of it into Perfect B&W from onOne Software's Perfect Photo Suite or Silver Efex Pro (seen above here) from the Google Nik Collection to see what kinds of looks they will give me (from Lightroom, go under the Photo menu, under **Edit In**, and choose a plug-in; you can download a free trial version of each). Can you do it in Photoshop alone? Of course. But if you own that software already, you may as well give it a shot and see what it looks like.

What you cannot argue with is that the sum of all of the exposures that you work with looks better merged than what you would have done with the individual frames (shown at left here). Experimentation is the key, even if it's a black and white.

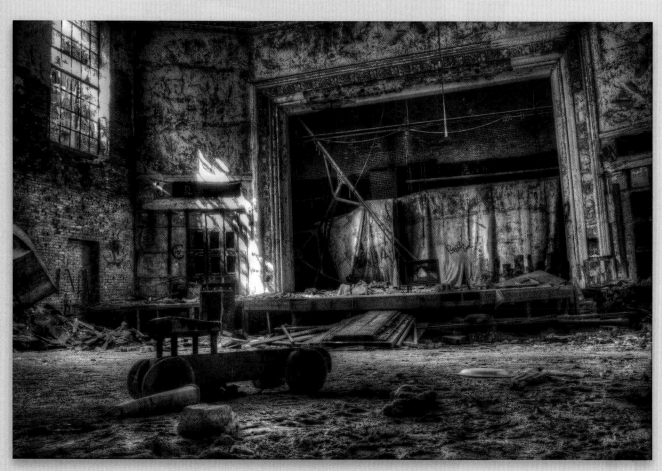

BEFORE

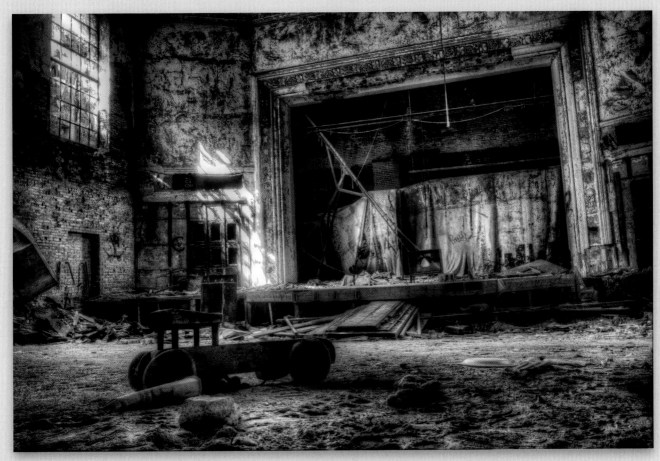

AFTER

CREATING AN HDR FROM A SINGLE FILE

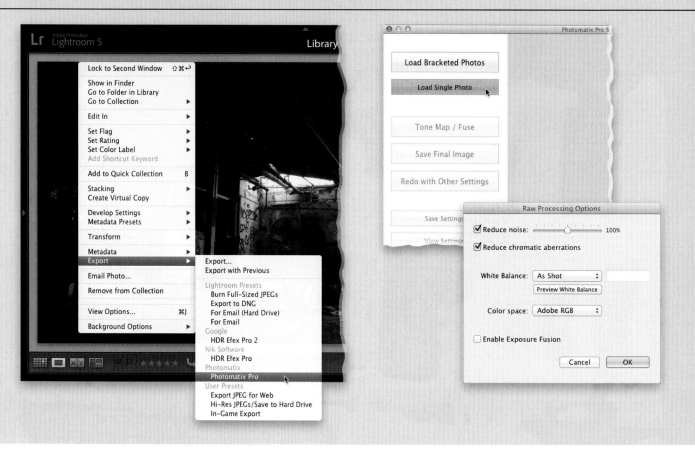

STEP ONE:

While it would be best for you to create an HDR file out of a series of bracketed images, you can also achieve a decent result by using a single image as the foundation for a tone-mapped file. You'll lose some details in the process, and the resulting file could be a little noisier than you would like it to be, but it's better than not having an image at all.

Lightroom Users:

To open the image in Photomatix Pro from Lightroom, Right-click on the file you want to use and then, under Export, choose **Photomatix Pro**.

Photoshop & Standalone Users:

If you are using Photoshop and the standalone version of Photomatix, click on the Load Single Photo button in Photomatix Pro. After selecting the file, you will be presented with the Raw Processing Options dialog, where you have an option for how to deal with noise, as well as the color output for the resulting file. I tend to leave the Reduce Noise slider alone and make sure that I am using **Adobe RGB** as the Color Space for the image.

STEP TWO:

In the Adjustments panel, you can perform a tone map much in the same way you do with a set of bracketed images. Starting with your Strength, Tone Compression, and Detail Contrast, move the sliders to the right to get the maximum amount of crunchiness. From there, move the Lighting Adjustments slider until you get the naturalistic (or surrealistic) feel you are looking for. I also tend to adjust the Gamma, White Point, and Micro-smoothing sliders to make sure that I have a good amount of detail.

In this example, the image looks a little warmer than I care it to be. But, we can solve that problem a little bit later. See that area over in the top-right corner of the image, by the windows? That area appears to be blown out. If I had more of a bracketed range of images, it would have fared a little bit better. This looks about as good as what we will get with just one file.

STEP THREE:

To try to minimize some of the blown-out area, let's bring back the original image as a layer. Before we do, we'll adjust the Highlights slider in Lightroom (or Camera Raw) to see how much data we can get back.

STEP FOUR:
With both of the images selected in Lightroom, I'll open them up as individual layers in Photoshop by Right-clicking on one of the images, going under Edit In, and choosing **Open as Layers in Photoshop**. (You can do this in Photoshop alone by going under the File menu, under Scripts, and choosing **Load Files Into Stack**.)

STEP FIVE:
If your tone-mapped image is on the top, click-and-drag it below the original image's layer in the Layers panel. Because the two images are exactly the same, there's no need to try to do any kind of alignment. At this point, all we need to do is hide the original layer behind a black mask and paint back in the blown-out areas using a soft-edged, white brush with a low Flow setting. It's not going to be perfect—there's just too much data loss in this region—but, again, it's better than nothing.

DOUBLE-TONE-MAPPING THE IMAGE

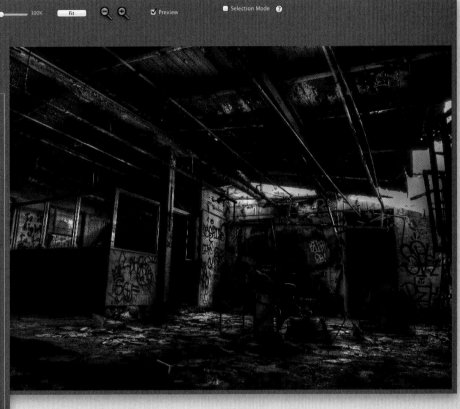

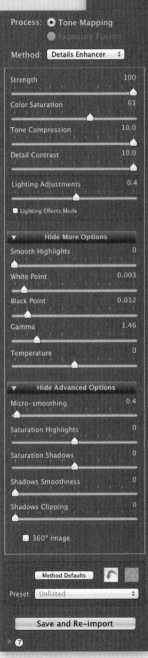

STEP ONE:

When working with single-image HDR files, you will notice that your tone mapping will tend to favor one portion of the image. Tone map for the foreground, and you'll see some muck appear in the sky. Tone map for the sky, and you'll get some weird color shifts in the foreground.

A common trick in working with HDR (both with bracketed images and in single files) is to perform two different tone maps of the same source image. Once you have

the two tone-mapped files completed, you can then put them together using layer masks. In this example, I used the same single-image source file to create a second tone-mapped image. This time, I focused on bringing down the Gamma and White Point to get a much darker and more detailed top portion of the image. The chair and foreground seem to suffer, but it's going to get masked out later in post.

STEP TWO:

Once both of the tone-mapped images are complete, open them as individual layers in Photoshop CC. Then, hide the top image using a black layer mask. In this case, I decided to hide the image that had a good chair and foreground element. Once the image is hidden by the layer mask, paint back in the areas that you would like to keep using a soft-edged, white brush with a low Flow setting.

Hiding the foreground image let me focus on a much darker version of the image. This allowed me to "step in" any changes by painting back in just the right amount of the foreground that I was looking for. Once the changes are complete, you can merge the two layers together by pressing **Command-E (PC: Control-E)** or by going under the Layer menu and choosing **Flatten Image**.

STEP THREE:

Let's go ahead and add a little bit of detail to the texture by running the image through Camera Raw. Go under the Filter menu and choose **Camera Raw Filter**. Inside Camera Raw, we'll add a little bit of sharpening (in the Detail panel) to make the texture of the image a bit more pronounced, as well as add a little bit of a vignette to the image in the Effects panel, and click OK.

Note: If you want to have a little bit more control over how this appears, you can always do this effect on a duplicate layer. Then, should your image need some finessing, you can always lower the Opacity of the layer.

STEP FOUR:

To minimize the sharpness of the image, I will add Color Efex Pro's Glamour Glow filter. To create that ethereal look for the file, I run the Glow effect almost to 100%, saturate and warm the file a little bit, and raise the Shadows and Highlights sliders to the right.

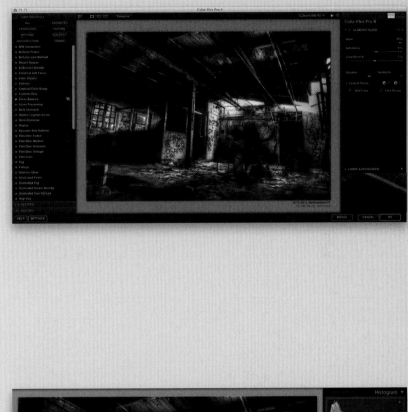

STEP FIVE:

The last change that I would make here would be to reduce the temperature of the file. You can do this with an additional pass through the Camera Raw filter in Photoshop CC, or by decreasing the Temp in Lightroom.

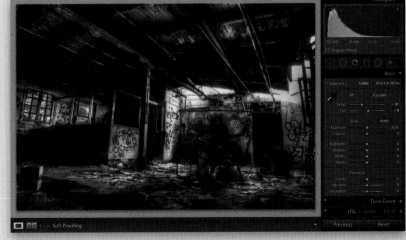

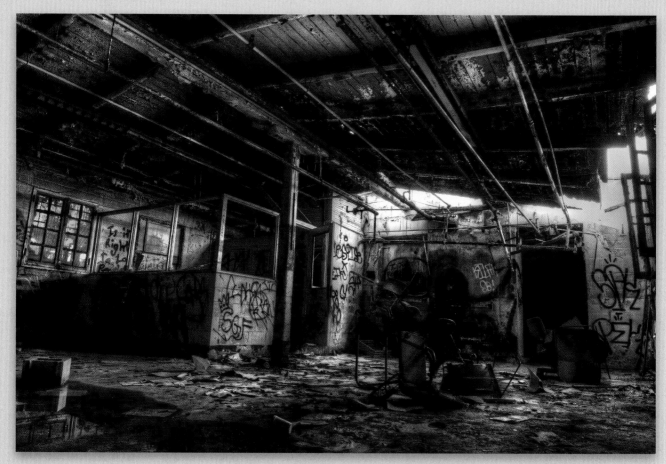

BEFORE

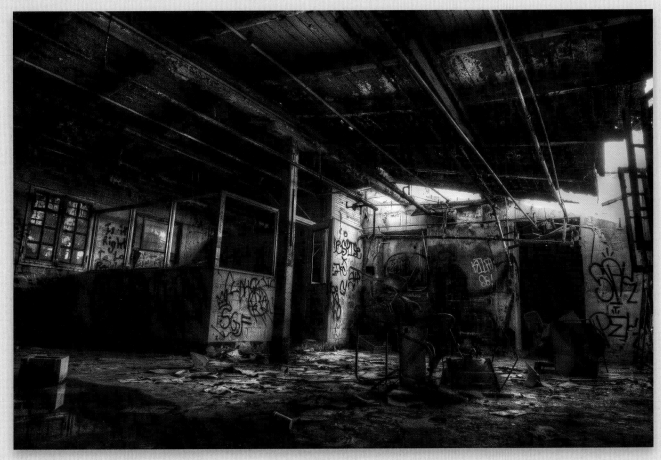

AFTER

HDR Spotlight: Tracy Lee

Q. Tell me a little about yourself.

I'm a fight photographer living in Las Vegas, NV, for the last 11 years. I travel all over the world for fight stuff and subsequently have shot a lot of cool HDRs in some remote locales. I am not limited to fight photography, although it has been my bread and butter for the last seven years—from shooting cage-side as an action sports photographer, to doing portrait work in and out of the MMA Industry, to event photography with a social media twist, to a recent foray into cinemagraphs. I always tell people I am forever a student and always learning, evolving, and refining my techniques and workflows.

I picked up a (35mm SLR) camera somewhere around 1996 and started shooting skateboarding and snowboarding. I didn't realize that this would eventually lead to me becoming a known sports photographer in the MMA industry some years later. There was a large break in my photography, as I transitioned from a broken SLR to small pocket digital cameras (I was one of the first of anyone I knew to go digital). My digital camera habit turned into me creating (for years) one of the largest nightlife websites, and eventually had me transitioning to a digital SLR (Canon 20D) at end of 2004. I got my first set of strobes (AlienBees) at the beginning of 2005, and the rest has kind of been history. Around 2007, I decided I wanted to go to the UFC fights for free, and since I had a hook up with credentials, I started shooting fights. I had no clue it would turn into a career for the last seven years of my life! To this day, I travel around the world for fight photography, although I am rarely shooting cage-side anymore.

Q. What got you into HDR photography?

If you want to know the truth, I would have to say it was Google+. I had known about HDR for a little while, but I hadn't really checked it out or learned how to do it. I felt like, when Google+ launched as invite-only at the beginning, I saw so much HDR stuff I had to learn to do it. Maybe it was just because I first started to see so much of it then. I feel like Google+ had a lot to do with the explosion that HDR photography experienced. I saw RC's work, as well as Trey Ratcliff's, Klaus Herrmann's, Ken Kaminesky's, Joel Grimes's, and more. I watched Trey's online tutorial, and did a Google Hangout with Trey and RC, and I was hooked. I found myself in Barnes & Noble poring through RC's book, as well as any info I could find online. I started shooting *everything* I could in HDR and, although I know now that I "overcooked" most of my photos back then, I'm happy that I have taken a step back from that and toned it down so much! I no longer am a far-to-the-right slider rider!

Images Courtesy of Tracy Lee

Q. How does HDR help you achieve your photographic vision?

HDR has allowed my photos to show what it is that I see with my own eyes, instead of being held back by the limitations of what the sensor can capture. My eyes are able to see into the shadows, as well as the light. I can see a beautiful photo before I take it and know that I have the ability to translate that and share it with people. I feel that the HDRs I create can help me to tell a story of something I have seen in my travels and catch the eye of people who are going out of their way to check out my images.

Q. What kinds of experimentation do you find yourself doing now with the HDR?

I was gung-ho with HDR in 2011, making sure to cook every interesting thing I came across. I have slowed this down quite a bit from being so busy and just wanting to be a lot more refined at what I put out. Nowadays, I find myself using my HDR to make a scene stand out in a way that only HDR can, without overdoing it and making it look clown-like, for lack of a better word. To do this, I spend a lot more time with my tripod than I ever did before.

Q. Is there a specific style you find yourself shooting?

I find that I tend to like to realistically process my HDRs, whereas before I overdid it. Then I darken the image a bit, and then add a layer lightening and muting the tones. This is the kick I am on as of late, although I still find that I am always evolving with my style, and I can't say that I've fully discovered my own uniqueness within HDR yet. I find that I enjoy the Joel Grimes style of composites, and that I love applying this to some of the photos that I edit. Although I tend to find photographers I like and mimic their style, as I come into my own and figure out where my style fits in the grand scheme of things, I think my next step is to learn to do stitched HDR panos, as I often see RC doing—he does them so quickly and effortlessly that I need to look over his shoulder through his process to learn and apply it to what I find myself shooting. The way I see it is the more I learn, the closer I will get to defining "my style."

Q. Where can we find out more about you?

Well, you can always check out my website at http://mstracylee.com, or my portfolio at http://tracylee.org. I'm really bad at creating an "About Me," so chances are you may not find that anywhere online—you will just find a ton of posts spanning six or seven years that are

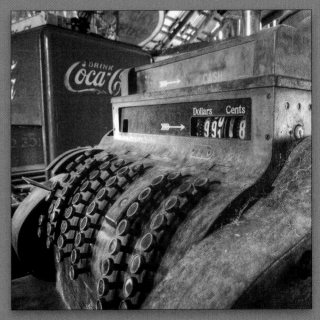

about my life as it happened. You can search my name on Google and tons of my fighter photos will come up under Images. I have a fight website, as well as a breakdance website, which can be found through links at www.mstracylee.com. I'm part of all the social media: Twitter, Facebook, Instagram, Tumblr, YouTube, Myspace, Pinterest, Flickr, and more, including Hang w/—can't forget how much time I am spending on that app—as well as a cinemagraph app called Flixel. You can pretty much find me, @mstracylee, on everything.

THIRTEEN

Putting It Together

There are three things that I hope to leave you with when you finish reading this book: First, the idea that the process of HDR does not need to be incredibly complex. Follow a couple of guidelines. Take as many pictures as you can. Jiggle sliders. Repeat. To get involved in the whole "Can I do it in less frames" idea just asks for you to miss the opportunity to make a great shot. And, isn't that what we are really after? Use the technology you have to your advantage. Let the pictures you make speak for you.

Second, the making of a good HDR image always lies in the post-processing. If you are on the Internet looking at an HDR picture and saying to yourself, "Wow, I wonder how he/she did that," you are looking at a file that has some post work done to it. This post work can be in Photoshop or it can be in some third-party plug-in. It always has at least one of these components. The trick is to know *what* to fix when you're finished and to know how to do it. If you're reading this chapter introduction, I'm pretty comfortable in telling you that you have *all* of the tools you need.

The third and last thing is my desire for you to take the components that we've talked about here and play mix-and-match with them. While these projects each focused on a specific image, that doesn't mean you can't pull some Oil Paint filter into a portrait. Or double-tone-map a realistic HDR. Or create a black-and-white HDR panorama. Think of all of these lessons as blocks that you can mix and match for whatever project you are working on.

In the spirit of this, I want to share with you some final images, and just give you a high-level view of what went into their creation, all from things you learned in this book.

The Bodie Bed

Here, I used a 7-image bracket to get the detail in the window and the shadow detail to the left of the basin. One layer served as the "warm" tone of the image, while a duplicate layer was cooled in Camera Raw. This cool layer was hidden and painted only into the window area. Sharpening was added in Photoshop, along with the Glamour Glow filter in Color Efex Pro.

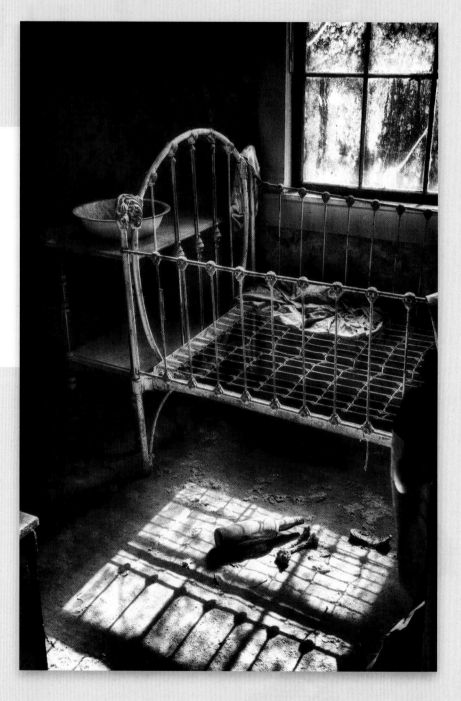

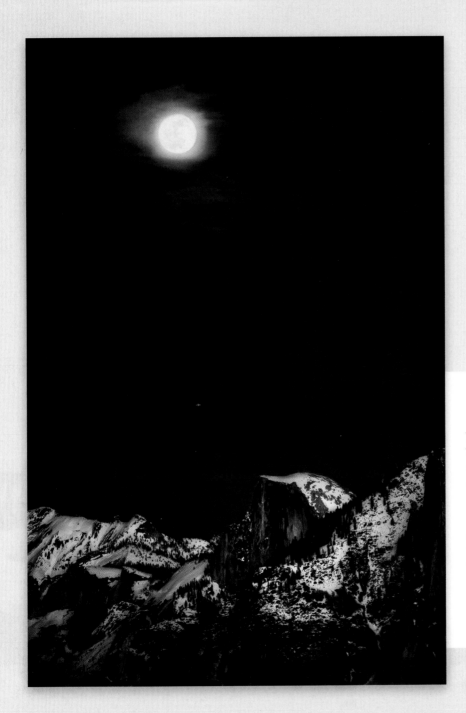

Moon at Half Dome

This HDR image was shot at blue hour. The color version of it lost a lot of the wisps of clouds from the moon down to the mountain. By exaggerating the HDR file, I was able to bring back the cloud wisps. In a tip of the hat to Ansel Adams, I turned it into a black and white and used dodging and burning to bring the wisps more to the front, as well as enhance the mountain snow detail. It was then processed in Silver Efex Pro.

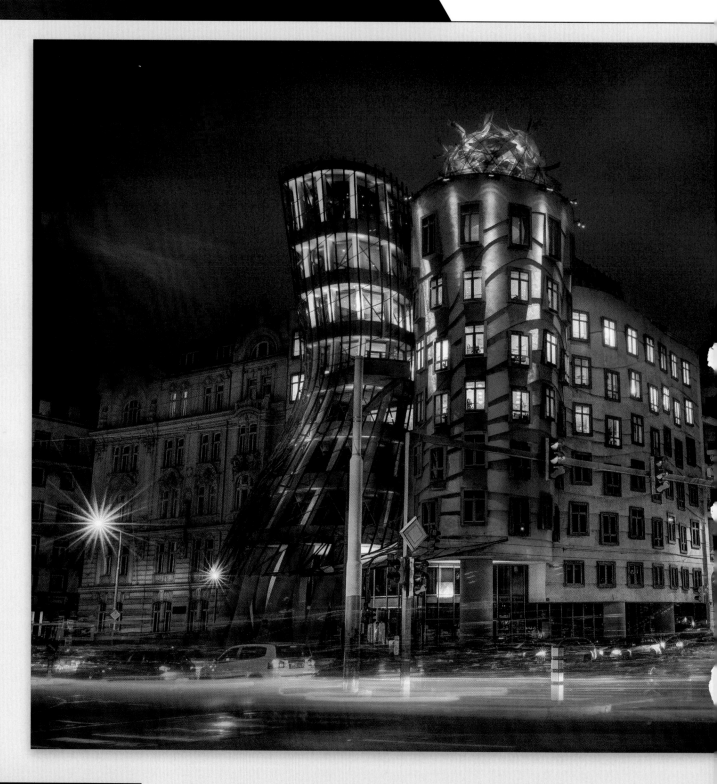

Dancing House

I traveled to Prague over the fall and made it there in time for SIGNAL—an annual light festival. Every hour, key locations in Prague were illuminated with lights. Music played and the lights moved around. This building was designed by Frank Gehry and is an often-shot icon of Prague.

I waited until blue hour (just after sundown) to get a nice cool color in the sky. After shooting the initial HDR files, I waited around and took some long exposures of the different lights that would hit the building, as well as some long exposures of the cars that would pass by. After finishing the HDR file, I went back into Photoshop and overlaid different colors that the long exposure shots gave me on the building, creating my own moment in time with the colors. Sharpening was then added in Photoshop, along with the Glamour Glow filter in Color Efex Pro.

Eric Wojtkun

My buddy, Bill Fortney, was giving a seminar at Old Car City—a wonderful car junkyard about an hour north of Atlanta, GA. At the workshop, I met Eric Wojtkun, the lone Pentax shooter of the group. I thought Eric had a great spirit, and was so eager to get out there among the car ruins to shoot, that I had to make a picture of him.

 This was a bracketed series taken with a Fuji X-Pro1. Five images were used. Once the tone map was created, I masked back in some of the blue skies and trees from one of the underexposed images (which helped the halos). A couple of dodge and burn layers brought back some of the details in the camera. I used one of the original exposures for the face and the watch, and then added some Curves adjustment layers to pop them out a little more. The entire image was then desaturated with a Hue/Saturation adjustment layer. To finish it, I added some sharpening in Camera Raw and gave it some Glamour Glow in Color Efex Pro.

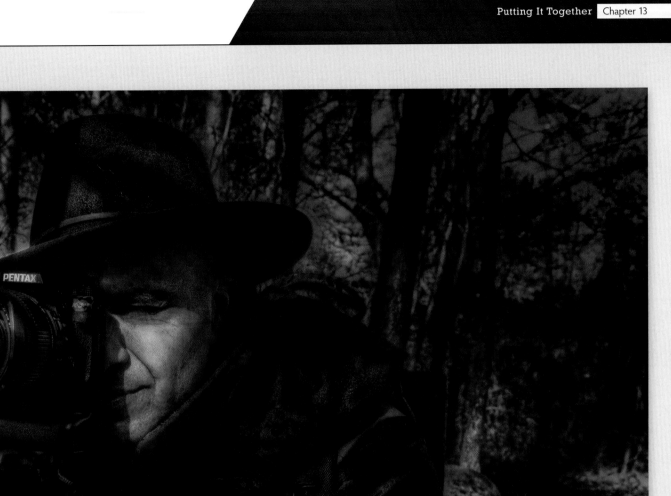

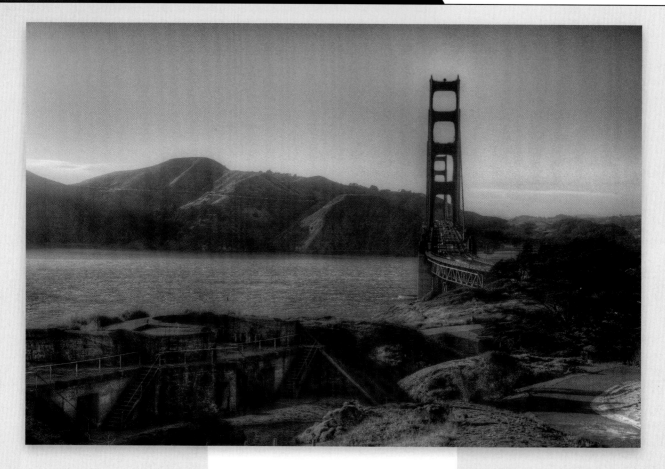

Golden Gate

This picture is a 9-stop exposure series shot with a Nikon D3S. The image was tone mapped in Photomatix, with the Lighting Adjustments slider left all of the way to the right, giving me a natural-esque look. From there, the Glamour Glow filter was applied in Color Efex Pro.

This, to me, was one of the first times that I realized that I could combat a lot of the halos that you see in bald skies by simply shooting a lot more frames than you would think you'd need, as well as shooting for the basement.

Glassblower

Imagine having to hold still with a giant flame just inches from your face! This is Chad Piece, a glassblower in downtown Ybor City (Tampa), who volunteered to hold still for this shot.

I made this shot at 2200 ISO, with a Nikon D3S, shooting through a store window. The 5-bracket image was tone mapped to create an overall mood. The face and flame come from a couple of the original images being overlaid into the tone-mapped file. To get the face and flame to match, I added Clarity to the images in Lightroom. The image was then darkened using Curves adjustment layers. Noise removal was applied and some sharpening was added in Camera Raw. The image was then finished with some Glamour Glow in Color Efex Pro.

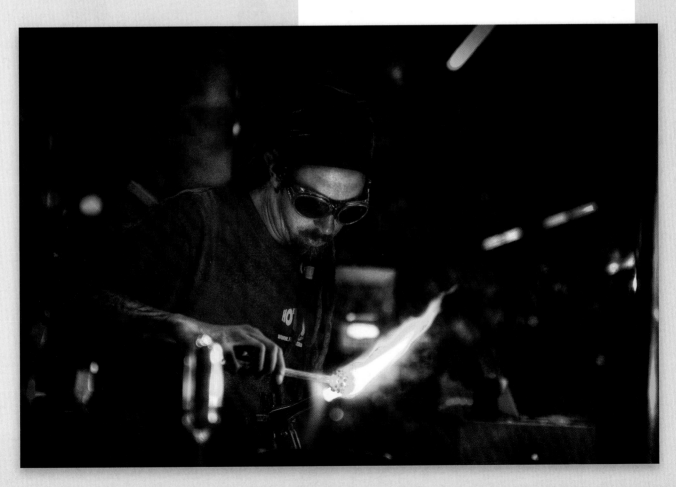

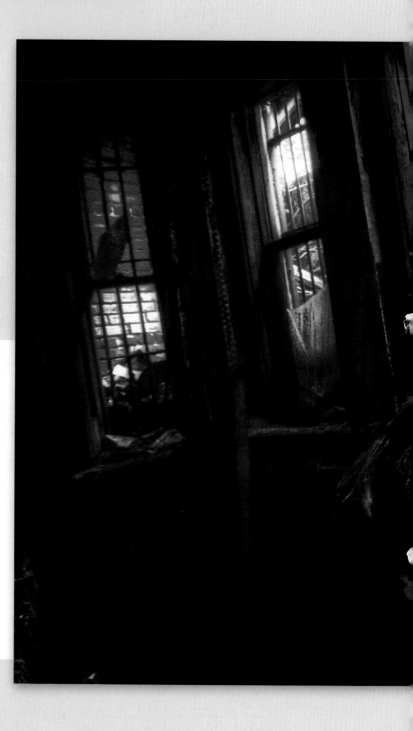

Zombies! Run!

I shot a class for KelbyOne called, "Exposing HDR." This class was much different than most of our classes in that we were teaching HDR in an abandoned church in Gary, Indiana, when all of a sudden, we were attacked by zombies! The actors we hired for the zombie shoot had some really intense looks. So, I figured it would be a good idea to try shooting them for an HDR portrait.

Usually, the HDR portraits that I try tend to be a little on the softer side. After I tone mapped the image for the scene, I did a second tone map focusing only on the face. I overlaid the two images in Photoshop and painted in the more textured face to the environment. Some blur in Photoshop whitened the eyes, and we were good to go.

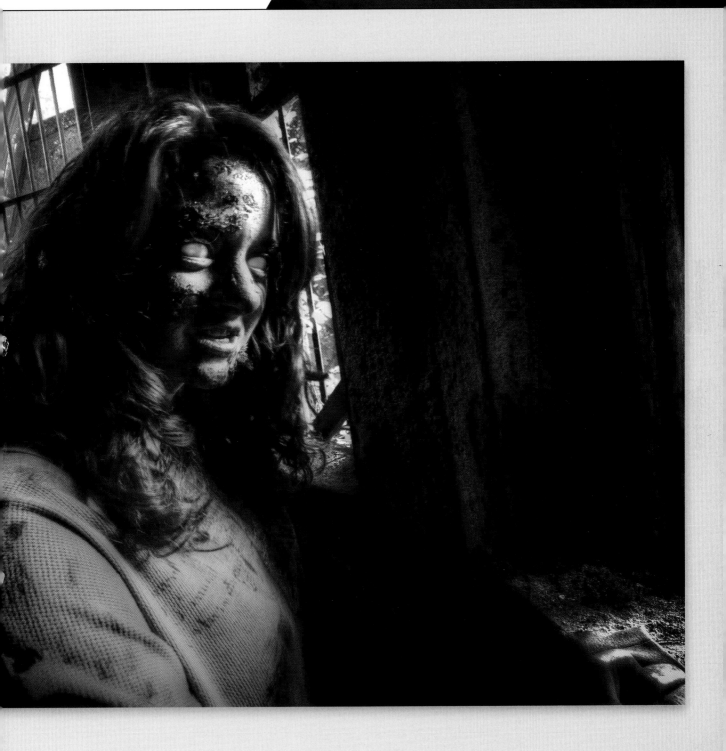

Jade Mountain

Located in the Jade Mountain resort in St. Lucia (www.jademountain.com), this is by far the most beautiful hotel room I've ever seen. I have the privilege of doing a workshop there with Joe McNally and, as part of this, I spend my evenings trying to make images of the hotel that just speak to the exquisiteness and romance of the rooms.

This was a 7-image bracketed shot just after blue hour. The image was duplicated, and then, in Camera Raw, toning adjustments were made to accentuate the colors in the room and out toward the mountains. From there, some of the original layers were masked back in to show the glow of the lights. Sharpening was added in Lightroom, and Glamour Glow was added in Color Efex Pro to finish the shot off.

Jade Mountain Club

As much as I didn't want to double-down on showing another shot of Jade Mountain, this picture illustrates high ISO very well. I wanted to really control how long I kept the shutter open for the shot, as I was trying to capture the Milky Way in the sky. Moving the image to 3200 ISO definitely helped on the Nikon D3S. Some noise reduction was applied, as well as some adding of the original brackets, and an HDR with stars was achieved.

Sabine's Christmas

Without a doubt, one of my favorite HDR portraits has to be of my daughter Sabine Annabel during Christmas. I had been looking for a good-looking Santa to try an HDR portrait on that evoked a bit of a Norman Rockwell-look. I found this Santa at the Oldsmar Flea Market in Oldsmar, FL (of all places).

Sitting her on his lap, I moved two artificial candles that he had just out of the field of view to the left and right of the image. I shot a 7-frame HDR at 1600 ISO at f/5.6. Once I tone mapped the image for the texture I wanted, I masked Santa back in. I also removed color casts on the white fur using Hue/ Saturation adjustment layers. From there, I masked back in an original frame of Sabine for the face, hands, and shoes. After some dodging and burning, I applied the Oil Paint filter to a merged layer. Finally, I used the Mixer Brush tool to soften the Oil Paint effect, and then mixed the paint layer with the original tone-mapped image.

Index

Welcome To Your Classroom

Open the door to world-class instruction on photography and design. Connect and share within a community of creative people. Discover on-demand creative training that you can learn anywhere, anytime and at your own pace.

kelbyone online education
for creative people

Join us now at **kelbyone.com**